the magic of digital nature photography

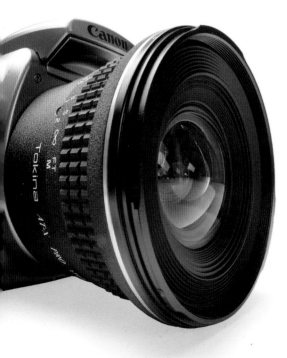

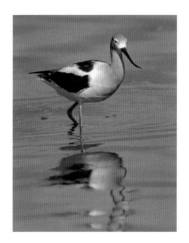

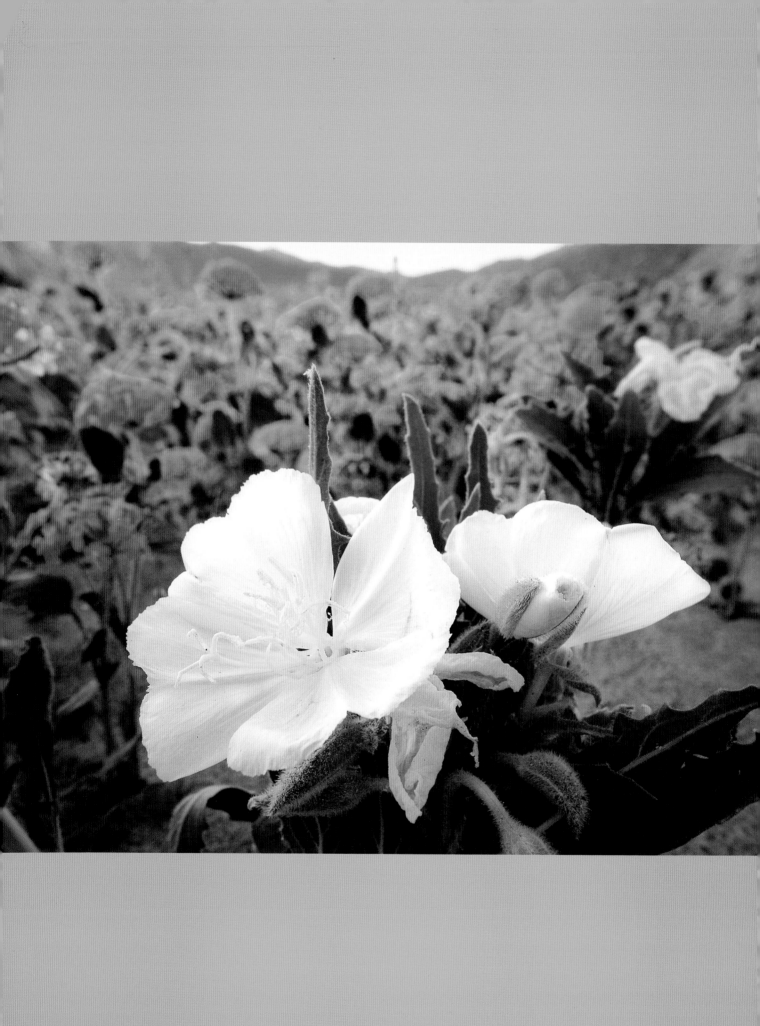

the magic of
digital nature photography

Rob Sheppard

LARK BOOKS

A Division of Sterling Publishing Co., Inc.
New York / London

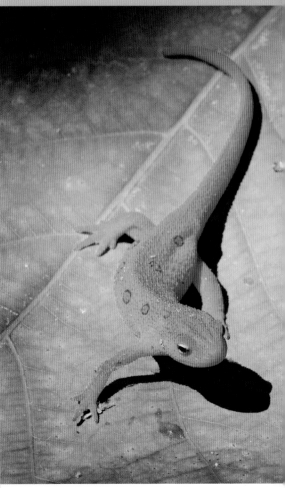

Editor: Kara Helmkamp
Book Design and Layout: Tom Metcalf
Cover Designer: Thom Gaines
Production Director: Shannon Yokeley
Editorial Assistance: Delores Gosnell

Library of Congress Cataloging-in-Publication Data

Sheppard, Robert, 1950-
The magic of digital nature photography / Robert Sheppard.
p. cm.
Includes index.

ISBN 1-57990-773-3 (pbk.)
1. Nature photography.
2. Photography—Digital techniques. I. Title.

TR721.S53 2006
778.9'3—dc22
2006001619

10 9 8 7 6 5

Published by Lark Books, A Division of
Sterling Publishing Co., Inc.
387 Park Avenue South, New York, N.Y. 10016

Distributed in Canada by Sterling Publishing,
c/o Canadian Manda Group, 165 Dufferin Street
Toronto, Ontario, Canada M6K 3H6

Distributed in the United Kingdom by GMC Distribution Services, Castle Place, 166 High Street, Lewes, East Sussex, England BN7 1XU

Distributed in Australia by Capricorn Link (Australia) Pty Ltd., P.O. Box 704, Windsor, NSW 2756 Australia

If you have questions or comments about this book, please contact:
Lark Books
67 Broadway
Asheville, NC 28801
(828) 253-0467

Manufactured in China

ISBN 13: 978-1-57990-773-0
ISBN 10: 1-57990-773-3

For information about custom editions, special sales, premium and corporate purchases, please contact Sterling Special Sales Department at 800-805-5489 or specialsales@sterlingpub.com.

contents

introduction

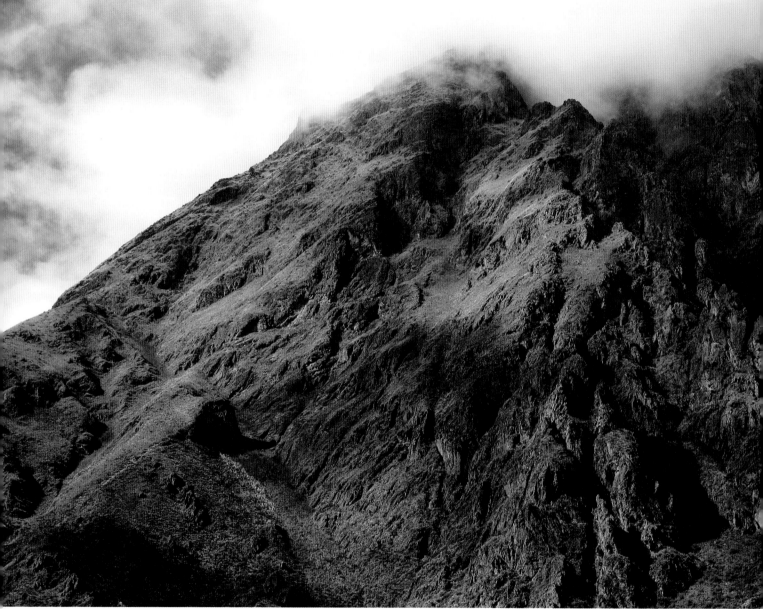

Rocky terrain in the Sacred Valley of the Incas, Peru.

When photographers are polled as to their favorite subjects, nature photography, from landscapes to flowers to wildlife, consistently comes out on top. But then you probably already suspected that.

I have enjoyed photographing nature since I was a kid. I remember entering a black-and-white print of lower Gooseberry Falls in Northern Minnesota into a local newspaper's photo contest when I was in junior high. I was very proud of that photo, but it didn't win. That really didn't matter, for being outside with a camera was a real joy.

And it still is. I have photographed from Peru to Newfoundland, Florida to Washington, and I have loved it all. There is a magic to being outside in a beautiful location and photographing the nature that surrounds you.

This book is my way of sharing that magic and hopefully giving you ideas on how to capture the magic of nature in your own photography. I have included techniques and ways of photographing natural subjects that I know work because they have worked for me and for many of my workshop students. You will find a range of ideas, from those basic things beginners need to new possibilities that might encourage an expert to try something new.

You will also see many of my favorite subjects. For me, nature photography is a way of sharing a part of the world that I care very much about. I want viewers to discover anew the neat bits of nature that I have discovered in many great locations, from the dramatic places most of us visit only once, down to the special little places that harbor nature right outside your door.

I don't want to simply share these subjects with you. I want to get you excited about getting out and taking photographs of your own special subjects. We all have them. You don't have to photograph like Ansel Adams or Jack Dykinga in order to find your vision of nature through photography. The key is to get out and experiment.

Digital technology has changed the way photographers deal with nature photography. I don't say that as one who simply enjoys what the new technologies offer, but from what I have seen again and again with photographers around the country.

Digital encourages you to take pictures. My wife, who is not as devoted to photography as I am, even says she loves digital because she no longer has bad pictures. She deletes them! Once you have a digital camera, there is virtually no cost to taking pictures, and if you take lots of them, you only need to keep the best. You also know that you've gotten what you want because of the LCD review.

If you prefer film, then get out and shoot with film. I believe there is a certain restorative power that comes from being outside connected to nature through your photography regardless of the technology you use. To take nature photos, you have to be in nature. Being in nature connects you with the world in ways that no nature documentary, Internet website, or realistic game can ever do. In today's world, I believe that connection is very important to us all.

So whatever your inclination for photography, enjoy the book, then get out and make your own photographs. Have fun exploring nature wherever you are!

Rob Sheppard
www.robsheppardphoto.com

1 possibilities

Who hasn't been excited by a stunning sunset and wanted to capture that as a photograph? Or who has visited a great landscape and hasn't wanted to share that with others?

Almost everyone who owns a camera has photographed nature. It has been a subject for photographers since photography began.

Nature attracts us with its beauty, grandeur, wildness, ability to provide refuge from our often hectic lives, and for its magic. The natural world holds so many wonderful and amazing things that do seem, at times, magical. Nature photography gives us the chance to experience and interact with another kind of magic: the ability to realistically capture the world in a still image.

I have to let you in on something about nature photography that not everyone talks about. Nature photography will transform you. This is no psycho—babble – it has affected me, true, but that would hardly be enough evidence to say it will transform anyone. I say this because I have seen it to be true time and time again. As editor of *Outdoor Photographer* magazine, I have had the privilege to know some of the great nature photographers of our time. For them, consistently, photographing nature is not simply about capturing a subject, but about connecting with the life around us to affect both the photographer and the viewer.

Nature photography lets us escape the challenges of our world and gives us the chance to share our unique experiences in the natural world. Whether we just like the color of a special flower, the drama of a mountain range, or want to alert others to environmental issues, nature photography is a great way to express a feeling. No matter what the skill level of the photographer, capturing nature in photos is a special experience that goes far beyond the photography itself.

Anne Lamont, author of *Bird by Bird*, a book about writing, says something that applies to nature photography, too. She answers the question about why writing matters. Her answer, I believe, fits nature photography perfectly: "because of the spirit...because of the heart. Writing and reading... deepen and widen and expand our sense of life: they feed the soul."

Nature photography definitely deepens, widens, and expands our sense of life. And I know from working with so many nature photographers that it feeds the soul. Ultimately nature photography comes back to you, the photographer. What do you love about nature, and how can you capture that on film? What is life affirming and soul expanding about nature for you?

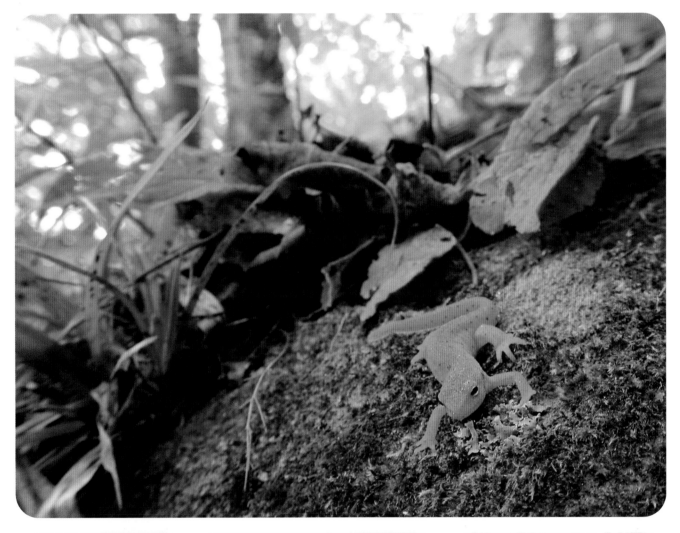

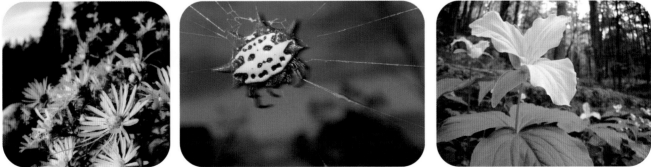

Top: Red eft (land form of newt) in Vermont. Bottom left: Asters in Acadia National Park, Maine. Bottom middle: Crablike spiny orbweaver in Florida. Bottom right: Showy trillium in the Great Smoky National Park, Tennessee.

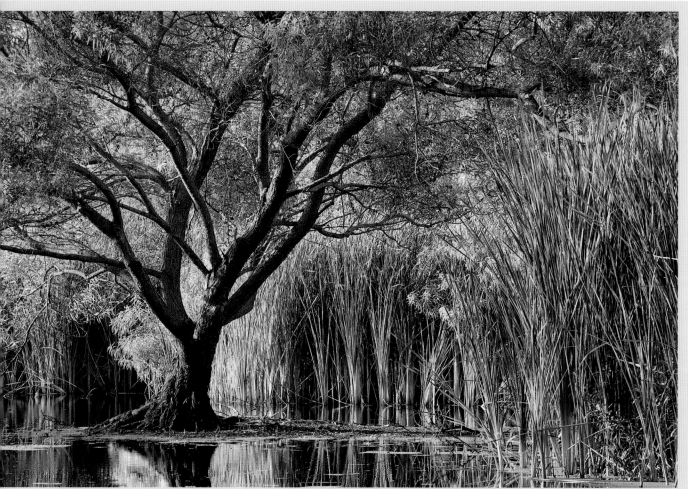

Marsh, Southern California.

appreciation

The natural world is home to a wealth of wonderful elements, from sunsets over the ocean to dew drops on a spider web. There is much to appreciate, but of course, what you like about nature doesn't have to be the same as someone else's preferences. That is what makes nature photography so exciting; you can take pictures of your favorite subjects and have totally different images than someone else with a different set of favorites.

Author Bill McKibbon once wrote, in a well-intentioned but sadly misguided article, that no more wildlife photographs were needed, so photographers could quit bothering animals. That misses one of the beautiful parts of nature

photography – the actual process of photography is an act of appreciation and enjoyment, and that process nurtures feelings of appreciation for nature. (Having worked as a naturalist, I can also note that while it is possible to bother animals, the natural world is far more threatening to a wild animal than a caring photographer.)

You don't have to be a National Geographic photographer to appreciate nature through your camera. Let your own loves and joys from experiencing nature, whether in a neighborhood park or the Grand Canyon, guide you to beautiful images that you can call your own.

Bristlecone Pine, Ancient Bristlecone Pine Forest, California.

record keeping and memories

A very basic and important part of photography is its ability to record things for posterity. When you go to a great location like Yellowstone National Park, or experience autumn in Acadia National Park, you want to remember it. Some of your photos will be just for the record, so to speak.

Today's cameras do a very good job of record keeping. Modern exposure systems, autofocus, zoom lenses, and more all give us the ability to go to a great location and record at least a reasonable facsimile of it. These will not be the shots that you will put on your wall or proudly show off to everyone as examples of your photographic skills, but if you don't take these photos, you will miss them when you get home.

Even Hollywood includes such shots in the best of films. An overall composition of the setting in which the action takes place helps the viewer better understand the context of the scene. The same thing applies to your photography. Overall shots that record the setting can give the rest of your photos some context, too. At a minimum, they help you better remember the location and provide context for a slide show.

California poppies.

connection

One of the real challenges of modern civilization is the loss of connection with the natural world. Even if we live in the city, nature still affects our lives in many ways. In general, most people need something of nature around them. We consider architectural spaces without plants to be sterile and uninviting.

We have many connections to the natural world, though they aren't always recognized. The rush of spring growth and its wonderful greens has a positive boost on nearly everyone. The weather around our homes is affected by the natural plants there; trees, for example, keep streets cooler in the summer. For many people, feeling connected to nature has spiritual connotations–on a very basic level, who has not been lifted by a field of flowers?

Photography is a superb way to connect with nature, and it works in three ways:

1. Connecting with the subject when you take the picture. When you take a picture of something in nature, you discover wonderful things that you love about our world. Finding a way to explore that through the viewfinder can be a way of focusing your attention, too.

2. Connecting again with the subject when you look at the photo later. That great subject you saw outside can be experienced and enjoyed again when you make a print or see it on your computer screen. It can help you relive the whole experience of being there with something in nature.

3. Helping others connect with the subject when you share the image. A great part of photography is the chance to share what we see and love with others. Once other people see your photos, they, too, have a chance to connect with that subject and gain something from that connection.

Canyonlands National Park, Utah

sharing your world

Let's explore the idea of sharing and why it is important. After all, that is the whole purpose of publications like *National Geographic* and *Audubon* magazines. They share images and ideas about natural things from around the world.

You can do that, too. I think this is an essential part of photography. When you photograph things in nature, I know that you feel something about that subject. When traveling, we often photograph things just to remember them. But a sunrise through the woods, richly colored flowers, or a pelican flying close to the water all provide something more. We take those pictures when we are inspired by the subject.

Dandelion.

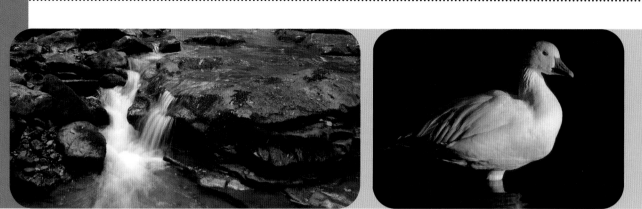

Waterfall in Eastern Tennessee. **Snow goose.**

When we share photos with others, whether attached to an email or put into a slideshow with music and special effects, we are sharing our excitement about the world. This is always worth doing, no matter what level of photographer you are. I sometimes hear amateurs making excuses for their photographs and not wanting to show them. Share those photos! The natural world is a special place and by sharing your special connection to it through your images you offer others new possibilities and insights to that world. No one sees the world exactly as you do.

As your skills improve, your photographs will become more refined and crafted, but the core belief in your subjects won't change. That is there from the start and is always worth sharing with others.

creative expression

Nature is full of creativity. Think of the brilliance of autumn colors painted across a hillside, the beautiful colors of a wood duck, or the clever way a Venus fly-trap plant captures its insect prey. That can be very inspirational, and you can certainly photograph that. But for most photographers, creative expression means much more. We want to make something beautiful and unique – a photograph that we can proudly display on the wall or an image that no one else has.

There are so many possibilities here. This book is filled with them and is meant to offer you ideas and inspiration for your own picture-taking. But there is a challenge. Sometimes nature just looks so good that it distracts from the photography! For example, a beautiful flower is so perfect that it seems all you should do is frame it with the camera and take the picture. Unfortunately, this does not always result in a photo that expresses how you really felt about that subject. The problem is the camera doesn't see the world the way we do. We have to control things like light, focus, and background to create an image that expresses the essence of the flower. This is creative expression.

One way to awaken your creativity with nature photography is to adopt a playful or experimental approach to picture-taking. Modern digital cameras make taking well-exposed, properly focused photos a lot easier than in the past. Plus, you can instantly check any of your shots to see if you like them or not by using the camera's LCD. The technical part of the process has been nicely simplified and adjusted for us so we can concentrate on other things. Now you can go beyond just framing that interesting natural scene in the viewfinder.

Take the first picture you see, for sure, but then take another. Go beyond that first image and find something else interesting about your subject. Use the LCD review to help you compare shots. There is always something else. Try a higher or lower angle of view. Get closer or farther away. Shoot through some leaves or look for a natural frame. Play with your photography and your subject.

Dragonfly in New Mexico.

You can certainly do all of this with a film camera, but its great disadvantage is that you cannot see your photos as you go. You have to wait to see those experiments–those new shots–until you get the film back from the processor. On the other hand, with digital, you can see exactly what you get as you go. In addition, once you have your digital camera, there is no cost to shooting extra images to find that new and creative shot. With film, there is always the concern of "wasting film," of running out of film, or at the least, of having to pay for the extra shots in film and processing. Digital is very liberating for the creative side of photography.

understanding

Photographs can help unveil the secrets and mysteries of nature. For that reason, scientists have used photography for years to aid in the study of subjects. Photographing nature can help us discover and understand the things we see in the world. In addition, photos are perfect for helping all of us remember special things we've seen. What did that contorted tree look like up in the mountains? Bring out the photos and see. How big were the fields of California poppies that year? Pull up the image files on the computer and check.

Immature lubber grasshoppers, Florida.

Lupine, California.

ple, I often try to take a photograph of it that emphasizes such things as its shape and leaf types. I don't try to be creative; I just try to make the flower as clear as possible for identification purposes. Then I look for additional, more creative ways to photograph the flower if the conditions are right. Sometimes, I just take the identification photo if, for example, the light isn't condusive to creative photography.

making a difference

Nature photography has a rich heritage of photographers using their images to make a difference in the world. Right after the Civil War, William Henry Jackson explored the American West with his photography. His photographs of the Yellowstone area in 1869 strongly influenced the establishment of this first national park in 1872. In the twentieth century, photographers Ansel Adams and Philip Hyde were also great advocates for the national parks and other environmental issues.

Wonderful things abound in the natural world but are threatened by people and politicians whose values are misplaced. You, too, can make a difference in your own area. You have many opportunities for doing this, and it all starts when you share any of your photographs with others. If you visit a spectacular natural location, put up prints of scenes you have captured on your home and business walls. That can make a big difference in both enhancing your home and business environments, as well as helping viewers think about the beauty of our world. Photographing and sharing local

Nature studies cover many areas, from the complex fieldwork of a professional ecologist to the casual observations of a birding enthusiast. Photography helps both, providing tools to capture images representative of their subject so they can later identify the subject, compare it to others, check unique characteristics, place it in a special location, and so forth.

Photography for nature studies, however, can be quite different than photography for creative expression. Scientists, for example, need a photograph that is clear and sharp so that special details of the subject are easily discerned. No creative lighting is necessary. Even an amateur naturalist will often need a more scientific photo that allows the subject to be readily identified.

There is certainly a place for both types of photography. If I find a flower that I don't know, for exam-

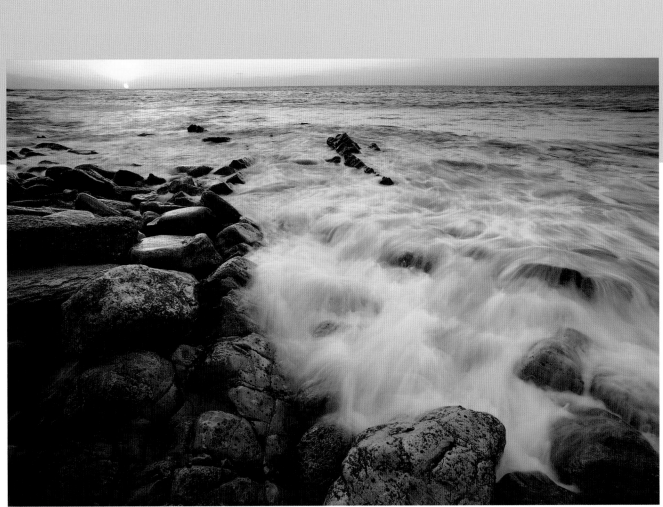

Sunset on rocky coast near Los Angeles, California.

nature can open the eyes of people who might not have noticed before they saw your images.

There are many opportunities to do more, if you are so inclined. Photographing local parks and putting on photo shows can be beneficial to both you and the parks. Capturing unique moments in areas threatened by thoughtless development and offering to create a digital slide show for community organizations can help others understand the importance of nature in your community. Presenting slide shows about the natural history of your region can be a great way to connect with your local schools and get young people more interested in the natural world, too.

make it fun

Nature photography is fun. At least it should be. After all, it is a great excuse to get outside and enjoy flowers, landscapes, wildlife, sunrises, sunsets, and everything else that makes up our natural world. Photography has both its technological and artistic elements, but that technology can have a downside if it distracts you from having fun with nature photography.

I am not talking about the photographer who loves technology for its own sake. That person has fun discussing millimeters of resolution of his or her latest lens, and if that offers an enjoyable way of passing time, then I'm all for it. What I am talking

about is the photographer who is intimidated by all the should's, must's, and ought to's that they encounter in photo magazines, ads for camera gear, photo books, and experienced photographers, whether they are well-known pros or local photo enthusiasts.

As soon as you start worrying more about the right f/stop than the subject, that can be a problem. It can keep you from enjoying the whole process. I know of avid amateur photographers who gave it all up because they didn't think they were "good enough." That is sad.

As I hope you have seen from this chapter, there are many reasons for getting out and photographing nature. It is true that as you learn more about your camera and photography, you can find more satisfaction in capturing the images you really want. Yet, at any level, you can find magic in photographing nature. Frankly, any reason that works for you, works for me.

Cactus flowers, Arizona.

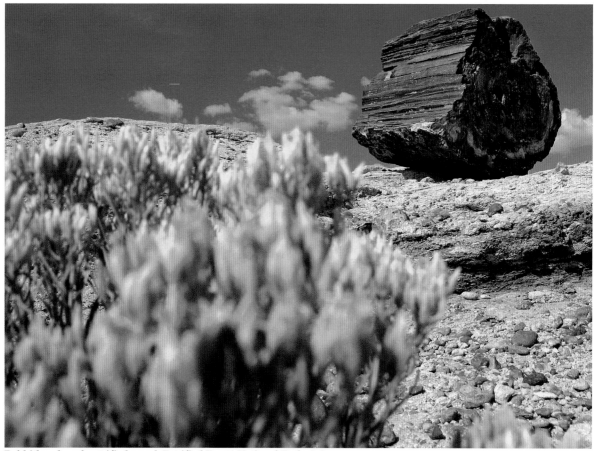

Rabbitbrush and petrified wood, Petrified Forest National Park, Arizona.

Connections – An Explanation

In each chapter of this book, you will find a small addition called Connections. I believe it is important to connect with nature beyond simply seeing it as a subject matter. It is easy to sometimes forget the natural part of nature photography amidst the technology and techniques of photography itself. Understanding a bit about the nature you photograph can make your photography better and more satisfying.

One of the problems of modern biology instruction is an overemphasis on details that few of us can relate to. The nature that we all photograph is very much something for everyone to connect with. Biologists are too often interested in reducing life to a gene and a cell, making the science of life not very exciting (even though life is what we are all about).

Nature photography is about celebrating life as we experience it in the real world. A flower may be made up of high-tech genetics and biochemistry, but none of that gives the average person much of a feeling for it's beauty, nor does it show the flower as part of an ecosystem that includes other plants, wildlife, microclimate, and more. Nature photography lets you share the magic of nature as you see it, a magic that can be lost when it is reduced to a chemical formula.

Photography can open people's eyes to this wonder of life. Ecology is not a dry, academic topic, but a way of seeing the diversity and interconnectedness of the world. Being aware of such connections can point you in new directions for your picture taking and even make it more fun. So look for the Connections in each chapter and the connections of nature to your photography.

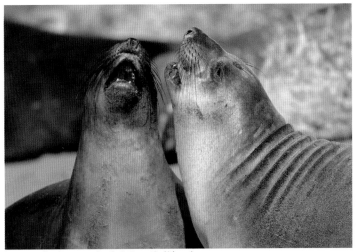

Young elephant seals fighting, California.

Wood sorel and woods, Great Smoky National Park.

2 gear

You will see a whole range of techniques and approaches to many different natural subjects in this book. You could even skip this chapter and go right into the nature photography, if you'd like. Good nature photography is not about buying the right brand of equipment or even some arbitrarily "right" gear because others use it. How you see nature and use your equipment, whatever it is, to capture your view of the natural world is most important.

However, since we all know photography is both art and technology, gear is important. No matter how great a time you have in a natural setting, you can't bring some of that magic into a photograph without the appropriate gear for the type of photography you want to do.

Keeping that in mind, photography equipment is a very personal thing. What works well for one photographer often does not work as well for another. You will find equipment specific to a particular type of nature photography discussed throughout this book. This chapter will offer you an overview of gear and how it relates to your specific needs.

Gear has a funny affect on photographers. Some folks get so caught up in the equipment and focus so much on the technicalities of the gear, that they lose track of the ultimate goal — taking pictures. Sure, it can be fun to discuss how the latest Nikon beats the latest Canon or vice versa, but for the photographer interested in the magic of nature photography, there is not much point to that (unless you just enjoy a good argument!).

On the other hand, some photographers go to the opposite extreme — equipment doesn't really matter and that photography is all about the photographer. They try to impress on others that old technology is just fine and new digital stuff is just a distraction. Still others get caught up in equipment lust —there is always a new piece of gear that is better and they have to have it. In truth, capturing the magic of our world in photographs sometimes takes a lot of technology and sometimes it doesn't.

One problem today is the rapid pace of technology for the digital photography industry. For a while, it seemed that as soon as you bought digital gear, it would be outdated the next day. You couldn't keep up. This was especially true with the megapixel race. That has changed today. You can buy digital cameras and associated gear that will serve you well for a long time. Unless you get caught up in technology lust, you don't have to buy every latest and greatest piece of equipment as soon as it reaches the market.

The whole point of this is that I want you to enjoy taking pictures and finding your own way in nature photography. Don't be discouraged or intimidated by photographers who tell you that you "must" use this or that gear or that you "must" photograph in a certain way. Find what works for you, then get outside, and start taking pictures!

choosing a camera for nature photography

Cameras come in many different types and styles that can fit the needs of anyone (digital and film are recording media and both can be found in all types and styles of cameras). When looking for a camera specifically for nature photography, you should fit your specific needs to the features on the camera.

First, you need to know a little about camera types and how they relate to nature photography. Secondly, you need to look at what types of nature photography are important to you and how they relate to camera features, plus any other features you may like. Finally, you need to find a camera that fits your personality.

Some people try to make picking a camera a technical, objective process, and if you are the technical, objective person, that may work for you. However, camera selection is too personal and subjective for this approach to work for most people. I can tell you from long experience with photographers and camera equipment that if you don't like your camera, no matter how great the features, no matter how much it fits arbitrary "standards," no matter if it got a top rating from *Consumer Reports*, you won't use it as much as a camera that you truly enjoy using. I believe photography should be fun, and for it to be fun, you need a camera that you personally relate to.

Advanced digital zoom camera.

camera types

Camera design has a long history, and so we have a variety of camera types to choose from. The type of camera you want can be more important than the film or digital choice (which I'll cover). The type of camera influences how you can use it, what lenses work with it, what other accessories you can use with it (or have to use with it), the types of subjects that are most easily shot with it, and more. Some of the following camera types are not common for the average photographer and you might not ever use them, but they can be helpful to know about. It can be frustrating if you are attempting a certain type of nature photography because you were inspired by a pro's work, but the pro is using a different type of camera and your gear is not made to do that type of photography.

Point-and-Shoots

A true point-and-shoot camera is a small, compact camera with a non-interchangeable lens (usually zoom) that is designed to only point and capture a photograph. It is mostly automatic, from focus to exposure. These models are relatively inexpensive. They are very limited in what they can do for nature photographs other than distant landscapes. Digital point-and-shoots do offer more than their film counterparts because the LCD screen shows what the lens is seeing.

Advanced Digital Zoom Cameras

These cameras are often lumped with point-and-shoots, but they are no more a point-and-shoot than a digital single-lens reflex (D-SLR) camera (just because both can be operated automatically). These cameras can be shot in point-and-shoot fashion, but the advanced digital zoom cameras have far more choices, offering complete control over the image, from choice of f/stop and shutter speed to white balance to manual focus. The lens is built into the camera, and there is quite a focal length range available in different models. Many have the ability to use accessory lenses for increased wide or telephoto field of view as well as close-up lenses. Plus, most accept accessory flash units to extend their capabilities.

Since they are small and usually have lenses with wide to telephoto capabilities, advanced digital zoom cameras can be an ideal travel or hiking camera. All of these cameras do a superb job with close-ups without any accessories. They offer a great deal of nature photography capability in a very small, complete package at a fraction the cost of a D-SLR and with similar features. In addition, they all have live LCDs, meaning you can see exactly what the sensor is seeing. Combine that with a rotating or swiveling LCD, and you gain some capabilities of using a variable angle "viewfinder" (the LCD) that cannot be matched by a D-SLR.

Digital Single-lens Reflex Cameras (D-SLRs)

The D-SLR is, without question, the most versatile nature photography camera. Such cameras use a single lens for both viewing and the actual picture taking, making telephoto and close-up photography easy and convenient. A moving mirror is used to send light from the lens directly to the viewfinder or sensor. Some people confuse D-SLRs with digital cameras that have an LCD in their viewfinders, and also have a single lens; however, they are not reflex

Digital SLR camera.

cameras as there is no mirror to change the way light goes through the camera, nor does the viewfinder see the actual light coming from the lens.

Lenses on a D-SLR are interchangeable, so you gain a whole range of possible of focal lengths, allowing you everything from wide-angles for deep perspective landscapes to macro lenses for detailed close-ups to super telephotos for wild bird photography. You have complete control over the image, from exposure to focus. D-SLRs contain a physically larger sensor than advanced digital zoom cameras, regardless of the megapixels. This results in higher quality colors and less noise. D-SLRs range from low-priced models designed for average amateur use to high-priced models built for the demands of professional work. While made to handle bad weather and tough conditions, the pro models can also be big and heavy. For this reason, many pros will often use in-between models because they are easier to use in the field.

sensor size

Digital camera sensors vary considerably in size. Physical size does affect image quality regardless of the number of megapixels. As a sensor increases in dimensions, the pixels can be bigger. Larger pixels record more light, resulting in improved colors, increased tonal range, and reduced noise. As technology improves, manufacturers are making better sensors that are smaller. The difference among sensors is most noticeable when comparing compact digital cameras with D-SLRs.

The compact cameras are capable of excellent results, so the question often comes up about megapixels – if a compact camera and a D-SLR have the same megapixels, what is the difference? The difference is that the smaller sensor in the compact cameras will not be able to deal with the same range of colors and tones as the larger D-SLR sensor. But if you shoot with both set for highest quality and don't put the images next to each other, this won't be noticeable. However, you will have more color and tonality to work with from the D-SLR once the image is in the computer. In addition, the smaller camera will show more noise, significantly so when set to ISO settings much above 100 (though with the latest small cameras, this is changing). The D-SLR may show negligible noise, even to ISO 400, and minimal noise at twice that setting or higher.

D-SLR cameras use several sizes of sensors: full-frame 35mm, the small-format sizes of APS-C and Four Thirds, and larger format sensors used in medium-format style cameras. The small-format sensors see only a portion of what 35mm film or a full-sized sensor would see. Consequently, they crop the view that you would expect to get with a certain focal length on 35mm. This results in a magnification of the subject in the framed area, a great thing for telephoto shooting (such as wildlife), but limiting for wide-angle focal lengths. The focal length equivalent to 35mm is found by multiplying the focal length by 1.5x or 1.6x for APS-C sensors and 2x for Four Thirds. You can buy special lenses for these small-format sensors that are designed to specifically gain wider-angle views.

digital versus film

When digital cameras first came out, there was a huge uproar among photographers. Digital had poor quality, it could never compete with film, colors were inadequate, noise was severe, and so forth. While early cameras really did have poor quality and could never have competed with film, none of this is true today. Digital cameras are now available in a large range of configurations, and all offer excellent, true photographic quality that easily matches 35mm film and approaches medium-format film quality in many cases.

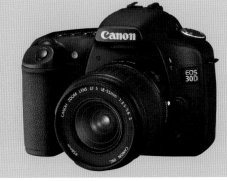

This doesn't mean film is no longer viable. Film has some qualities that digital does not. In the larger formats, it offers performance that cannot be matched in digital at the price of film and film cameras. You can still photograph on film without batteries, and even when batteries are required for the camera, they last a very long time. Film can have exposure times counted in hours, which digital cannot yet do.

But for the average nature photographer, digital is quickly becoming the dominant medium and offers terrific advantages. First, once you have the equipment, there is essentially no cost to shooting. This really encourages experimentation. Second, the LCD monitor lets you check your shots as you go so you can be sure you record the image you want while you are still with your subject. That can be a tremendous advantage for nature photographers since that group of flowers you are photographing might not be there tomorrow or the landscape in front of you will not be available to you in a few days because you have to leave the location tonight.

The LCD monitor also means you can make a photograph and immediately see what your subject looks like in a photograph. This is a wonderful learning tool— it means you can respond more directly to your subject and what you might do to make it look better in your photo. Another important advantage to digital is that it allows higher

quality prints than was commonly available before. Of course, you can scan film and get similar results in prints, but you can get to a high quality print much faster with digital. Digital images also lend themselves to quick and easy slide shows that include music and great visual transitions that were barely possible in the days of film slide shows.

are megapixels equivalent to image quality?

Megapixels are an easy way to define differences among digital cameras, but unfortunately they have been hyped so much that too much emphasis is put on them. Megapixel value is less about quality of an image and more about size. With more pixels to work with, you can make a larger print, for example. If you don't need large images, you can use a camera with much lower megapixels (and price) and have photos that will match a much higher megapixeled camera.

The size that an image can be printed (or used) is largely dependent on megapixels. More megapixels mean more detail that can be used in larger prints. On the other hand, a small print from a lot of megapixels will not look any different than the same size print from much fewer megapixels – the extra megapixels are meaningless. You can actually get a top-quality 8 x 10-inch image from 3 — 4 megapixels (and I have seen 2 megapixels match it when shot and processed with care). At 6 megapixels, 11 x 14 and even 16 x 20 prints are possible. With more megapixels, you can go bigger or crop your image significantly and still get a high-quality large print.

Buying a camera strictly for megapixels can be a waste of money and might not even give you better results for your purposes. However, it is true that a new camera with higher megapixels may represent better sensor technology and offer improved color, tonalities, and less noise, so it isn't the megapixels you are really buying, but the better technology. This is not a simple issue and it is difficult to offer really specific advice. The best thing is to be aware of what megapixels really are and figure out what you are actually getting when you look at a camera with more of them.

downloading images

Many beginning digital photographers think that the best way to download images is to use the camera and connectors that come with the camera. I can't recommend that. It is an awkward and often slow way of downloading. Plus, it means you have to find a place to plug in the camera and make room for it on your desk (you can't afford to have it lose power while making the transfer from the CF card, so AC is important).

I recommend using a memory card reader. Card readers are easy to use, small enough to take up little space on your desktop, can be left connected and make transfer of images to your computer drag-and-drop easy. This is a simple device that plugs into your computer, using either a USB or FireWire connection. You then take the memory card from your camera and put it into the card reader. This is just like taking film out of a camera, except there is no rewinding and no danger of exposing it accidentally.

The card will usually show up as an additional hard drive (for older operating systems, you may have to install drivers that come with the reader). You can then open a folder on your hard drive for your new photos and drag-and-drop them into it. Some programs, such as Adobe Photoshop Elements or ACDSee will do this for you automatically.

You can get card readers relatively cheaply for single card types, or you can pay a little more for multi-format card readers that can be used with multiple cameras.

choosing and using lenses

Focal Lengths

You will see specific information about lenses throughout this book concerning specific nature subjects. In this chapter, I simply want to offer you a quick overview of focal lengths and how they affect all types of photography, plus a look at special lens characteristics.

First, here's a look at focal lengths. You will see the term "35mm equivalent". Since most photographers who know something about focal lengths usually know 35mm film as a reference, manufacturers

have taken to comparing the results seen on smaller sensors with full-frame 35mm. This is referred to as a 35mm equivalent, meaning that a particular sensor size and focal length results in an equivalent look in the image frame (this does not mean the focal length changes or that the look is identical, just comparable.

Superwides: When focal lengths are shorter than 20mm (35mm equivalent), the lens is typically called a superwide. This is an extreme focal length that picks up a very wide view of the scene. That sounds great for landscapes except that it also picks up a lot of extra foreground or sky, which can make such lenses a challenge to use as you try to deal with all of the extra elements in a composition. They do offer extreme perspective effects that can be quite visually dramatic.

Wide-Angles: Standard wide-angle lenses typically go from 20mm to 35mm (35mm equivalent). The wider lenses have more perspective effect and you still have to deal with a lot of foreground. However, focal lengths like 24mm offer a very strong wide-angle perspective and a great deal of depth of field, but don't draw as much attention to themselves as wider lenses often do. 28mm is the most common wide-angle focal length and offers a very good wide-angle view, great depth of field, is readily available, and doesn't give obvious wide-angle effects. 35mm is a very moderate wide-angle and less used in nature photography, though it is certainly available on many zoom lenses. It just does not have a very strong effect. Wide-angle lenses are great for landscapes, for perspective effects, for places

where you have limited movement, and for getting more depth of field.

Full-Frame Fisheye: A unique type of wide-angle lens is the full-frame fisheye. (There is also the full-circle fisheye which is uncommonly used by nature photographers.) This will take in a 180° angle of view for 35mm and full-frame digital sensors, though it works well with small-format digital sensors as well. It curves straight lines, especially near the edges of the frame, in order to capture its wide-angle view, and gives a unique look to images.

Moderate: This group of focal lengths, from about 40-60mm (35mm equivalent), used to include the standard focal length of 50-60mm that everyone had as their camera's "normal" lens. It was so common that some pros avoided it because the look was so pervasive. In some ways, these focal lengths are "invisible" in the sense that they have no distinctive look and actually mimic the way we see unaided with our eyes. Some photographers, especially the pure documentary photographer, have deliberately chosen lenses in this range for that reason.

Short Telephoto: The short telephoto is called that because the focal lengths are relatively short compared to most telephotos. The range is typically 70-105mm (35mm equivalent). Such lenses offer a slight magnification but do not have strong telephoto effects (such as strong perspective compression). They are common in macro lenses offering a bit of magnification so that you can give a little space between your lens and subject. This is a very popular focal length range for photographers who do formal portraits.

Moderate Telephoto: Typically about 100-300mm (35mm equivalent), moderate telephotos cover a range of focal lengths that offer some magnification, yet the magnification isn't so strong as to make the lenses difficult to handhold. Moderate telephoto lens magnification is 2x. These focal lengths offer a great set of choices for using telephotos on a landscape or for getting shots of close-up subjects that won't let you get close, such as butterflies. They just get into the range needed for wildlife photography; these lenses are relatively affordable and easy to carry.

Long Telephoto: At 400-500mm (35mm equivalent), long telephoto lenses become prime lenses for wildlife, offering 8—10x magnification. Some photographers also use them for their extreme perspective effects on landscapes (flatten perspective, isolate details in a distant scene). They can be large and expensive.

Extreme Telephoto: At 600mm and above (35mm equivalent), extreme telephoto focal length lenses reach a range that most nature photographers rarely use. The exception is the wildlife specialist. Wildlife photography, especially of small birds and wary animals in big spaces, can demand such magnification, which at 600mm is 12x, but these lenses can be very large and quite expensive. Tele-extenders and small-format D-SLRs can help achieve this range at a lower cost

Speed, Type, Size, and Construction

Besides focal length, you need to consider four things when thinking about buying a lens: speed, type, size, and construction. These affect the usability, quality, and price of the lens.

Speed: The speed of a lens refers to the widest lens opening or f/stop that the lens can offer. Lenses are always described with this speed, e.g., a 100mm f/2.8 lens or a 70-200mm f/4 zoom. The f/2.8 and f/4 are the widest lens openings for those lenses. The faster the lens, the more light can potentially come through it. Faster lenses let you photograph more easily in lower light levels, allow faster shutter speeds and slower ISO settings, make autofocusing easier and faster for the camera, and provide a brighter viewfinder in a D-SLR. In zoom lenses, the speed of the lens may change with focal length (called variable aperture), such as a 28-80mm f/4-5.6 zoom. That means the lens is f/4 at 28mm but loses a stop of speed at 80mm (f/5.6).

However, faster lenses are also more expensive, sometimes considerably more. This does not mean that they offer higher quality results. This is a very important thing to consider. In fact, if two high quality lenses are compared, the less expensive, slower lens may beat the higher priced, fast lens because it is more difficult for lens designers to maintain quality as the f/stop increases at the wide end. The higher price of the fast lens is due to the need for added glass elements, larger optics, and more challenging lens designs. That said, the lowest priced, variable aperture zoom lenses will generally not match the quality of higher-priced zooms or single-focal length lenses, though modern computer designs and manufacturing technologies allow these lenses to be remarkably good for the price.

Faster lenses are also much heavier. Many photographers have welcomed high quality high ISO films/digital settings because they are now able to use slower lenses in the field.

The speed of the lens is not a simple choice. If you are shooting wildlife, you may want to get every bit of speed possible to ensure you can use the highest shutter speeds at all times. If you are shooting landscapes, speed may be much less important. Slow lenses are smaller but less expensive, and this does include the budget lenses now manufactured by many companies.

Type: Zoom versus Single-Focal Length Lenses: Zooms are definitely the most popular lenses today, and for good reason. They offer a great range of focal lengths in a single package, giving the nature photographer more options without having to carry more lenses (or having to spend more money). Image quality will match single-focal length lenses.

So why consider single-focal length lenses? Mainly because of speed – single-focal lengths are almost always available in speeds that are much faster than zooms. Zooms can be very slow, or if they are fast, much more expensive. In addition, a zoom lens can be much bulkier and heavier than a single-focal length lens (though it will be much lighter than a group of such lenses), and it will often have a larger front lens element that requires very large filters. Finally, wide-angle zooms, and especially wide-to-telephoto zooms, are difficult to produce without some barrel distortion (a bowing of straight lines along the edges). In many cases, this latter condition is not a serious problem in nature photography since straight lines are not common (except for water horizons).

Size: As a nature photographer, you need to consider size when you are trekking into the wilds. Lenses vary considerably in size due to a number of factors, some of which have already been discussed, such as speed. Sometimes you need to make compromises in order to gain a lighter lens for field use. Lenses get lighter as their speed decreases, the zoom range is smaller (or the lens is a single-focal length),

the lens has special construction (such as diffractive optics that reduce the size of lens elements), or the lens body is polycarbonate rather than metal construction. Less expensive lenses will usually have polycarbonate bodies, which can still offer a good quality lens.

Construction: How a lens is designed and made will influence cost, quality, size, and more. Elements used in the construction of a lens have a big effect, but the good news is that modern manufacturing techniques have allowed some of the highest quality lens elements to be used in very affordable lenses.

The two main lens elements affecting lens construction are aspheric elements and low dispersion glass. Aspheric elements are optics with a very unique design – they have a changing curve to the lens so that the surface is no longer a standard spherical lens. This allows lens designers to more easily correct certain lens defects (such as spherical aberrations) that can especially be a problem in wide-angle zooms. Aspheric elements were once a very expensive optic to produce, but this is no longer true, and they have allowed the construction of very affordable wide-angle and wide-to-telephoto zooms.

Low dispersion glass (also called extra low dispersion, super low dispersion, and other variations) is another high quality addition to a lens that used to be quite expensive. This glass is optically very pure and allows lens designers to minimize problems like chromatic aberration. This will make a lens give a crisp, brilliant look to the images. You'll also see the term apochromatic or APO to describe lenses that are highly corrected for such aberrations (and usually include low dispersion glass of some sort).

How a lens is made affects its weight, durability, and price. Low-priced lenses can be optically fine, but are not built to the standards of high-priced lenses, so they may not hold up as well under tough conditions. High-priced, "pro" lenses often have extra gaskets and seals to allow these lenses to function in rain and other severe conditions. If your nature photography never stresses your equipment,

lower priced lenses may be fine. On the other hand, if you are going into rough environmental conditions, the pro-type lens may be a necessity.

Internal focusing is a special construction that is becoming more common even on budget lenses. Internal focusing allows a lens to focus without the front of the lens turning, which is a huge advantage when using polarizing or graduated neutral density filters. It also means the lens keeps its size and balance, and it can focus faster.

A final innovation in lens design that is worth considering is lens stabilization. This first appeared in camera lenses with a Canon 70—300mm IS (Image Stabilization) lens back in the mid 1990s. Now lens stabilization technology is available in quite a range of lenses from Canon (Image Stabilization), Nikon (Vibration Reduction), and Sigma (Optical Stabilization). These all work similarly by moving lens elements inside the lens to counteract camera and lens movement during the exposure. The result is that slower shutter speeds can be used and sharpness maintained even when the camera cannot be locked to a heavy tripod. This is a great tool for nature photographers who need to handhold a lens or wants to use a lighter tripod.

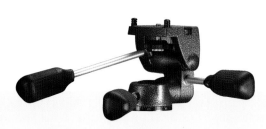

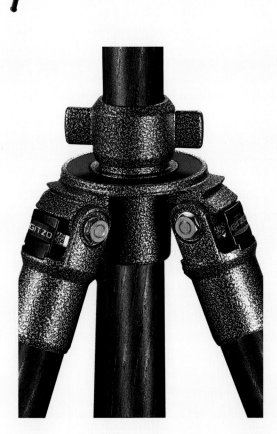

choosing a tripod and tripod head

The tripod is an extremely important accessory for the landscape photographer. It is true that a tripod is an extra thing that must be carried along, and it is not particularly easy to carry. Many photographers decide not to take it, but that can be a real problem in nature photography for several reasons.

Much of nature photography is shot in low light conditions. With a tripod, you can shoot these conditions and have free choice of f/stops because you can use slow shutter speeds.

Ultimate sharpness of a lens is achieved with a tripod. I have seen photos from photographers using the most expensive lenses that don't come close to matching images from a budget lens because the photographers with the expensive lenses didn't use a tripod. A tripod will make images taken with an average lens look great and those taken with a great lens look like it is worth the price.

Camera movement destroys image brilliance. Sometimes photographers not using a tripod will say their photos are sharp, and in small prints, they look sharp. However, tiny movement of the camera during exposure can dull minute highlights in a photograph that affect the or crispness of an image.

Composition is better assessed with a camera on a

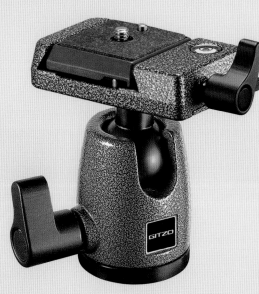

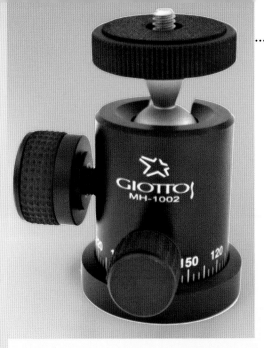

tripod. You can easily judge your compositional choices and better see what is happening within the frame.

Of course, you don't need a tripod all the time, nor is it possible to always use one. If you can use fast shutter speeds or image stabilization, you can shoot without a tripod. However, in nature photography, a tripod is a necessity for many scenarios.

Getting the right tripod can make a big difference in how often you use it. If the tripod is hard to use, too heavy, or hard to carry, you won't use it.

Here are some tips on finding the best tripod for you:

• If you can afford it, get a carbon-fiber tripod. Lightweight and very sturdy, these tripods are a pleasure to carry into the field. Plus, they do not pull the heat from your fingers when it gets cold like metal tripods do.

• If you look for a metal tripod, get a good one made from lightweight metal alloys.

• Set up the tripod to be sure it is the height you need without the center column. Only use the center column if you have to as it is not as stable as the tripod itself.

• As you set up the tripod, pay attention to how easily the leg locks work for you.

• Once the tripod is set to its maximum height, be sure the legs are locked, and then lean on it so that you put some weight on it. A good tripod will easily handle your pressure without moving much if it all.

• If you need a small tripod to pack in a suitcase for travel, check its collapsed size. You may have to compromise on the full height needed. Be wary of inexpensive, multi-segment-leg tripods, as these are often so unstable that they are worse than no tripod at all.

Most high quality tripods come either without a head or with a removable head. This is important because the tripod head is a very personal decision and affects how certain types of photography can be done. There are two head types commonly available, plus some special heads designed to facilitate certain lenses and subject matter.

The ballhead is the most commonly used head among nature photographers. It has one knob or lever to loosen the head. The camera can then be moved in all directions as the ball part of the head rotates in its socket. This freedom of movement makes it very easy to set and level quickly even if the tripod is set up on uneven ground. They come in a variety of ball sizes, but the little ones really aren't very practical (even if they are cheap). The larger ball sizes lock down better and hold your camera in position without movement,

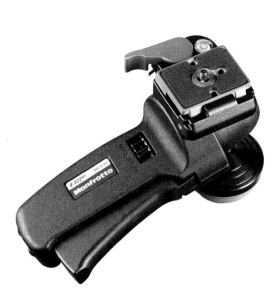

Indian milkweed, California.

though you don't need the largest sizes, either, if you are shooting with a typical digital camera and a set of average-sized lenses.

The problem that some folks have with the ball-head is that it has just one control to lock the head. If you aren't careful, a heavy camera can drop unexpectedly against the tripod when you loosen the control because you weren't ready for it to move in that direction. The pan-and-tilt head lets you limit the movement of the camera to certain planes, one at a time, so that the camera is less likely to dump. Some people also find this head easier to level. However, the pan-and-tilt head has large handles that can get in the way, is usually physically larger, and is much slower to use. Both heads work well and it really comes down to personal preference.

A special head for big telephotos used in wildlife photography is the gimbaled head. These are not generally available in most camera stores and may have to be ordered directly from the manufacturers (which are small companies). The gimbaled head balances a big lens quite nicely and allows you to keep the head unlocked so you can follow a moving bird, for example. This head can be expensive, but if you really need it, you'll find the price is worth it.

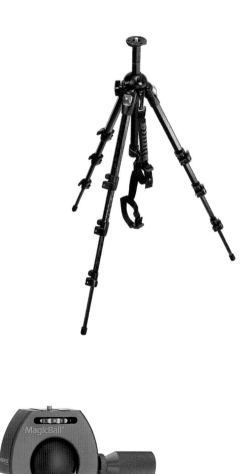

Connections — Binoculars

Binoculars are a great bit of gear that won't automatically help you with photography (though they can help you locate and identify subjects), but can greatly increase your enjoyment of nature. I like having a compact, lightweight pair of binoculars in my camera bag for a number of reasons, from watching wildlife to spotting flowers.

Binoculars come in a huge range of sizes, prices, and power. For the photographer, I recommend the moderately priced compact type. Cheap binoculars are rarely worth the price. They typically are bigger and heavier, plus their optics can strain your eyes. You might not know why, but you will find you don't enjoy using them.

With increased power, binoculars become harder to hold. The view just bounces around too much to be useful. (Canon makes image-stabilizing binoculars that do work well, though they are also pricey.) Binoculars of 6, 7, or 8 power offer good magnification that can still be easily handheld, plus they can be kept small. Binoculars are described with two numbers, such as 6x28 or 7x35. The first number is the magnification power, while the second is the size of the front or objective lens. The larger the objective lens, the better the binoculars work in low light, but that means they get bigger, too.

Binoculars come in the traditional zigzag shape of the porro prism design or the straight tube roof prism design. The roof design is more expensive because the optical path is more complicated (the light does not go straight through the tube), but it is much more compact. Porro designs give you more for your money, but might not be appropriate to your needs.

Great binoculars are available from all the camera manufacturers as well as binocular manufacturers. It is important to pick up a pair and look through them before buying. You need to see how easily the controls work, how clear and crisp the view is (look through several models for a comparison), and how comfortable they feel to you. A good pair of binoculars will almost seem invisible, like you are just seeing something magnified with your own eyes. A poor pair of binoculars will make your head ache from your eyes trying to compensate for optical problems.

Top: greater yellowlegs at sunset, California. Center: early fall colors, Vermont. Bottom: Torrey pines at sunset, Southern California.

tech details

hotography has long been an interesting blend of art and technology. Some photographers mainly emphasize the artistic side of photography, while others are more fascinated with the technical side. Good nature photography demands both. You don't have to be a scientist or an engineer, and don't let anyone intimidate you into thinking so. However, mastering at least some of the technology will help you control the photographic process so that you are more likely to get the results you really want.

Ansel Adams used to compare photography to playing the piano. If one masters the scales and other technical parts of piano playing, but has no feel for the music, then no art will appear, though people may be impressed with your skill. If one has a great feel for the music but no mastery over the keyboard, no art will appear either. The master combines both, blending technical virtuosity with sensitivity to the music in order to create something of real beauty.

This chapter will offer you an overview of key technical parts of nature photography. Some you may know, some you may not know. You can pick and choose those that supplement your skill level. Or you can just skim through this chapter to figure out what is most important to you right now in your photography.

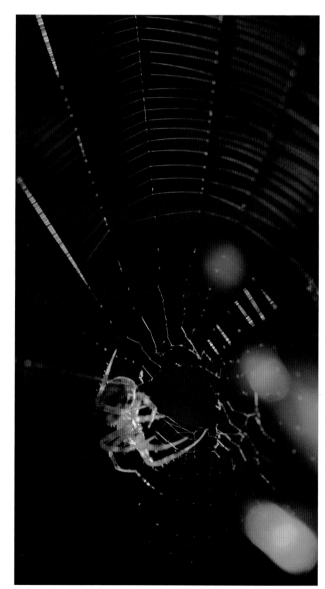

Orbweaver on web at sunset. Dark backgrounds can fool an exposure meter.

Goldfield flowers with different exposures. Exposure affects colors and tones in a photo.

good exposure is important

Exposure meters and cameras have reached a state of amazing capabilities. In average situations, you can be sure you will get a good exposure. Unfortunately, nature photography sometimes throws us challenges that are not average. If you know how an exposure meter works and how to deal with its interpretations of light, you will be able to quickly deal with any lighting situation.

Exposure is based on three variables: f/stops, shutter speed, and digital sensitivity (ISO settings). All three will be covered shortly. But first, I think it helps to understand what exposure is all about – or how bright an image is on the sensor. It is not a simple thing in the sense that it is either right or wrong. Many photographers get a "right" exposure that makes the image look okay, but not necessarily the best for interpreting the scene. I have seen many amateurs' landscape photographs that have technically fine exposure, but the exposure does not support the scene as well as it could.

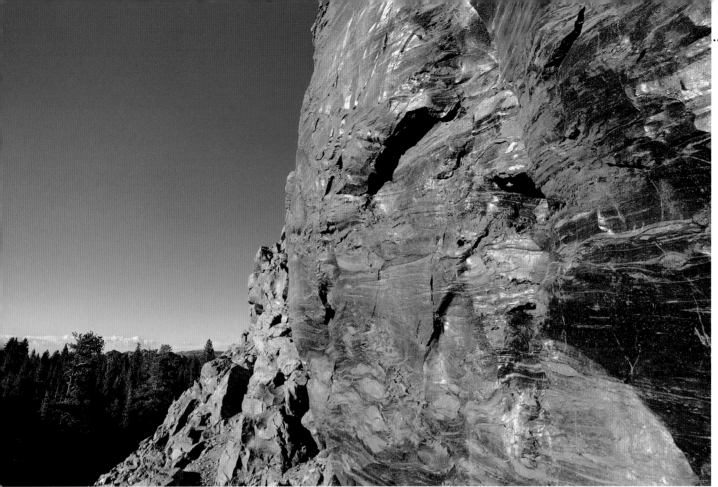

Obsidian dome near Mammoth Lakes, California.

Another problem with exposure has come with the advent of the digital darkroom. It creates an attitude of "you can always fix it in the computer." In addition, many digital photographers have been misled into believing that using the RAW file format means you don't have to worry as much about exposure. Finally, because digital files can have a problem with overexposure, many photographers overcompensate by consistently giving too little exposure.

Good exposure gives you the tonalities and colors that make your subject look its best for the light. Strong under- and over-exposure problems are obvious: too little exposure creates dark tones with little color and detail, while too much exposure results in too bright shadows and washed out highlights. But even slight under- or over-exposure can cause problems.

Exposure Problems

Under – poor color overall

Over – weak highlight color

Under – shadows become too deep

Over – shadows become too dominant because of revealed detail

Under – grain and noise become more of a problem with both film and digital

Over – lost tonal range results in contrast problems

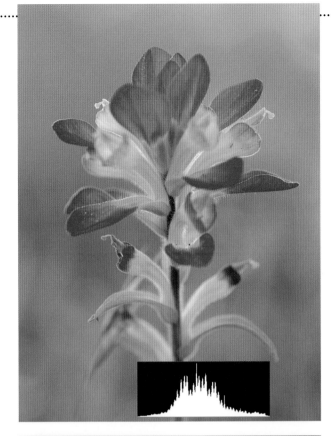

Exposing Properly

To understand exposure, it helps to know what an exposure meter does. It gauges the brightness of things in a scene and directs the camera to an exposure reading that will make elements of the photograph appear middle gray. It does not know if those elements are supposed to be middle gray or not; the subject could be pure white snow or a dark grove of evergreens; the meter will try to make either scene middle gray. That reading would underexpose as the snow scene and overexpose the evergreen scene.

The Histogram and Digital Cameras

I consider the histogram an excellent tool for achieving the best exposure of an image with a digital camera. A histogram is a graph of the tonalities that your sensor sees in a scene the camera records. Since it is a graph, it can seem intimidating to some photographers, but it doesn't have to be. You can break it down very quickly into the key elements, and use that information to help you choose better exposures.

If you understand four important things about a histogram, you can use it to get better digital exposures.

1. The histogram is an accurate interpretation of exposure. It is far more accurate than your LCD monitor.

2. The left side represents shadows and the amount of black in the scene.

3. The right side represents highlights and the amount of white in the scene.

4. Exposure problems are indicated by the shape of the histogram and how the left and right sides interact.

Texas paintbrush with histograms; top is properly exposed; bottom is underexposed and puts important tones and colors too far to the left in the histogram.

Keep those things in mind – as you use the histogram, they will become intuitive – so that you can use the histogram in these ways:

• Watch for clipping. If the histogram hills stop at a steep cliff at either end, detail is clipped. This means there are additional tones and colors that could be captured but are not, because the detail is "clipped" off; you have reached the end of your sensor's capabilities. If clipping occurs at the left, you lose shadow detail. If clipping occurs at the right, highlights will be blown out. If those details are important, change your exposure to move the histogram left (less exposure) or right (more exposure) to avoid the clipping.

• Avoid right or left gaps. Gaps can be as bad as clipping. If there is a distance of flat line that goes to the left or right edges of the graph, there is a gap in tonal details. You are not using the full range of the sensor and this pushes colors and tonalities off their optimum exposure range. Change exposure to lessen the gap.

• Watch where main tonalities fall. This is especially important with dark subjects. You do not want all of their tonalities on the left side, even though they are actually dark. You will get better color and less noise if you give "enough" exposure so that the bulk of the exposure is not pressed tightly to the left. It is better to darken a low-light scene, which has a little too much exposure, on the computer than try to make a dark scene lighter.

Note: A low contrast scene may have gaps at both ends – that is normal. However, you do not want such a scene to have a histogram with a large gap on one side.

f/stops

Aperture is a variable opening inside the lens that controls the amount of light coming through. The opening varies in precise steps called f/stops. These are derived from a mathematical relationship of focal length to the size of the opening, which is where the numbers come from.

The numbers can be confusing. Large numbers, such as f/16, are actually small apertures, and are called small f/stops. You "stop down" your lens to get to them. Small numbers, such as f/2.8, represent large apertures and are called wide f/stops. You "open up" the lens to get to them. Any given f/stop allows the same theoretical amount of light through the lens so that f/5.6 on one lens is the same as f/5.6 on another. In reality, lens construction can cause minor variations, but this generally has little effect on most photography; your camera lens will compensate for the difference.

With the exception of some specialty lenses and optics for large format cameras, nearly all lenses have an f/stop range that includes all or part of the following set of numbers:

f/2 f/2.8 f/4 f/5.6 f/8 f/11 f/16 f/22

Each f/stop affects the light coming through the lens in a strict doubling or halving relationship. For example, if you go from f/2.8 to f/5.6, you halve the light coming through the lens. If you go from f/4 to f/16, you go through four f/stops and the light drops to 1/16. If you change f/stops from f/8 to f/4, you double the amount of light coming through the lens. Other numbers do show up on the camera; these are usually half or third stops and affect the light accordingly.

In addition, f/stops also affect depth of field. In the f/stop list above, depth of field increases as you choose f/stops toward the f/22 end and decreases as you move toward f/2.

Moss in Vermont. The difference in depth of field comes from the f/stop chosen. The top photo has a small f/stop (large number), the bottom, a wide f/stop (low number).

Shutter speed has a great effect on movement, as seen in these two photos. The left shot of a waterfall in the Columbia River basin, Oregon, has blurred water from a slow shutter speed. The right one still has movement in the water, but a faster shutter speed changes the water and the surface of the pool.

shutter speed

Exposure is also affected by the selection of shutter speed. Shutter speed controls how long the light coming through the camera is allowed to strike the sensor. It is a fraction, such as 1/125 second, but is often expressed on the camera as a single number, such as 125. Shutter speeds are very direct in the way they affect exposure. 1/125 second is twice the number of 1/250 second, so it lets in light for twice as long. Similarly, 1/30 second is half of 1/15 second, so it lets in half the light. Numbers do get rounded, so 1/8 second is used for twice the duration of 1/15.

Shutter speeds have a direct bearing on sharpness. Faster shutter speeds will stop the action in a scene, and slower shutter speeds will blur a moving subject. You need the fastest shutter speeds with fast moving subjects, such as a running animal moving across your field of vision. You can actually get away with slower speeds if the animal is moving directly toward or away from the camera.

You also need faster shutter speeds for handholding a camera, as slower speeds will allow camera movement to register during the exposure if you are not using a tripod. Faster shutter speeds are needed with wind-blown trees or flowers, too. Finally, you will often need the highest shutter speeds not to stop action, but to allow you to choose a wide lens opening when the light is bright.

Slow shutter speeds balance small lens openings. The lens lets in less light, but the slower shutter speed lets it through to the film or sensor for a longer period time. In nature photography, slow shutter speeds usually mean you have to use a tripod. If you like blur effects, such as the blending of moving water, or the abstracts of blurred vegetation blowing in the wind, then you need to experiment with slow shutter speeds. No specific guidelines can be given, since the type and speed of movement will change the blur effects with every exposure chosen.

You do need to be careful of shutter speeds the camera is setting if you are shooting on automatic in either program or aperture priority autoexposure modes. Many photographers neglect to notice the

A slow shutter speed blurs the Urubamba River in Peru at the bottom of page 46, while a fast shutter speed shows a different amount of detail (left) for the same scene. Above: A blurred waterfall from a slow shutter speed; eastern Tennessee.

speed the automatic function sets for the shutter, and the camera chooses too slow a shutter speed for the action or for handholding the camera resulting in images that are not sharp. Here are some minimum shutter speeds you should keep in mind if you are handholding the camera:

Wide-angle lenses (28mm or wider) – 1/30 second
Moderate focal lengths (35—105mm) – 1/125 second
Moderate telephotos (105—300mm) –1/250 second
Long telephotos (300—500mm) –1/1000 second

Quick Guide to Exposure Modes

There are five common exposure modes on most cameras: full auto or program, shiftable program, aperture priority, shutter priority autoexposure, and manual exposure. There are also special program modes on many cameras, such as "close-up" or "night flash," but as these change from camera to camera, consult your manual to best know what modes are available with your model.

Full Auto or Program

This is exposure under full control by the camera (identified as the green zone). Nothing can be changed. Whatever the camera chooses for f/stop and shutter speed, that's it. This is a good one to use when some-

Variations of mountain laurel flowers, all shot with
aperture priority.

one else is using your camera to take a picture of
your family, for example, because they can't
change any settings. However, this is not the best
mode for nature photographers. Generally, you will
want to have some say in either the shutter speed
used to stop action or the f/stop chosen to affect
depth of field.

Shiftable Program (P):

This is the autoexposure mode that lets the camera
arbitrarily pick a shutter speed and f/stop combina-
tion, but if you don't like it, you can adjust either
the shutter speed or f/stop for a single exposure

and the camera will follow your lead. Better than
full auto, shiftable program autoexposure is still lim-
ited since you can't set exactly the f/stop or shutter
speed you need for each shot.

Aperture Priority (A or Av):

Here, you choose an f/stop that is appropriate to the
needs of your photograph or subject and the camera
automatically sets the right shutter speed to match
that f/stop. This is probably the most useful autoex-
posure setting for nature photographers. It allows
you to choose an f/stop for depth of field and for
the optimum shutter speed. Many sports and
wildlife photographers want the fastest shutter
speed possible for the conditions. If they use aper-
ture priority and choose the widest aperture possible
on their lens — the lowest f/stop number —the
camera will automatically choose the fastest shut-
ter speed possible for the conditions, even if the
light changes.

Shutter Priority (S or Tv):

With shutter priority autoexposure, you choose the shutter speed and the camera picks the right f/stop to go with it. In bright light, you can use this to set a fast shutter speed for action, but if the light changes and drops below the combination of this speed and the lens' widest opening, you won't be able to photograph. This setting is often used to control how action blurs by choosing a specific slow shutter speed.

Manual Exposure (M):

In manual exposure mode, you can set both the aperture and shutter speed. You can follow the meter's recommendations or do something entirely different. Manual exposure is very useful when shooting in difficult lighting conditions, such as following an animal in one light (that your camera set for) that moves through differently lit backgrounds (which would fool the meter). It is also very important for multiple image panoramic shooting so each shot is consistent.

Jimsonweed (or datura) flower shot with manual exposure to compensate for the whiteness of the flower.

California poppies

ISO speeds and settings

ISO is an international standard from the International Organization of Standards. (ISO was chosen as a simple letter designation for certain standards, like the speed of film; it is technically not an acronym.) ISO speed refers to the speed or sensitivity of film, and has a direct connection to exposure. ISO settings are the equivalents of film ISOs.

A low ISO speed, such as 100, refers to a lesser sensitivity to light than a high ISO, such as 400. The numbers relate directly to each other, i.e., ISO 100 is half as sensitive to light as ISO 200, and ISO 400 is four times as sensitive as ISO 100. In digital cameras, the numbers relate to each other in the same way.

An ISO value of 100 or less usually gives the highest quality image results in terms of sharpness, color, tonality, and low grain or noise. But it also means slower shutter speeds or wider lens openings must be used, and such speeds refer to slower films or ISOs. Higher ISO speeds will reduce image quality, though modern digital cameras do offer

extremely good results with ISO settings of ISO 200 and ISO 400 that are very close to ISO 100 results. The exception to this is the compact digital camera. Such cameras typically have high noise levels as soon as you choose any setting above 100. In some of the latest D-SLRs, noise levels are excellent even at settings of 800 and 1600 (though you will notice the difference). Higher ISO choices allow you to shoot at much faster shutter speeds or use smaller lens openings.

Most nature photographers will use ISO settings of 100 or less for general nature photography, especially landscapes. If you are shooting from a tripod and during the day, the low ISO sensitivity will not be a problem. Wildlife photographers, however, will often shoot with faster films or at higher ISO settings so that they can use faster shutter speeds to stop animal movement or to deal with slower telephoto lenses.

Goldenrod.

Yellow composite flower.

raw versus jpeg

In the digital realm, there is a lot of discussion about RAW versus JPEG file formats. You'll hear pros and cons about both. The problem comes, however, when judgments about image quality are made arbitrarily about these formats, or when people think erroneously that RAW is a pro format and JPEG an amateur format.

Let's quickly make a one thing clear: Both formats are perfectly capable of creating pro-quality images and pros use both. This book has images that were shot using both and you will not be able to tell the difference. It is unfortunate that some photographers give the impression that you must shoot one or the other or your photos will suffer. That is simply not true. There are good reasons for both formats. Their use depends mainly on your needs. We'll look at the advantages and disadvantages of both.

JPEG is a high-quality compression format. At its high-quality settings – which should always be used on a digital camera – image quality can be equal to that of RAW. As long as it is used just as a shooting format and not as a working format in the computer, it works well.

> **note:** Once you have opened a JPEG image on your computer, save the image as a non-compressing file format, such as TIFF or the native file format of your imaging software, such as PSD in Photoshop or Photoshop Elements.

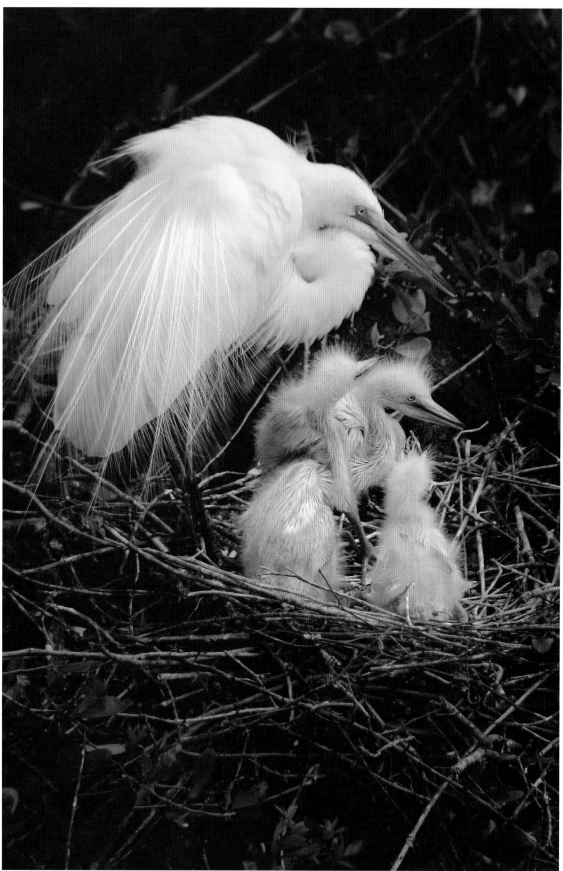

Snowy egret nest with young and parent, Florida. A scene with a lot of tonality in the bright areas, like this one, is a good candidate for RAW.

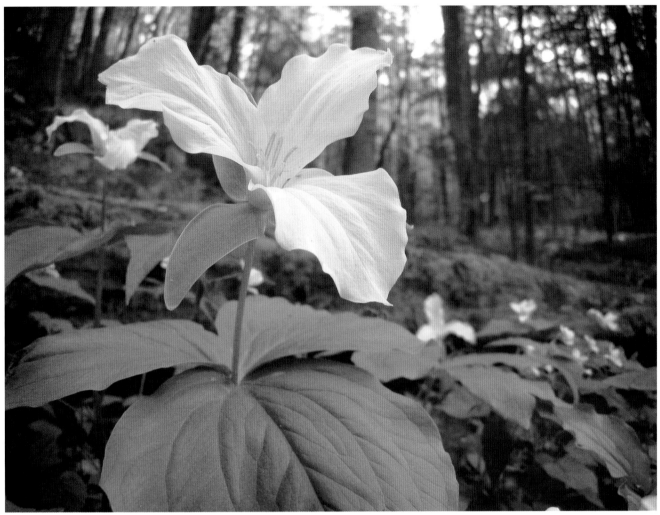

Trillium, Great Smoky Mountains.

One great advantage of JPEG over RAW is that the file is very smartly processed in the camera. Many camera manufacturers have put a great deal of engineering into their cameras' image processing capabilities. It is almost like having a RAW expert inside your camera to get the most from the image as it comes from the sensor. Another advantage is file size. Since JPEG is compressing data to manageable image files, it needs a fraction the space on a memory card that RAW files require. Smaller file size also means faster operation for the camera, and you can usually shoot longer bursts of continuous shots.

On the other hand, JPEG has a reduced color range (or bit depth) compared to RAW. JPEG has 8-bits of data per RGB color with which to construct colors (8-bit is sometimes also called 24-bit), while RAW generally deals with 12-bits per color (36-bit). (You'll hear RAW described as 16-bit; nearly all digital cameras record images at 12-bits, but put this data into a larger 16-bit file.) This extra data represents an exponential increase in data, but you won't directly see it since 8-bit is plenty for our eyes.

What the extra data gives is more processing capabilities for the image file. You can make stronger adjustments without really hurting the quality of the photo. This can be especially important if you have challenges in dark tones or if you have a very wide or very narrow tonal range to deal with. But RAW is not just for problem photos. It can be used to gain the optimum tonality and color from any scene.

RAW is also comprised of more basic data from the image sensor compared to JPEG. It is actually using the raw color information from the camera in a more complete way. You won't always need that, however, and JPEG can be easier to manage in your workflow.

The question of which to use —RAW or JPEG — really comes down to several things:

• When images are exposed well, JPEG usually requires less work in the computer. It has already been smartly processed to its 8-bit file in the camera.

• RAW will retain better detail in bright and dark areas when needed.

• JPEG is faster to use and requires less memory.

• RAW offers a great deal more flexibility in processing an image.

• JPEG is a complete file, which is its advantage and disadvantage. On one hand, it is ready to use in almost any photo software program. On the other hand, since it is complete, there are limitations to that complete file so that less processing can be done

• RAW is a great format to use for people who like to really work an image in the computer because it offers a larger amount of workspace.

Many photographers are now taking advantage of camera capabilities and less expensive, larger capacity memory cards by setting the camera to RAW + JPEG. This allows you to shoot both at the same time. Then you can use JPEG for quick processing of images and still have the RAW files when you need them.

white balance

Light has color —color that can be a critical part of a nature photograph. White balance is a unique part of digital photography. It has a direct effect on how colors look in a photo based on how the camera responds to the color of light. With film, you have to use filters to affect the overall color balance of an image and most photographers don't bother. They choose a film that they like based on how it deals with colors in most scenes.

White balance, on the other hand, is a digital camera's ability to deal with the color of light (which affects how colors appear in a scene). It makes white and other neutral colors stay neutral without a color cast. But this has another effect that is very important to nature photographers; it can add or subtract a color cast that can be a critical part in interpreting scene.

Cameras have three general types of white balance setting: auto, preset, and custom. Auto means the camera looks at the scene and picks a white balance setting for you. Preset allows you to choose a specific white balance setting to remove, keep, or enhance a color cast in a scene (such as a sunset's colors). Custom lets you very precisely measure and control the color of light as the camera captures it.

Leaving the camera on auto white balance just means one less thing to think about when photographing. You can easily change this color balance in the computer later (especially when you shoot RAW). However, I like to choose my white balance while shooting for several important reasons:

• By choosing a white balance while "on the scene" with your subject, you can compare what you are seeing in the LCD with the actual scene. For natural subjects, this ensures you have a solid reference for dealing with adjustments to the scene.

• Locking down a white balance can mean a much more efficient workflow in finishing the images in the computer (i.e., you are not having to readjust different shots because the auto white balance changed its interpretation of the subject).

White balance is a great feature in digital photography. It allows you to better capture the colors of a scene. This shot of wetlands in the Everglades of Florida shows three versions, with the changes due to white balance choice.

These cherry blossoms have unlike backgrounds, which can result in quite different subject colors if shot with auto white balance.

• Auto white balance can be a compromise and give you a weaker interpretation of the scene.

• Auto white balance will often change white balance readings as you select a new focal length or reposition your camera in a scene (so that it sees a different background, for example). If the resulting photos now have to match, you have more work to do in the digital darkroom to make them the same.

• Auto white balance can be a compromise of color that "looks right" when the image is opened in the computer so that you don't go any further to find a better mix of color.

Learning White Balance

Take your camera out to a natural scene, put it on a tripod, and shoot a sequence of shots as you go through all of the white balance settings your camera offers. It will give you a more intuitive feel for white balance. Try this:

• Set your camera up to a constant f/stop – aperture priority exposure works well for this. Changing f/stops changes the sharpness of elements in the photo which will affect color tonalities. You want to keep them constant.

• Find a scene in light that will not change for the five minutes it might take to do this exercise. Also, look to include light and neutral tones, as these are very sensitive to white balance changes.

• Shoot a series of images changing your white balance settings for each. Follow the order that your camera control takes you through from auto through all the presets, or take careful notes with shot numbers. This is important because the metadata of most cameras does not specify which preset was used, so you need to be able to compare your shooting with the actual images to know what white balance was used in each shot.

• Open all images directly in the computer without changing them. Compare the colors.

White Balance for Nature Photographers

Auto white balance used to be a poor choice in the early stages of digital camera development. It was inconsistent and undependable. That is no longer true. Manufacturers have worked very hard to make auto white balance work well. It really is to their advantage to make cameras do well on automatic for the great mass of amateur photographers because that translates into camera sales.

However, auto white balance can be an issue for nature photographers. When the colors are critical, the compromise of auto white balance will often fall short of what is possible from a scene. Important colors can have the wrong hues or an inadequate balance with the rest of the scene. In addition, a big problem with auto white balance and nature photography is that a lot of the magic in landscapes and other scenes comes early and late in the day when

White balance can be a creative control for the photographer. This shot of a dandelion seed head gives quite different impressions with varied white balances.

the light naturally adds a warm color to the photograph. The camera doesn't acknowledge this and will often try to remove that color when you shoot with auto white balance.

This can really affect a sunrise or sunset. Nature photographers have long shot these scenes with daylight balanced films as a convention that actually makes the sunrise or sunset warmer than it appears to the eye. With auto white balance, the camera may take a lot of the color out of the scene, trying to make it "neutral," which is exactly the wrong thing for this type of photography.

Preset white balance choices are usually a much better way for the nature photographer to go. Digital cameras come with a set of preset white balance settings. These allow you to lock white balance to a specific adjustment. Most cameras include daylight, shade, cloudy, electronic flash, and fluorescent presets. Each one will create a consistent and reasonable interpretation of the light under those conditions. You can change lenses or move all around, but as long as the light doesn't change, the

colors of your subject will stay firm.

Some cameras include additional presets and controls to tweak the presets. For very precise work, this can be useful. You can adjust a preset to better meet the specific conditions or to match your personal preferences in a particular shooting situation. The important thing to remember about a preset is that it locks your camera to a specific lighting condition. So, if you go back to the sunrise or sunset situation, you can use a daylight setting, such as daylight or cloudy, and ensure that the scene will record more like you would expect from film.

You can also choose a preset for general shooting to make the scenes have a consistent color. I will often use a setting that warms up the scene as my standard setting (such as cloudy or electronic flash) as I like the colors that come from this. But these settings are not consistent from camera to camera, so do your own testing to see what your camera can do.

Rabbits foot clover, Maine.

special section: digital nature photography

As far as the photos go in this book, most could have been taken with either digital or film cameras. Nature photography is not about digital or film technology. However, it must be acknowledged that digital photography is the dominant way photographs are made today. Though film is still quite viable for photographing nature, there are some distinct advantages to using digital. Digital cameras, especially D-SLRs, have become extremely versatile tools for the nature photographer.

Sensor capabilities have reached a point where high quality is possible from even low-priced cameras. This includes both the megapixels of the sensor as well as the noise and color characteristics of the sensor and its attendant processors. In fact, most of the photography in this book were taken with a range of advanced compact and style digital cameras, from budget to high-end professional models.

One of the great advantages of digital is the ability to see a representation of your results instantly. It is like using Polaroid tests but without the mess or trash. With landscapes and flowers, you can photograph the subject, then immediately compare the LCD review of the shot with the actual scene. Did you get the photo you wanted? Is the composition working for your subject? Since the digital camera is already paid for, there is no cost to actually taking a picture when shooting digital. You are free to experiment, check the results, and make changes while you are still with the subject.

This experience really connects the photographer more solidly with the subject. Photographing becomes an organic process that evolves as you shoot. It has been my experience – and I have heard it from photographers again and again – that this has made us all more creative and willing to try new techniques.

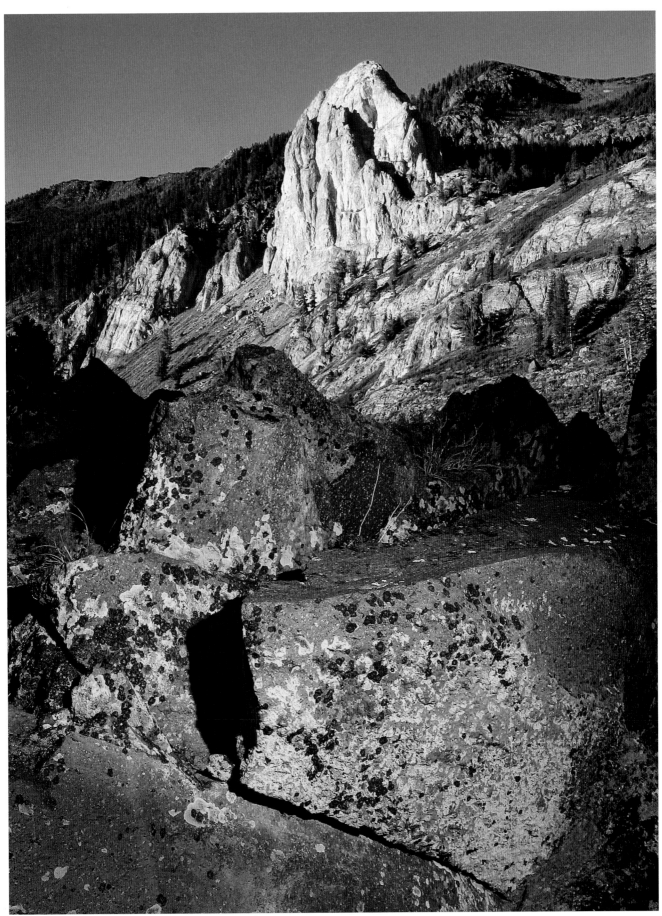

Lichens on rocks in Sierra Nevada Mountains, California.

1. Expose for the most important part of the scene. Look at the light on your subject and expose to get the most from that light. This might mean exposing for a brightly lit flower and letting the surrounding dark areas go black. Or it might mean exposing for a perched bird and letting the background go bright.

2. Beware of large bright or dark areas. These will over-influence your meter and almost always guarantee a wrong subject exposure if you don't compensate.

3. Lock exposure on the most important part of the scene. Almost every camera on the market will let you lock an exposure by pointing the camera at a key tone or color on your subject then pressing the shutter halfway. You can also point the camera completely away from the main subject to lock exposure on a sunny spot, for example, that matches the sun on your subject when it is surrounded by darkness. You can then reframe for the actual composition. (Caution: on most cameras, this also locks the focus, so read your camera manual to fully understand the camera's exposure and focusing capabilities.)

4. Use +/- exposure compensation. Most cameras have an exposure compensation setting. You can add exposure with + settings, and subtract with—settings. Look at your subject and decide if it should be darker or lighter than an average or middle gray tone. Use the exposure compensation settings to adjust.

5. Use your LCD monitor. The monitor is imperfect for showing you colors and tones that are really in your image, but it can help give you an idea of exposure, especially as you gain experience with a particular camera. Many cameras have over-exposure warning displays that can be used. Histograms are a very important tool for determining correct exposure. Use this to determine exposure range.

6. Avoid overexposure. Watch your highlights. If the bright areas get exposure beyond the capability of the camera's sensor, no amount of work in Photoshop or use of RAW will help.

7. Avoid underexposure. While you can make a digital image look better in the computer even if underexposed, it will have less color saturation, harsher tonal transitions and more noise than one that is properly exposed in the first place.

8. Shoot manually. If you have dramatic light, often you are better off metering for the key parts of your subject in that light and shooting manually so the exposure does not change as the light changes.

9. Use a spot meter. Whether in the camera or hand-held, a spot meter will precisely meter key elements in a scene so that you can choose your exposure based on the brightness of those elements.

10. Bracket. If you have any doubts, try making several shots of the same scene while using different exposures. Many cameras even offer auto-bracketing capabilities. Some photographers use bracketing as a creative tool, as it will offer them a range of color and tonal possibilities to choose from later.

Connections — Water

How often do we stop and contemplate water? We drink it from birth, splash in it, play in it, delight in its sun sparkles, and on and on. Water is a part of our lives from the very start, so much so that we are never really conscious of it. Water, in some form, is always around, even in the driest deserts.

Our planet has been deeply affected by water. Have you ever tried to cross a rapidly rushing stream? Especially a stream at flood stage. I have both fished and photographed along streams and rivers. Even the smallest stream can sweep you away at flood stage. You gain the sense of awe of the power of water at such times.

But water is much more than brute moving power. Dripping water will slowly, steadily erode even the toughest rocks over time. As water freezes and thaws, it will break the hardest rock, loosening whole sections of rocky cliffs, sending huge boulders tumbling down to create new landscapes below.

While plate tectonics, volcanoes, and earthquakes represent a different sort of power that moves mountains, water, from the raindrop to the flood, moves and shapes every part of our world, creating landscapes from canyons to nutrient rich floodplains. Water is the ultimate sculptor of much of the beauty of earth.

Water also has a remarkable beauty that few other materials possess. It changes color constantly, depending on the light and whatever is in and around it. It reflects the reds of sunset as well as the blue of midday sky or the gray of rain clouds. It absorbs red light quickly, making everything below the surface appear blue.

It provides us with visual delights that no other substance on earth possesses. It can be a gas (water vapor), a liquid (water) and a solid (ice), all at normal temperatures on the earth. These characteristics are, very rare in the chemical world. But from them we have the beauty of clouds, the shimmer of streams, and the wonderful shapes of snow and ice.

4 light

ight truly makes the world what it is. Without light, green plants can't exist to add oxygen to the air. Then animals, including us, wouldn't be able to exist either. But light is so much more than the energy source for life on earth. With the right light, nature in all its beauty comes alive and sings with its own energy. In a photograph, light can make a scene go from boring to exciting with the passing of a cloud.

Think about how you feel on a gray, cloudy day when a shaft of light appears and spotlights a hillside in front of you. That grabs your attention. Consider what it is like to walk through the woods in a soft, enveloping fog where the light wraps all around you. And most people can relate to the sparkle of light dancing across the rushing water of a mountain stream.

Using light for photography starts by recognizing how light works in relationship with natural subjects. We might not be able to move the sun, but we can seek out the best possible light for our subjects. One thing that separates the serious nature photographer from some-

one who takes snapshots for record-keeping is the ability to see the light, so to speak, and make it work in their photographs. Good photographers also learn to see when light is not working in a scene so that they avoid that photograph or look for another angle where the light does work.

The nuances of light are infinite. Many different types of light play across a natural scene or subject. That's one thing that makes nature photography exciting and always new. You can photograph a scene one day, then return to it the next and find something totally different because of the light.

Soft light on bromeliads (air plants) in the Everglades, Florida.

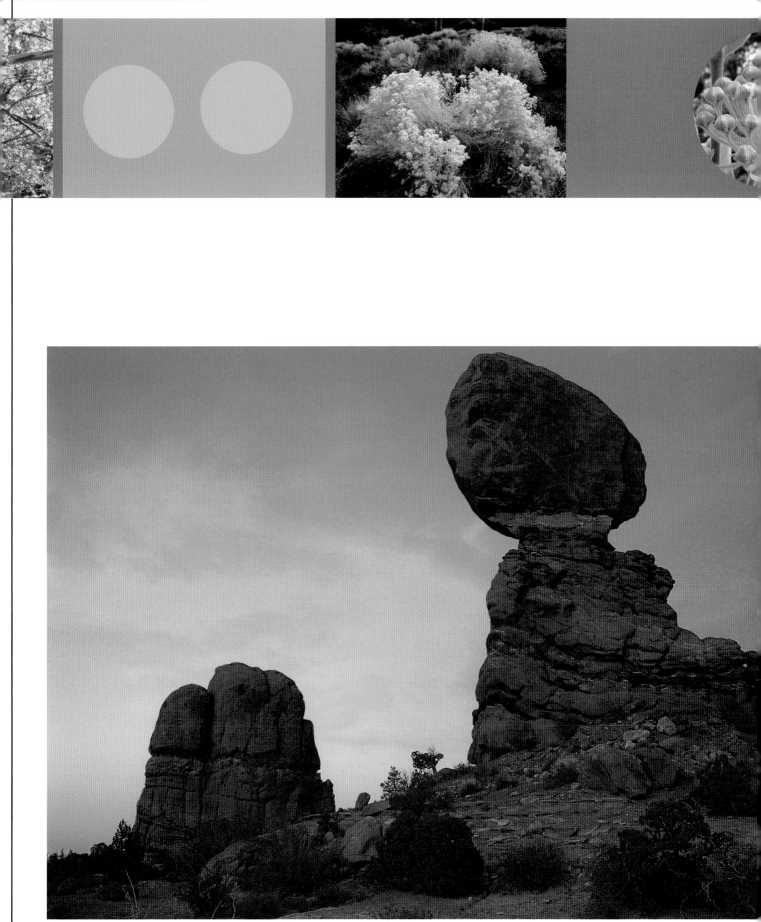

Balancing Rock, Arches National Park, Utah, in soft, after sunset light.

Sunrise over clouds from top of Cadillac Mountain, Acadia National Park, Maine.

hard or soft light

Watch the play of light across a landscape through the day and in varying weather, and you quickly notice the difference between hard and soft light. Hard light is the crisp light of sunlight. As haze forms, or clouds begin to cover the sun, the light spreads out, making it soften and change. Neither is good or bad. On a specific subject, hard light can be great … or awful. The same goes for soft light.

Hard light is at its strongest on a clear day without clouds. When anything gets in front of the sun, from light clouds to high humidity, it starts to lose some of its edge. To get the most from hard light, consider what it can do for your subject.

Drama: Bright sun with heavy shadows can be very dramatic. This can be an excellent effect when the subject warrants it.

Contrast: Hard light is often very contrasty, with extreme exposure differences between the darkest and lightest parts of a photo.

Shadows: Shadows gain sharp edges with hard light and can take on interesting forms and shapes themselves that are worthy of a photograph.

Form: Three-dimensional forms in a landscape come alive with hard light.

Texture: Bright sun will make textures appear with the most detail.

Bright Colors: Strong colors look very strong, indeed, with hard light.

Angular Forms: Hard-edged shapes, like rocks, gain increased emphasis in hard light.

Backlight makes a red oak leaf light up and highlights the texture of the rock.

Note: Photographers sometimes try too hard to get a photograph when the light isn't right for the subject. The answer is simply to be aware that light can be wrong and unflattering. Look at what the light is doing to your subject, and if it causes problems, such as being too harsh or too gray, then avoid taking photographs in such conditions. They will make you unhappy with your results.

Soft light comes whenever the direct sunlight is not hitting your subject. This can be from clouds obscuring the sun, or when you are on the shady side of a mountain, or in a grove of trees. It varies considerably from the open shade of a canyon, to light clouds over the sky, to heavy clouds, to fog. Here are some beautiful things it can do for your subject.

Gentle, Quiet, Calm: Soft light evokes a much different feeling than hard light. A forest scene in soft light can be very calming.

Gentle Colors and Tones: The soft light of a cloudy day will make subtle tones and colors more obvious. It will even tone down bright colors.

Less Contrast: Soft light often provides a lower contrast, even to the point that the brightest and darkest parts of a photo do not have a strong exposure difference.

Soft Forms: Rounded, gentle forms are often complemented by soft light.

Atmosphere: The air becomes more visible and important as the light becomes softer.

direction of light

In nature photography, you can master various conditions simply by observing the direction of the light and how it affects the appearance of your subject. Light can come from any direction to the subject compared to your position, hitting it from the front, side, back, top, and every place in between. Each direction offers unique qualities to the light that can be used to make good images.

Backlight

I put backlight first because it is the light of the pros and a light that intimidates many amateurs.

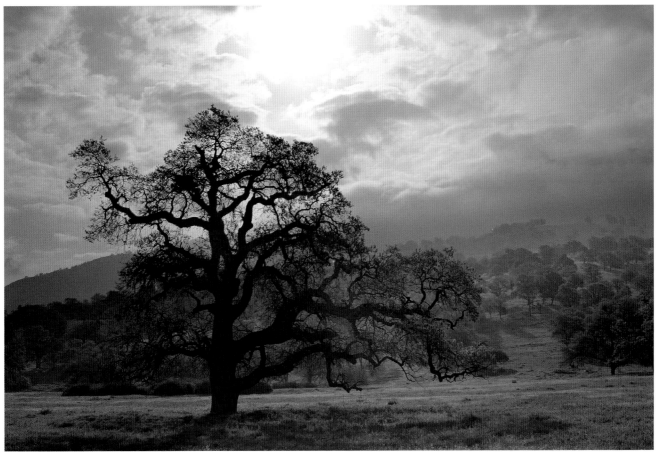
Breaking clouds and backlight add drama to this scene of live oaks in central California.

Backlight hits the back of your subject and shines right toward the photographer. In other words, you shoot toward the sun or bright area in the sky. Because of old wives tales about photography, many photo enthusiasts are concerned about photographing into the sun. Can't it hurt the camera? Won't it make awful shadows? And won't it mess up exposures? The answer to all is no, backlight doesn't do any of these things automatically. Sure, shadows can be a problem and exposures are sometimes affected, but none of that has to be. And it won't hurt your camera.

Here are some wonderful things backlight can do for a natural subject.

Drama: This light is definitely dramatic, and this alone can make it worthwhile. It is both bright and dark and creates highlights and shadow. It offers dark backgrounds to contrast with bright subjects and also the possibility of dark silhouetted subjects against bright backgrounds.

Separation: Backlight separates elements in a scene because of the highlights and shadows. Even on a cloudy day with soft light, backlight will make shapes and forms appear in a scene.

Glowing Colors: Backlit leaves and flowers will glow from their translucence against the dark shadows around them.

Sparkle: Light dances and sparkles on water and other shiny surfaces when the light come from behind.

Great Texture and Forms: When the light is high enough to wrap over your subject, backlight will make textures show up and give more depth to three-dimensional forms.

Variations in light really change how you see a subject. Far left: soft light in grove of coastal live oaks. Center: gray day on harlequin bug in bladderpod bush. Right: cholla cactus in Nevada lit with flash, while background gets side light.

Note: Watch for flare – flare is a challenge with backlight. It comes from the sun bouncing around inside your lens, creating bright spots, odd shapes, and haze over the image. To block it, use a lens shade, change your angle to the sun, or look for something that shades your camera lens like a tree branch.

Sidelight

Sidelight hits your subject from the side and creates great highlights and shadows. It is a very popular light for nature photographers because it generally offers excellent results with a great many subjects.

Texture: There is no better light than a hard sidelight for texture. Texture, whether in a landscape, on a rock, or an animal, will have a lifelike look to it.

Form: Three-dimensional form comes from the interplay of light and shade, and sidelight gives you both. Sidelight makes natural objects from rocks to mountains look very solid and dimensional.

Simple: Because nature is filled with texture and forms, sidelight always brings them out. It is a quick and easy way of making a natural scene look good, especially when the light is low to the horizon.

Front Light

Front light is light that hits the front of your subject and throws shadows to the rear of that subject. It is often avoided by many nature photographers, and for good reason, since it can be flat and uninviting. It is at its worst in the middle hours of the day. However, when it is low to the scene, it can be quite effective. Here are some strengths to a low front light.

Bold Colors: Colors are lit up by front light because there are few shadows to obscure them.

Patterns: Any color patterns in rocks, birds, flowers, or other natural objects are brought out strongly by front light.

Minimal Texture: Without texture, underlying colors and patterns show up better.

Strong Shapes: Two-dimensional shapes of objects are emphasized by front light.

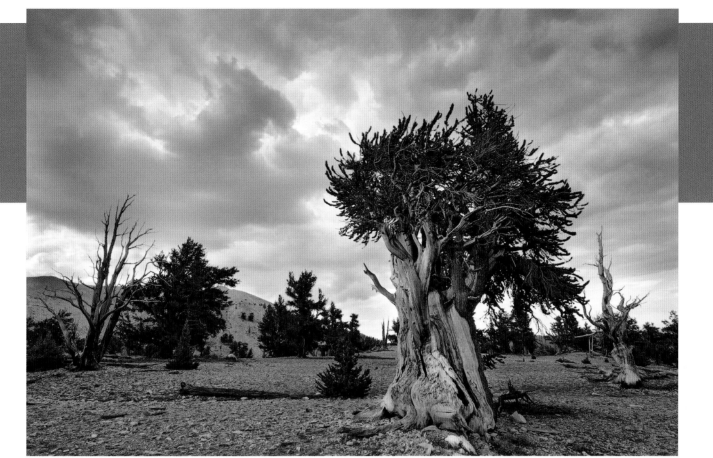

Stormy light on ancient bristlecone pines in California.

Top Light

Top light, unfortunately, can be a deadly light for nature because it usually occurs toward midday when light, for many reasons, is not at its best. Even when the sun is out, it can be a flat and dull light with too much blue in it. There are times when this is useful, however, such as when the top light comes from a softly lit sky reflecting in water. High clouds lit by a setting sun offer a wonderful top light to a scene after the sun has actually set or is blocked from the scene by something in the landscape, too.

Color

The color of light coming directly from the sun is neutral, warm, or amber, but when it comes indirectly, whether from the sky or clouds, it is usually cool or blue. The two strongest influences on the color of light are the time of day and the sky. It is very common to have a scene with both warm and cold light in it – warm light in the highlights and cold light in the shadows. This adds a certain richness and liveliness to the color of a natural scene.

Warm light, like that from a setting sun, is always seen as a very attractive light. Cool light, like that from the blue sky in the shade on a winter day, is often seen as uninviting, and many photographers work to correct it through warming filters or the use of warmer white balance settings on a digital camera.

time of day

The time of day you photograph in nature has a huge effect on the light. One reason why so many landscape photographers are up at dawn, relax during the middle of the day, then photograph again at sunset is for the light. Here's how the time of day can affect the light.

Twilight Before Sunrise: Soft, diffused light that is usually very cool in color. This can be an interesting landscape light when shot toward the brightening sky.

Sunrise: On clear days, this can be a very hard-edged light, yellow in color with strong blue contrasts in the shade. This light is low and dramatic.

Early Morning: Directional light, with less color in it. Offers good sidelight and backlight, but front light is less effective.

Late Morning, Noon, Early Afternoon: Go home and go to bed if you are a landscape or wildlife photographer. The light is high, especially in the summer, and tends to make things flat and ugly. Colors are weaker. The best thing is to do close-ups at this time, maybe even in the shade to avoid harsher midday light.

Late Afternoon: As the sun drops lower in the sky, it becomes like early morning light, just a different direction.

Sunset: This is usually a softer light than sunrise because of particles (from dust to humidity) in the atmosphere that accumulate during the day. It is usually more orange than sunrise, and shadows often have less blue than early morning conditions. It is also low and dramatic.

Twilight After Sunset: Soft, diffused light that can be quite warm in color, especially in northern areas at certain times of the year with long twilight conditions. This can be an interesting landscape light in any direction, and this is why it is often worth staying with the location after the sun has set.

key gear

Sun Shade

Lens or sun shades limit the amount of bright light, including sunlight, that can bounce around inside your lens. You don't have to have the sun in the photo in order to have flare problems. A lens shade can reduce flare, increase image contrast, and retrieve color lost from flare. This is probably the most underused, yet important piece of gear around. Most lenses today come with lens shades, and if they don't, you should get one for it. A sun shade will also protect the front of the lens from fingers, stray branches, and rain.

Graduated Neutral Density Filter

At least one graduated neutral density filter (grad ND) should be in every nature photographer's bag. They are also called graduated neutral density and split ND filters (or variations of these names). Half clear and half dark neutral gray, these filters come in different strengths of gray. The 2x and 3x strengths are probably most useful to the nature photographer. Such filters commonly come in a rectangular shape that can be rotated and moved up and down in front of the lens to put the dark area of the filter over a very bright area of the scene, bringing that brightness more in balance with the rest of the photograph. While holders are available for these filters, you'll see most pros simply holding them in front of the camera while the camera is mounted on a tripod.

Some people think you don't need these with digital cameras. That simply is not true. A grad ND will allow your sensor to better capture strong tonal ranges often typical in nature when sky and ground are seen; the image recorded will then need less work in the computer at the minimum. It can enable you to better define detail in extreme conditions that would be lost without the filter's effect.

Accessory Flash with Cord

As you'll see throughout this book, an external flash can be a great help in controlling the light on a subject, especially in high contrast situations or when an important subject is in shadow. External flash is far more powerful than a built-in flash, making it more likely to be able to balance bright daylight. An accessory cord to allow the flash to be used off-camera is a very useful addition to the unit (or you can look into some of the new wireless units that most manufacturers are now offering). Often you need to redirect the flash's light on the subject, especially for close-ups, and being able to have the flash off camera and still connected to the camera is a big benefit.

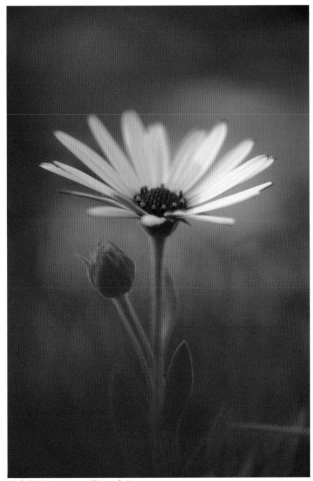
Soft light on a trailing daisy.

Reflectors

Any neutral object that reflects light is a reflector. Small, portable reflectors can be very useful tools to have along when shooting into the sun or if your subject is in the shade near sunlight that can be reflected to it. You can even bounce a flash into a reflector to change its direction and quality. Reflectors can be made from a piece of white Fome-Cor™ (available from an art supply store), a white or silver sunshade made for a car, or even aluminum foil. If you decide you like a reflector's properties, you can buy ones that fold quite nicely to put in your camera bag. Reflectors also have a couple of non-light affecting uses: you can put one on the ground to protect your equipment in sandy conditions, you can use one to block the wind from a blowing flower, and you can even use them to block light from a part of your composition.

Diffusers

A diffuser is anything that softens and diffuses light coming through it so that the light looses its hard, harsh qualities. These are perfect for close-up work, especially for flowers. They just need to be held over the flower, between it and the sun. This can give you a very pleasant light. You can try out the effect of a diffuser by using any white translucent material. I have used such things as tracing paper, a single side of a white garbage bag, or a part of an old sheer curtain. You can buy diffusers that fold up into a neat a package and come in varying strengths. There are even some box or tent diffusers that can be erected around a flower to block the wind and diffuse the light.

1. Try backlight (beginner) – You'll see the refrain again and again that backlight can make for wonderful nature photos. For the beginner, it does have some challenges, such as exposure and flare, but try it, experiment with it, and find out how it can work for you.

2. Warm your photos (intermediate) – It is very easy to add warmth to a photo. Set the white balance to shade or cloudy, and it will warm up the scene. Warming your photo is especially important if the scene is somewhat cool from the light of a cloudy day or light in the shade. You can add this warmth to any scene by choosing a preset white balance setting that makes the scene warmer. Check your LCD to see how different settings are affecting your image.

3. Shoot the wrong color balance (advanced) – You can get some dramatic and interesting colors from the light if you shoot with the "wrong" color balance. Try the tungsten white balance (usually an indoor setting) preset.

4. Use a reflector (beginner) – When the sun hits near, but not on, your subject (such as a flower in sunny woods), use a reflector to redirect brighter light onto it. Folding photo reflectors that fit your bag are readily available, or make your own from a silver sunscreen for a car or with aluminum foil.

5. Expose for drama (intermediate) – If you have dramatic light in your photograph, such as strongly lit areas contrasting with bold shadows, expose for the highlights, the dramatic light. Don't use an overall exposure in such a condition. You want to hold color and detail in the highlights and let the dark areas go dark; do that by exposing for the highlights.

6. Use a flash to brighten the shade (advanced) – A way to complement dramatic sunlight is to find an interesting subject in the shade that might contrast with sunlit elements of the photograph, such as flowers in a darkening meadow set against a mountain still in the sun. Use a flash to light up those flowers. Set your flash on a telephoto setting and use a flash cord to allow you to point the flash right at your subject. Use your LCD monitor to see if your exposures match so that you can make adjustments.

7. Bracket in difficult light (beginner) – If the light is very contrasty, with hard backlight or large areas of light reflecting right back at you, bracket your exposures. This means using several different exposures, allowing in more and less light, so you can be sure you have at least one that is correct. Many cameras have autoexposure bracketing (AEB) settings that allow you to dial in your bracket and let the camera do the work. Otherwise, use your +/- exposure compensation control. Experiment with a difference in exposure of +/- 1/2 stop.

8. Balance light with a graduated filter (intermediate) – One of the most useful tools for a photographer is a graduated neutral density filter (see page 70). Rotate this filter so the dark part covers a hot spot in the photo, whether that is sky, bright sand, or reflections in water; the over-bright area will expose more in balance with the rest of the image.

9. Use your hand to block flare (advanced) – With your camera on a tripod, set to your ideal composition, and shooting into the sun, you may find flare causes problems no matter what you do. Use your hand. Move it out over the lens until you see it in the corner or side where the flare is. The flare should disappear. Now move your hand out of the frame until it disappears from view, but is still blocking the flare.

10. Star-burst sun effect (intermediate) – A very cool effect comes from shooting into the sun when the sun is contrasted next to something dark (like a shaded tree trunk or silhouetted rock formation). This creates a star-like pattern caused by light diffusing along the diaphragm blades of your lens. It will happen every time you shoot with the smallest f/stops of your camera and the sun is in the photo, though it won't be noticeable unless there is darkness around the sun. Every lens will give a different pattern.

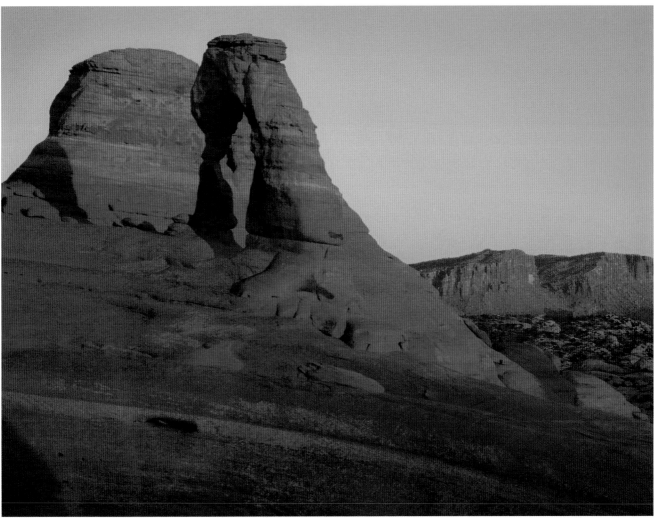

A gentle sunset lights up Delicate Arch, Arches National Park, Utah.

Backlight emphasizes cracked mud in the Anza Borrego desert, California.

Early morning sun warms a rock formation in Arches National Park.

Connections – Light

Look at a leaf glowing against the sun and you can almost see the energy being absorbed and growing. Leaves do their work well in any light, but when hit by direct sunlight, they show off their most dramatic shapes and patterns. This brings plants to life, both literally and in photographs.

Photosynthesis is the work that plants do to create food from sunlight, water and carbon dioxide, and in the process, release the oxygen we must have to breath. Sadly, photosynthesis carries some unfortunate connotations for many of us. It all too often goes back to biology class and a dry formula – there died many an interest in nature and plants. I actually thought about including it here, but it looked so academic and alien to the love of nature, I decided otherwise.

Nature does hold a lot of magic, and photosynthesis is a prime example. I love a walk in the woods at any time, but sunny days make the magic of photosynthesis almost visible. Sunlight dapples through the canopy of leaves arched over the ground, leaves busy intercepting sunlight, using its energy to create sugars from water and carbon dioxide.

When you look up toward the sun on such days, a light wind will move the leaves and they will alternately block and reveal the sun, making their connection seem very real indeed. The light behind the leaves makes them glow with color and light, creating a luminescent canopy. Shade even takes on a tint of green, quickly seen by taking a photograph of something light in tone.

Photography and photosynthesis use the same beginning for a very good reason – they are both about light. Think about this as you photograph. The same light energy that your digital camera translates into pixels to create your image is the same energy plants capture for photosynthesis. Light is basic for photography, but on a deeper level, it is key to life. Photosynthesis is the foundation for life on earth.

Backlight makes a dramatic photo of red oak leaves near a bay in Maine.

color

Top: Beech leaves; Bottom: The fiery color of a fall maple contrasts against the blue sky

Wile black-and-white photography can be stunning, color is really what nature photography is all about. A world without color would be a sad place, indeed! From the joyful abundance of a field of sunflowers to the brilliant reds and yellows of a sunset to the soft blues of dawn, color in nature fills a scene with energy, emotion, and life.

Color means a great deal to everything, from flowers to bugs to bears. Flowers use their colors to attract pollinators to ensure that seeds can be set and more flowers grown. Animals use color to warn others, attract mates, demonstrate dominance, blend in with their surroundings and much more. Color can signify life and death; it marks autumn and announces spring.

Visually, color can be playful, exuberant, sensuous, and more. You can do much with color in a photograph, more than simply recording the colors of nature, though that can be important, too. Unless you are simply a collector of scenes you have visited, a snapshot that does little beyond recording colors is not a very magical use of color. There is much more available to photographers who are willing to immerse themselves in the colors of nature.

the drama of color

Color can be dramatic. Think bold sunsets, fields of poppies, and blazing fall leaves. The danger in dramatic color is that it can be so dramatic that it overwhelms the photographer's thought process. The viewfinder is lined up on the color, but when the color overwhelms the image, that can lead to problems of color conflicts or colors that don't translate well from the real world to the photograph. It is always important to remember that a photograph is not the same as the subject; to get the most from a subject you need to see it as a photograph, not a part of the real-world scene. This is especially important with color so you can get the most from visual relationships.

In the past, photographers sometimes used Polaroid tests to see what a scene looked like as a photograph, but that causes problems such as having to take extra stuff for the Polaroids and the trash that results. Now, with digital technology, you can take a picture of a scene and quickly see what it looks like as a photograph on the LCD monitor. Newer cameras with large LCDs really help, but any LCD will let you see how the colors are working in your image.

Texas bluebonnets in the Hill Country west of Austin.

making dramatic colors behave

It is worth thinking about how colors interact in an image to get their drama to work well in your photographs. Here are some things to consider to help you refine your use of color.

Saturation – Colors have different levels of vividness or saturation. Saturated colors are lively and fun. A great way to use them is to look for compositions that contrast a saturated color near a less saturated color. A bright green next to a dull brown will make that green stand out more.

Cold/Warm Contrast – Cold and warm contrast is a staple of nature. Cold colors include all those with blue in them. Warm colors include all those with red in them. The strongest cold/warm contrast comes from blue and orange. A wide-angle photo of a sunset on blue sky, or an orange fall tree against a deep blue sky, offer rich and dramatic color contrast. In winter, you can often use the warmth of the sun and the cold of the blue sky to capture richly colored snow scenes, such as snow lit by the sun contrasted with snow reflecting the sky.

Complementary Colors – The strongest color contrasts come from colors that are opposite each other on the color wheel. Compare blue to orange, red to green, and yellow to violet, for example. Yellow to violet is also a tonal contrast, while red to green has little to no tonal contrast and relies totally on color. Complementary colors will make a scene look dynamic and energetic, but they can also make it look harsh and uninviting if you aren't careful.

One-Color Scenes – Nature often gives us beautiful scenes with one main color. Think of a bright green forest, red rock canyons, or the pre-dawn blues of a landscape. This can make for very interesting and forceful compositions. When working with one-color scenes (also called monochromatic, though some people reserve that term for black-and-white photography), look for tonal contrasts to give structure and form to the scene. Without such contrasts, one-color scenes can be hard for the viewer to make sense of.

Size/Color Contrasts – A very striking image can often be made by finding one small color that contrasts strongly with the rest of the image: a small tree full of early fall yellow against a sea of green leaves or a small red cardinal on a branch against the blue sky. The small size of the bright color will make the color even more dramatic.

You'll notice that quite a few of the ways to use color involve some sort of contrast. Color contrast can be an excellent way of working a composition as you look specifically for colors and tones that interact with each other.

black is beautiful

To use color effectively, you need to pay attention to black and dark areas of a photograph. Black is one of the most effective ways of concentrating, isolating, and handling color. In nature, black mostly shows up as dark shadows. Look for such shadows to contrast with your color.

Black does a number of things when used with color. When a color is surrounded by black, it gains a luminosity and transparency that makes the color vivid and rich. Black will set colors off to their most vibrant saturation. Very dramatic, yet quite pleasing photographs can be made with an image filled with black shadows contrasting with brilliant color.

You do not, however, need black throughout an image for it to be helpful. Even a small area of black

The grays and blacks of the rocks offer a counterpoint to the green color of the trees in Acadia National Park, Maine.

can make colors around it look more vivid. The black gives the viewer's eye something to compare to the colors, and will always make the colors look richer.

Black will also tame strong colors so they don't overwhelm the subject. Strong, saturated, complementary colors can overwhelm a subject. This is most common with fields of flowers on a crisp, blue-sky day. So much color can make it hard for a viewer to really see the flowers and any composition you might have. Black shadows running through the scene can help define and separate the colors, creating clarity for the image and the subject.

The rich color of a starfish gives distinction to this scene in this pacific coast tide pool.

Tonal contrast along with a bit of color contrast makes this mushroom stand out in the image.

This photo of paintbrush in Texas works because of its color contrasts.

tonal contrasts

Black is an important subset of tonal contrasts. Using black next to a color provides a tonal contrast between them, making both show up better in the photograph. If the color is light, such as a yellow, then the contrast is very strong. If the color is dark, such as a purple, then the contrast is weak when black is used this way.

Tonal contrasts affect color much more than the use of black, however. Anytime you can contrast one brightness in your composition with a different brightness in the same composition, you create contrast and interest for the viewer. This will give structure and form to an image. Stronger contrasts can make a composition easier to understand, but they can also be harsh and distracting, too, if they do not complement or support your subject.

Subtle color just before sunrise in the Great Smoky Mountains National Park, Tennessee.

Hint: You've probably noted the reference to structure in a photograph several times. Structure is how the elements in an image relate to each other. Contrasts help structure an image because they visually stand out, making them the first things viewers will see in a photo. Look for contrasts to help structure your compositions and make them better understood for your viewers.

White can be important as it will make a color look solid. A problem with white in nature is exposure. If small in the frame, it can be easily overexposed, making the photo look washed out rather than interesting, or if it covers a large area, it can easily overwhelm the meter, causing underexposure, which will cause colors to look muddy and dull. Large expanses of white are rare in most seasons of nature (except in places like the White Sands National Monument in New Mexico). Winter with snow is the most common place for white expanses in nature, though winter has few bright colors to contrast with it. Yet, the white of snow is never pure white if the sun is out and the sky is blue. The sun will make the white warm, the sky makes it bluish, either of which can make for interesting tonal contrasts.

Grays mute strong color contrasts and make them work together without competing. Include a gray rock in a colorful scene and, instantly, the colors change. Too much gray, though, can really dull even bright colors in a photograph. This is why you generally want to avoid large expanses of gray sky in your image. Even a brightly colored fall forest will lose some of its zip if a heavy, gray sky hangs over it in your image.

color can be subtle, too

Nature offers some wonderful colors that aren't dramatic and bold, but rather subtle and soft. Think of trees in a fog, the gentle colors of spring flowers in the woods, the pastel hues of twilight, and so forth. Each can make for wonderful photographs, but they can also be boring. Subtle colors that are flat and gray make for bland photographs. To make the gentle hue of nature work for you, there are a number of things you can do.

Look for contrasts – When colors are subtle, they need some contrast to give your composition some shape and form. The eye of a viewer likes to move over an image, examining its different parts. Without contrast, things blend together and the image loses structure that is essential for the viewer.

Avoid strong contrasts – Contrasts that are too strong can destroy subtle colors. The viewer's eye tends to go toward contrast, so if you have a heavy black tree branch next to bright sky, that area will always dominate subtle colors. Heavy contrasts of any type can make subtle colors look dull. Subtle colors need space surrounded by their own kind.

The black of the dandelion seed head provides an important reference for the eye and makes the rest of the color richer.

Small black areas – Having said that about strong contrasts, it is true that small areas of black in a subtly colored scene can actually help. Black is always useful. Including a black rock or a darkened tree trunk in a supporting role, not as a main player, can set off the rest of the colors in the photograph and give the subtle colors more strength.

Avoid bright whites – If that fog starts to burn off and the sun breaks through the clouds, yet your scene still has lovely colors in it, keep that breaking sun out of the composition. It will quickly take the viewer's eye away from the rest of the scene and will contrast badly with the gentle colors you care about.

Look for analogous colors – Analogous colors are colors that are close to one another on the color wheel, such as green, blue-green, and green, or red, red-orange, and orange. These colors give much more subtle effects than the complementary colors

mentioned earlier, but still work quite nicely together. The key to working these colors is to be aware of them in your scene, then avoid colors outside of their range. For example, when photographing a group of yellow, orange, and red fall trees, keep the composition tight and avoid including blue sky that is a complementary color.

exposure and color

Exposure has a great effect on color. One downside of digital is that many photographers think they can always "fix" the shot in Photoshop. However, the colors never look as good as they do if shot correctly in the first place. Yet the exposure/color relationship is not an arbitrary, right-or-wrong kind of thing. The right exposure for a color is the exposure that gives you the colors you need.

If colors are underexposed, they get dark and lose their "chroma" or inherent color richness (this is similar to saturation). They can look dull, gray, and dirty. You can restore them slightly by making a lighter print or by boosting tonal values in the computer. But without increasing color saturation, the colors will not be what they were in the first place. Even with a shot of saturation adjustment, the colors will not be the same as colors shot with more exposure from the start.

Backlight makes these Utah cottonwoods glow at sunset. Too much exposure would make this color look washed out.

On the other hand, if colors are overexposed, they get lighter and also lose chroma. They look washed out. Overexposed colors are difficult to get back, as they never look quite right in a print, even if printed darker or adjusted in the computer.

Some colors, however, look good with more or less exposure, which may mean a compromise with the rest of the photograph. Yellow flowers, for example, can quickly lose their color with too much exposure, and may need to be exposed so that they keep their color even if those nearby go dark. Dark animals, for another example, often have more color in their fur than most photographs show. Giving more exposure may not be an option, as the rest of the photograph will look washed out. You can try shooting for this color by using a fill flash or by shooting on days with less contrast to the light.

getting a good exposure

So how do you get a good exposure? Chapter 3 goes into this in more detail, but you need to understand your camera and its exposure meter and how they combine to make exposures. The amazing computer technology built into modern cameras will work quite hard to give you a good exposure. Still, the system doesn't know what your particular scene should look like and can get fooled. It wants to make scenes an average, middle brightness in tone. But not every scene is middle brightness, and needs appropriate exposure, not an average exposure.

If you consistently get dark images with muddy color, make an adjustment to always give more exposure (you can do this by using the plus exposure part of your exposure compensation dial) or change your metering technique (try metering darker parts of your scene and locking exposure there as the meter will want to make darker things brighter). If you consistently get bright images with washed out color, then make adjustments to give less exposure (use the minus part of your exposure compensation dial) or meter brighter parts of your scene as the meter wants to make bright things darker.

Top: The dragonfly against out-of-focus leaves will expose well with most cameras. Center: The West Virginia forest. Bottom: The bright fern leaf may be overexposed by many cameras because of the dark background.

Leaves like these in gentle light pose few exposure problems.

problems for color

Two things consistently give photographers problems with exposure and color: a big bright area in the photo and large areas of dark. A big, bright area fools the metering system. It just wants to make everything middle brightness in tone, which means it can't keep it bright, so the whole image will often get dark. That means colors will lose much of their saturation because they get too dark. Most cameras that offer some version of multiple point metering will minimize this effect, but it can still be a problem. The correction is to increase exposure when you have a big bright area in the photo (especially if it is snow or the sun).

Large areas of dark, such as big shadows, contrasted with a much smaller and brightly lit subject, will also fool a metering system. The system will want to make that darkness much brighter to get it to the middle brightness it is designed to record. The best way to deal with this is to decrease exposure so that the dark areas stay dark and the light areas have a proper exposure for their colors.

key gear – filters

While you can use many filters to affect colors, two filters are especially helpful for getting the best color in your nature photography: the polarizer and the graduated neutral density filter. These filters come in two basic forms, a round screw-in filter and a rectangular system filter. Screw-in filters are quick and easy to use, but they are limited to lenses with their specific screw-in size. System filters work with a system of holders, filter rings and a variety of different filter types, making them very versatile and adaptable.

The polarizer is known for affecting skies. It will intensify the blues of skies with a maximum effect at right angles to the sun and no effect looking at the sun. You change the strength of the effect by rotating the filter. For colors, though, their big bene-fit comes from the removal of glare and reflections from natural surfaces. Leaves, flowers, and rock, will all gain brighter, richer colors in many situa-tions when you see them through a polarizer. You just have to rotate the filter to see what, if any, effect is possible. Don't just leave the polarizer on all the time, though, because there is a cost; it is dark and cuts the light to the sensor and viewfinder to a fourth of its actual intensity. This means you have to use longer shutter speeds (risking camera shake during exposure) and your D-SLR's viewfinder will be darker and harder to use.

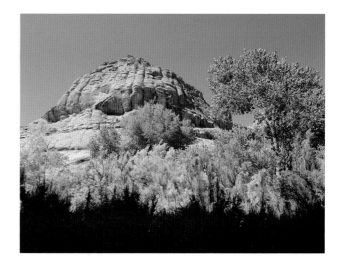

A polarizing filter is a key tool for getting the best color from many scenes. The top butte in Canyon de Chelly, Arizona, was shot with a polarizer; the photo underneath was not.

Hint: If you are unsure of what exposure is best, shoot several different exposures and pick the one with the best colors later. Changing exposures on the same scene is called bracketing.

The graduated neutral density filter has a variety of names: grad ND, grad filter, split ND, split neutral density, and so forth. They all refer to a filter that is half clear and half dark gray with a graduated blend through the middle. The gray cuts the light by one, two, or three f/stops – for most nature photographers, the two or three stop versions are most useful. You use this filter by moving it in front of the lens so the dark gray is over the bright part of a scene and the clear part over the dark areas. The result is that the two brightnesses are better balanced, allowing you to get an exposure that will capture colors and tonalities better. This is especially helpful with landscapes, to bring the brightness of the sky down to reveal its colors while allowing the ground to be brighter and show off its tones, too.

1. Use a polarizing filter (all levels) – This is a quick and easy way of getting more saturated colors in bright light, especially when the sky is bright.

2. Limit your colors (beginner) – Limit the colors in your composition to a few that work well together. Fewer colors are easier to deal with than a big mix.

3. See photo colors (intermediate) – Your camera will see colors differently than you do. Teach yourself to identify and respond to how colors will appear in your image rather than simply trying to capture the colors in the world.

4. Use color for emotional effect (advanced) – Colors will affect the emotional or evocative content of your photo. Yellow sunflowers in a field can be photographed to emphasize the yellow for a joyful effect or to emphasize the sky for its contrast with the flowers.

5. Use a telephoto focal length for broad color effects (advanced) – Use a telephoto lens or the telephoto end of your zoom to flatten perspective, bring colors closer together, and allow for out-of-focus, soft colors in the foreground and background.

6. Use a wide-angle for defined colors (intermediate) – A wide-angle focal length will make colors smaller, and with increased depth of field, sharper. A wide-angle gives a considerably different look than a telephoto.

7. Use a flash on gray days (beginner) – Turn your built-in flash on when shooting natural color on a dark, gloomy day. The colors will immediately get a boost.

8. Use a telephoto for soft colors (intermediate) – If you deliberately shoot through nearby leaves or flowers, for example, when using a telephoto lens with little depth of field, you will gain washes of soft color from the out-of-focus objects.

9. Surround key color (intermediate) – Look for ways to surround and isolate an important color in your composition so it stands out. This can be done by surrounding your subject color with dark shadow or by finding a composition that allows you to envelope the color in a contrasting, yet less saturated color.

10. Use accent color (advanced) – When photographing something because of its color, whether that is an orange field of poppies or a green grove of spring trees, look for small bits of different and contrasting colors, such as a complementary color or a cold/warm contrast, to add to the composition. This will enliven the main color, such as using a bit of blue sky with the orange poppies, or a reddish tree trunk with the spring green trees.

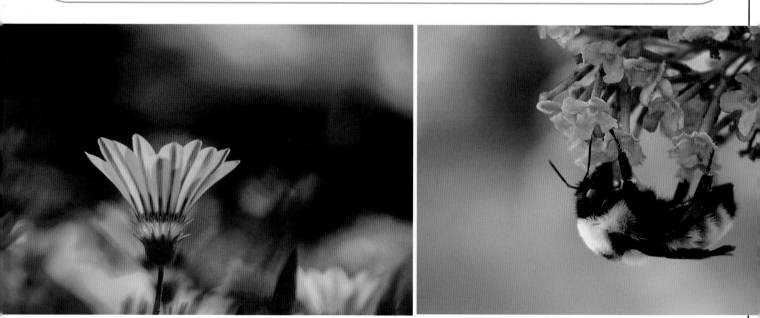

Left: A soft backlight makes flowers glow. Right: the out-of-focus green behind the bumblebee is a very important part of the photo.

Connections — Color

A world without color would definitely be a dull place. Black-and-white photography is a fun exercise in aesthetics, but imagine if one day we all woke up to find flowers that were only shades of gray! Or fall color that was as hue-less as rainy-day clouds. Or the amazing red rock of the Southwest with all the colors of an Amish buggy.

Color is very important to the natural world. As you might remember from biology, greens are critical for photosynthesis. Maybe you have never considered why there are so many greens in the plant world, though. Many things modify the green, from added internal leaf pigments, to tiny hairs on the leaves, to waxy coatings, and so on. Mostly, these modifications help leaves function better in specific environments. Lighter leaves are common on plants in sunny, warm climates, for example, where a dark leaf might heat up too much and limit photosynthesis. Dark evergreens in northern, lower light areas, on the other hand, absorb light for heating purposes as well as photosynthesis.

Many flower colors advertise the flower's identity, specifically attracting insects to aid pollination. If you get in close to a flower and photograph its details, you may find blossoms with landing patterns reminiscent of aircraft carriers, and indeed, these patterns are guides for the insects. Flowers that are wind-pollinated, from willows to ragweed, generally have non-descript flowers that blend in with the rest of the plant.

Colors are very deliberately used in the bird world. Many males are brightly colored so that they stand out in the landscape, giving them the ability to hold a territory and attract a mate (research has actually shown that birds without the bright colors have difficulty doing either task). On the other hand, most females have much more neutral browns for color so that they can better blend with the surroundings while on the nest and tending their young.

The sky is filled with color effects. Technically, the sky isn't colored like a solid object, like, say, an apple. It shows off its color due to the way light passes through it. Blue sky is blue because blue light is broken up and scattered by the molecules in the air (red light is not). We see it reflecting from all over, hence, the whole sky is blue. When the sun gets low in the sky, light has to pass through so much air that all the blue light is scattered and never reaches your eye.

richard hamilton smith

Richard Hamilton Smith is a Midwestern photographer who finds ways to make any natural scene inviting and exciting. His attention to light and color brings us dramatic, invigorating, and fresh views of nature, offering viewers new insights into the natural world around us. Smith has worked for many years in commercial photography, doing everything from Budweiser's Clydesdales to Panama Tourism. But nature is his long-time love, and it shows in his commercial, work, books, magazines, calendars, and more.

RHS: I photograph nature in part because it is dynamic and ever changing. You can't control it. In fact, my favorite parts of nature are water, weather, and light—the most fluid and capricious parts of the natural world.

© Richard Hamilton Smith

I began as a nature photographer. Although my career has expanded to encompass many subjects, I always come back to my roots for visual sustenance. I find it has restorative power for me.

Each day in nature comes with new challenges, an infinite palette of new things to see, and new ways of seeing. That makes it exciting and rewarding to me.

Though I've been photographing nature for a long time, I never get tired of finding new images there. It's like that Eliot poem:

"We shall not cease from exploration/ And the end to all our exploring/ Will be to arrive where we started/ And to know the place for the first time."

There's a birch tree below my yard. I must have photographed it hundreds, if not thousands, of times at every hour in every season and weather. Although I think I have made some nice and interesting images of it, I feel I have yet to show its essence with film or pixel. It's beguiling and bedeviling. So I keep making pictures of it.

© Richard Hamilton Smith

© Richard Hamilton Smith

As a nature photographer, who wants to explore new images, I explore possibilities in a couple of very different ways:

1) I will often try to pre-visualize a scene, consider how light and season will play across it, then decide the right time to return to make pictures of it.

2) I want my mind and eye to be open to serendipity, to that 'moment' in nature, and to respond to those moments. The photographer Sam Abell once said, "If you are passing a scene and your brain 'clicks' an image, and you fail to stop and actually make that image, you lose."

Of course, light and color are important parts of any photograph. But as I look for images, one doesn't come before the other in any organized way. Sometimes it's the light, sometimes the color, other times it's shape, texture, and pattern. More often it is the gestalt of those photographic ingredients.

A particular mood or quality of light may strike a feeling within me that I want to express in an image. I might then use a certain filter to enhance that mood or feeling. Other times I may use the filtration to deliberately push the color for visual effect and to understand how the natural colors in the viewfinder are affected by the filtration. Now that I'm shooting more digital images, I find myself using filters less and working the color with white balance settings or more with image processing software.

I love shooting in so many places. I can't say I have a favorite, because there are so many great things to see in nature everywhere. In prairies, I love the interaction of wind and light on the expanses of grass. In Denali, there is the interplay of weather and light and its compression of the seasons. What temperature and humidity do to light along Lake Superior is remarkable in its variations. Then there is my backyard ... because it's my backyard.

Although I came of age in the minimalist landscape of the Dakotas, I started making pictures in the Boundary Waters wilderness of Minnesota and Ontario. It's a very subtle, but busy landscape. It's one of the world's grand places, but not that 'in your face' grandeur like the Tetons, Yosemite, or Monument Valley. It demands a certain attention to detail and to distilling those details to a few ingredients to make

©Richard Hamilton Smith

©Richard Hamilton Smith

an image as sublime as the place. Because I started there, going back to photograph there is coming home.

Still, whether it's the nature of Manhattan or Montana, I find most every place pretty interesting. Often I'll try to look beyond the "where" of my location to see how it is comprised photographically and how light might play across it. I will admit to being contrary at times. When I find myself at those "most" photographed famous landmarks, there is some part of me that rebels against the traditional picture of the landmark and strongly urges me to see a different point of view.

I also believe it's important to stay visually acute. The best way for me is to practice that acuity in the places I see every day. You know, how can I see my backyard differently every day?

What I learn in those exercises I apply to the new places I travel, whether I'm there for myself or to produce images for a client. I never think of these exercises as chores, rather as exploration and play. I might say today every picture is with a 600mm lens, or every picture is 2 stops overexposed, or every picture is with tungsten film outdoors. It is the way I taught myself photography—learning by my mistakes. I'm still making mistakes and learning from them.

I have never been completely satisfied. There is always more to be seen and that endless quest to know a place for the first time.

To see more of Hamilton's work, go to www.richardhamiltonsmith.com.

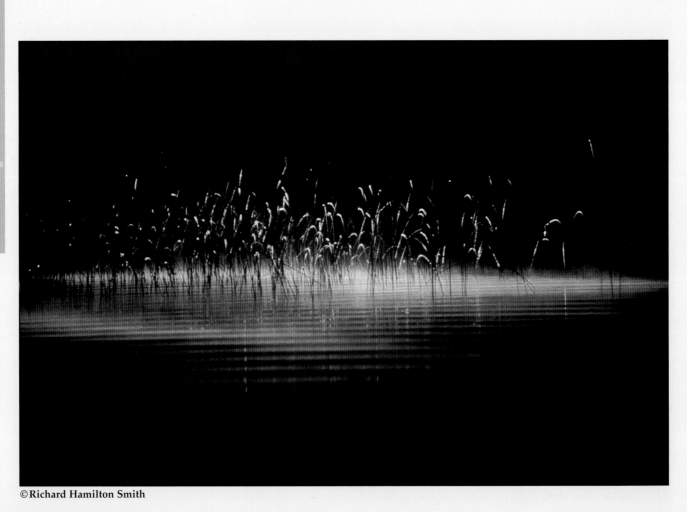

©Richard Hamilton Smith

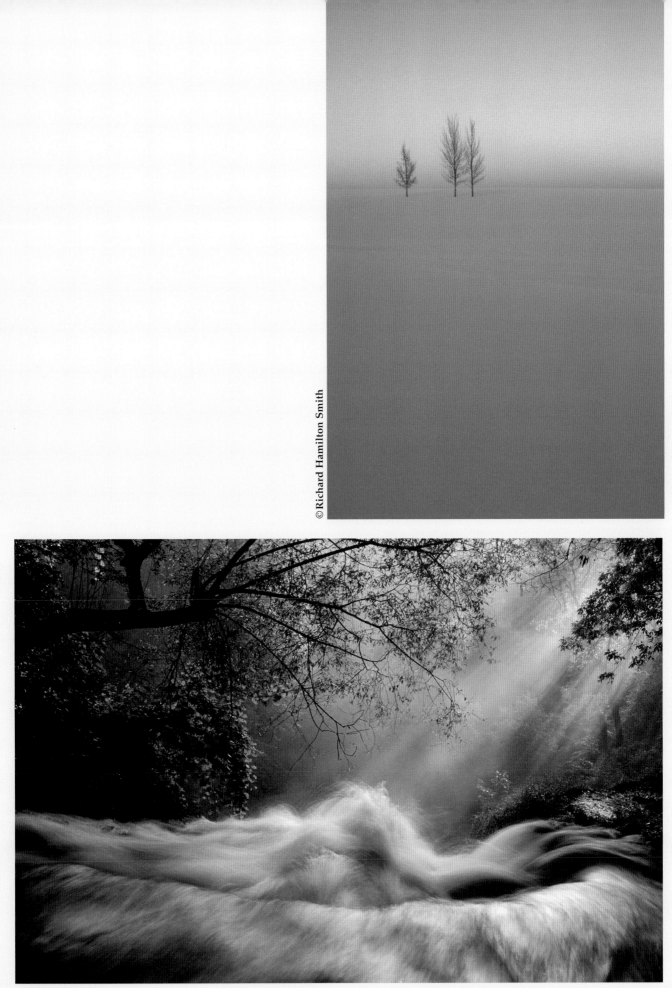

6 landscape

T he landscape has long been a great subject for photographers. And for good reason! There is truly magic in experiencing a beautiful natural landscape spreading out before you and capturing its feeling on film. Everyone who has a camera, even a camera phone, photographs landscapes.

But sometimes the landscape can be frustrating and the photographs are anything but magical. Part of that reason is because the landscape itself is such a bold experience that a photograph of it can hardly match the experience. Photographers often come home from a trip and are disappointed in their photographic results.

In order to bring home great landscape photos, we need to see the photographs in the landscape. In other words, we all have to go beyond the actual experience of the scene and find what parts of that scene photograph well. All scenes are not photogenic, even if they are dramatic as seen from a popular overlook. A photograph is both less and more than the landscape. It is less because it's two-dimensions without sound, wind, or smells. It is more because a photograph can create its own aesthetic that represents and emphasizes the scene without trying to duplicate it (which is impossible).

Leaves beginning to turn color near Rutland, Vermont.

truly rich heritage

Landscape photography has been a part of photography since the very beginning of its technology. Most of the first photographs captured by the early technology innovators were landscapes of some sort. The reasons were simple – landscapes were always a big part of the art world, and they dominated much of the art made in the 1800s when photography got started. In addition, landscapes didn't move – a great benefit when exposures in sunlight on the first, very insensitive light-sensitive materials required hours to complete.

After the Civil War, photographers went west to capture the wildness there. This was a very important part of the exploration of the West that had not been part of earlier explorations in the world. Wouldn't it be great to possess recorded images of what the first settlers found in the early colonies of the United States? But, of course, photography did not exist then.

By the time William Henry Jackson took his wonderful landscape images of the Yellowstone area in the late 1860s, photography had matured and developed considerably. People were interested in seeing what the world looked like. For the average person who had no way of seeing them on his or her own, photography of exotic and strange landscapes became an important thing.

It still wasn't easy. Timothy O'Sullivan took extensive photographs of the West in the 1870s as photographer for the Geological Exploration of the Fortieth Parallel, the first survey of the American West. It was a great project, but he worked with an 11 x 14-inch view camera and wet plates for film. He actually had a mule-drawn wagon just for his gear and portable darkroom. He would set up his camera, go into the "darkroom" to prepare a glass plate with light-sensitive emulsion, get that plate into the camera while the emulsion was still wet, and get it out and into development before it dried.

Photographers such as Paul Strand, Edward Weston, and Ansel Adams continued this tradition of photographing landscapes. And this rich heritage of photography is continued by modern landscape photographers, from David Muench to William Neill to Jack Dykinga and more. If you take any photograph of a landscape, you, too, become part of this tradition.

landscapes for the taking

While famous locations like Yosemite or the Great Smoky Mountains can be a joy to visit and photograph, they are only a small part of the opportunities awaiting anyone interested in landscape photography. If you had to wait until you could visit the big-ticket landscape locations, you'd be a sad photographer. And this book is about magic, joy, and fun, so let's look beyond those settings.

Landscape opportunities are nearly everywhere. I have literally photographed landscapes from Florida to Minnesota to California, then up to Washington and back out to Maine. I've found them near big cities and small towns, in the middle of farm country, and in the middle of wilderness.

You just need to find a scene that includes some space and depth. It can include rocks, trees, sky, water, and so on. For a good photograph, a landscape needs to have a good sightline so that you can photograph it without getting a lot of junk in the way, such as signs, telephone poles, or houses. It needs to have some sort of defining structure that you can make a photograph around, a strong detail that stands out from a scene and helps you make the composition.

Hint: A telephoto or zoom lens can be a big benefit for fragmented landscapes in and around populated areas. They allow you to isolate and focus in on the important details without including unwanted visual distractions.

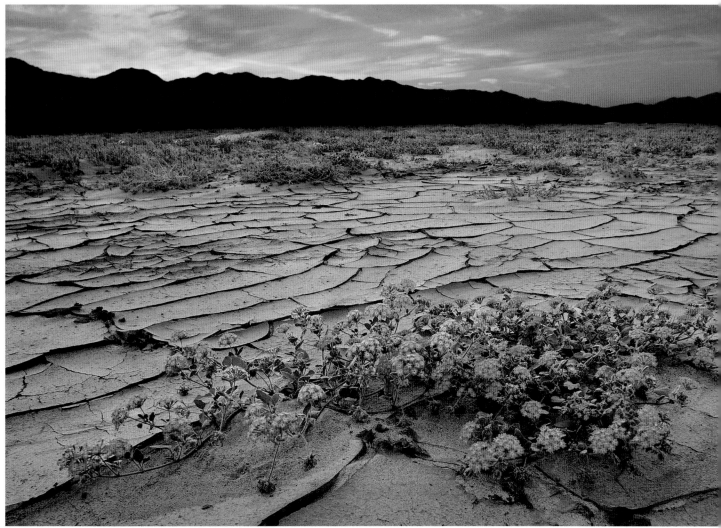

Sand verbena at sunset in Anza Borrego State Park, California.

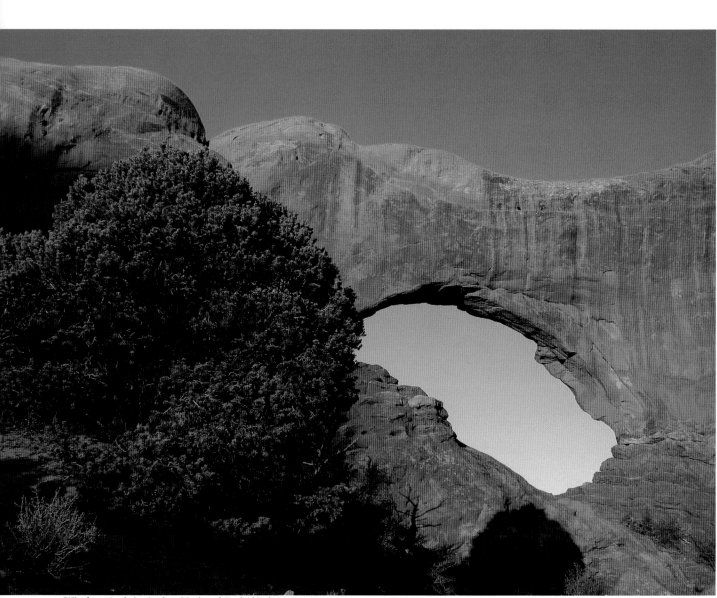
Window Arch in Arches National Park, Utah.

Rock formations at dusk in Arches National Park.

Light will often make or break a landscape image. Good lighting enhances colors and brings out important details in the scene. Problem lighting can make shadows in the wrong places so they distract from the composition, create harsh contrasts that can't be handled by your camera, or make it dull, gray, and lifeless. One reason why so many great landscape photographs include sunrise, sunset, or times just before and after is the light. Light from a low sun creates warm and rich colors in a landscape, offers great directional choices, and forms wonderful shapes and textures that light at other times simply cannot.

composition – landscapes never move

Composition is a key element of landscape photography, and well it should be, since that landscape is not going to move. Composition is simply what is in the picture and how it is arranged. Light may change and require you to set up a camera quickly, but you always have time to consider how the image should be composed.

This is one reason why you'll see the pros always using a tripod, even with smaller cameras and even when the light is bright enough to shoot handheld. With a tripod, you can lock the camera onto a scene and study how it is formed as a photograph. You are not simply sighting the scene through the viewfinder, but rather creating an image by seeing how it forms within that viewfinder.

Digital technology makes this even more helpful. You can keep the camera locked in position, check the LCD playback, and see if you like what is happening to the scene as a picture. If you don't like it, readjust the camera and try again.

Composition has been analyzed, dissected, and taught in everything from classic painting to modern abstract art to photography. You can get as involved as you want, but to simplify it, I have some tips. Don't be deceived, though, if you find these tips fairly easy to understand. They offer a wealth of pictorial depth based on how they are applied.

Watch the Edges

You might find it odd that I put watching the edges first for composition. That's because the center is obvious. Everybody puts the subject (or strong picture elements like the horizon) in the center of the frame because it's easy. There is nothing wrong with putting things in the middle if that works for your subject, but most of the time, things get stuck in the middle simply because no conscious effort was made to find a better place for them.

There are reasons to avoid the center:

The center can be boring. If every photo has the subject in the center, that will make your pictures look the same.

Space is poorly used. There is a lot of space in the frame that defines your scene. If everything is in the center, I can guarantee that there will be wasted space around the subject.

Relationships are unclear. With the subject in the center, it dominates the rest of the photo and other important parts of the photo lose their effectiveness. A nice foreground rock, for example, loses its strength if the background mountain dominates the photo from the center.

Coastal scrub landscape in Los Osos, California.

Edges can be problems. If you focus on the center, you tend to forget the edges. The edges of a photo are often the places where annoying distractions show up. You may also find that elements get awkwardly cut off in a way that could be fixed by just moving the camera to include more or less of that edge.

Edges are interesting. If you start looking around the edges of your photo, you'll often find some interesting things that deserve more attention in the composition.

Rule of Thirds

The rule of thirds is a helpful reminder to get the subject out of the center of the photo. It is based on dividing the image area into thirds, top to bottom and left to right. Then you, the photographer, use those four lines and intersections as a way of organizing your composition. You can put the horizon at the lower third or the upper third of the frame, then put strong visual elements, such as a dramatic tree or a mountain, at the intersections of the lines.

I have mixed feelings about the rule of thirds. On the one hand, it simplifies and makes decisions about compositions easier. But on the other hand, it can be restrictive since the real world is not made up of thirds. Beginning photographers sometimes take it too seriously and try to make a scene fit this "rule" when it really isn't appropriate.

It probably would be better called the guideline of thirds, and if you think of it that way, it can be helpful without causing problems. Start with an image fitting the thirds idea, then move the camera around and watch your viewfinder to see if the actual scene looks better when its parts are in different places in the frame. Use the edges of the frame as reference lines, and experiment by moving compositional elements get closer to them.

Balance

Perhaps a better rule of composition is balance. This is a harder concept than the rule of thirds, because it has no set pattern or guideline. However, balance for your photograph is something you can use for any image, even if the real world doesn't fit the rule of thirds.

Balance is simple in theory, but takes some thought to make it work in a photograph. With practice, it will become intuitive. Balance relates to how well the whole photograph works; i.e. from side to side, top to bottom, elements on the right

Rocky scene in the Eastern Sierras, Bishop California.

Clouds break in the early morning near Yucay, Peru.

visually balancing things on the left, and elements on the bottom balancing items on the top. In a symmetrical landscape, the balance is pretty obvious, but often uninteresting.

To see balance in a photograph, you need to look at the image as a whole and not just the main subject. Examine how strong parts of the composition interact with the rest of the image and consider if one side seems heavier than the other. If a big, contrasty subject sits exactly in one half of the frame and simple space occupies the rest, the photo will look unbalanced. Think of it as a child's teeter-totter – a big kid on one side will not balance a little kid on the other if the two sides of the playground structure are equal. The little kid has to have a different length of teeter-totter.

You can't change the basic dimensions of the photo when you take it, but you can change where objects end up in it. Some things to think about:

Small objects can be equal partners to a big subject. Fill most of the frame with the big subject and use the small object as a balance in a restricted area of the composition. This can make a nice contrast.

Big sky will often balance a smaller area of land.

Space in a photo is a pictorial element and can balance other parts if thought of in that way.

Colors will affect balance. A bright, saturated color will have more visual power than a dull color, so each needs to be used in the composition differently. You can use a brightly colored subject that

fills most of the frame and contrasts with smaller, less colored objects. Or you will also find that a small, brightly colored subject will nicely balance a composition with a lot of space to one side or the other.

Centered photos are often unbalanced. You might wonder how that can be if they are centered. This is exactly the problem of the big kid on the teeter-totter. Large, strongly colored, or highly contrasted objects on one side of a photo that is centered on a key part of a landscape will not look right if the other side of the image has no such element. An example: a photo is centered on a mountain peak and includes a big, contrasty pine tree on the right and dull brown cliffs on the left. The pine will unbalance the composition.

Foreground/Background

One way to really work the composition of a landscape is to look for foreground/background relationships. This gives you the chance to create very interesting visuals for the scene. Relationships among the elements of your composition make the composition come alive. The foreground is always seen in close-up relative to a landscape background, so by including it, you add detail to a scene that would be impossible to see if you only framed on the background.

Of course, if you use a wide-angle lens, you will see more foreground by default. You need to use that foreground consciously. What is in it and how can you move to include interesting elements in that part of the composition? The worst thing to do is to simply frame up on the big landscape and hope for the best for the space above and below it. Work that frame by finding interesting shapes, colors, and objects in the foreground.

This can also give you the opportunity to say something special about what you find unique about the scene. I'll explain with an example. Suppose you are photographing the Grand Canyon

Night shot along cost of Maine.

Red Rock Canyon near Las Vegas, Nevada, at sunset (a flash was used on cholla catus in the foreground.

Hint: Seeing the composition can be hard for beginners. The camera viewfinder is set up like a sighting device and there is a tendency for photographers to use it as such, rather than a compositional aid. One thing that helps is to put the camera on a tripod, then study the viewfinder as if you were looking at a photograph. Is it a picture you like? Would you put it on your wall? If you are shooting digital, add in the LCD review. Look at the image there as a small photo and ask the same questions.

from a famous overlook. Everyone who has visited that scene has the same background. But then you start looking for something in the foreground that catches your eye: a special rock, tree, flower, whatever. When you include that foreground, you know that not everyone has this photograph. And what you choose for that foreground can reflect what you feel about the scene. A tree barely holding on to the rocks says something very different than a big, solid rock dominating the foreground.

Distractions

The best that can be said for distractions is to look for them and get rid of them. Even a very beautiful scene can be damaged by something that sneaks into the corner of the composition that obviously does not belong there, such as your companion's boots at the edge of the frame in an otherwise attractive photo of a rushing stream. Distractions are most common at the edges of the composition, another good reason to check edges, but they can be anywhere.

Train yourself to look carefully through the composition for anything that takes away from it. Distractions can be anything from lights (harsh light where it doesn't belong, problem reflections, or annoying shadows), to colors (a bright red stop sign in the distance of a lovely green spring composition), to shapes (a branch or part of a rock that you did not see along the edge of the photo) and so on.

A fall scene in Eastern Tennessee, after a rain storm.

Horizontal and Vertical

Cameras, for the most part, are designed for horizontal photographs. They often feel awkward if turned from the standard horizontal position. And, in general, landscapes are pretty much horizontal parts of our world. Vertical photos, however, can be worth the effort as nature is not purely horizontal.

Turn the camera on its side once in a while and look for interesting compositions that fit the vertical format. This helps you see new things in the world, and may even allow you to discover some new magic in your scenes that is not revealed in a standard horizontal image.

Horizontals are important to landscape photography. They parallel the horizon; they fit the scene spreading out in front of you; they fit the way we see most landscapes. They strongly deal with the left-to-right, side-to-side parts of a composition. You can get some great foreground/background things happening, but they usually act side to side as well. Horizontals have their problems if the horizon always goes through the center or distractions keep appearing along the left or right edges.

Verticals, however, offer a unique way of seeing the landscape. They obviously work great with tall trees, high cliffs, and towering clouds. They help with images that you want to develop a strong foreground/background relationship because there is now so much distance in the frame from bottom (foreground) to top (background). You can use a vertical to increase the feeling of sky, or intensify the length of a stream by having it go from bottom to top of your vertical.

With wide-angle lenses, verticals also give a strong feeling of depth because you can set your camera so you look down on something at the bottom of your composition and out at the top. Verticals give you variety. It means you will always have something different to enliven your images.

Young coastal redwood forest, California.

Spring scene in Eastern Tennessee.

Deep versus Flat

A landscape is usually deep in front of you, yet in photographs, we have to flatten it out into a two-dimensional picture. You can definitely make that photo appear to be very deep and dimensional, or you can take the opposite approach and emphasize the flat qualities of the photograph.

I'll provide tips for making scenes look more dimensional, but you might be wondering, why make a three-dimensional landscape look any flatter than it has to in a photograph? Actually, some very interesting photographs come from flattening the look or perspective of a scene. Perspective is the relationship of things in your photo as they go from near to far; close things are typically bigger and better defined than more distant objects, for example.

When you deliberately go after a photo that masks or disguises that relationship, the landscape becomes flat and two-dimensional. In many situations, this is not helpful for making a landscape look magical. However, when this flattening is used creatively, the photograph gains some abstract and graphic qualities that can be quite effective for a composition.

You gain a flatter perspective on a scene by using a telephoto lens or by finding a flat scene to start with (such as a rock cliff). Telephotos are very important for controlling perspective. They reach out and bring in distant objects, which in the case of a landscape, usually means missing close-by objects that could contrast with the distance for a perspective relationship. You can actually change the perspective of a scene by zooming in with any zoom lens.

A more dimensional landscape comes when perspective is enhanced and emphasized. Any time you can contrast something close with something far and the relationship of distance is obvious, the photo gains more depth. Wide-angle focal lengths are a great asset for increasing depth in a photo (not to be confused with depth of field, which is about sharpness in depth, not perspective). They allow you to pick up close objects in your composition that can contrast strongly with distant subjects.

Deep perspective on a scene in the Columbia River Gorge area, Oregon

Flattened perspective of trees in Southern Florida at sunset, after a storm.

Hint: Practice helps you see horizontal and vertical compositions. Whenever you are taking pictures of a scene, try holding the camera in both positions just to see what they look like and how they are different. If you do this often, you will begin to see the vertical and horizontal compositions without even bringing the camera to your eye.

Dramatic sunrise through driftwood, Northern Florida.

Wide-angle lenses or settings on a zoom lens will make foreground objects large and distant things small, creating a very strong perspective relationship. In addition, these focal lengths let you get in close to foreground objects, emphasize them, and show their detail compared to distant things, all of which will emphasize perspective.

Using the Sky

Sky is a key part of most landscapes, and can make or break your photo. To get the most out of a sky, pay attention to it, see what it offers the landscape, and work to bring the right things out of it to complement the ground.

A common problem with landscape skies is a washed out, blank sky. At best, this is boring; at worst, it can destroy any magic in the rest of the photo. You can deal with it in two basic ways. If the sky is featureless clouds, keep it out of the photo, or at most, use only a small section showing in the composition. This defines the top edge of the landscape and adds depth to the photo.

The other solution is to add a filter (see page 86). A straight grad ND filter will darken part of the sky and make it more dramatic, especially if it is a blue sky. A colored grad filter will add some color into the sky to make it more interesting. You have to be sure to expose for both situations to make the sky dark enough for a rich color. That will usually mean slight underexposure for this situation when the camera meters the scene through the filter.

Hint: Perspective is a very important for the landscape photographer. It is strongly affected by how far you are from your subject and by the focal length of the lens. Try using a wide-angle setting closer to the foreground parts of your composition. Compare that with using a telephoto focal length and backing up so you can include those same parts of the scene. The scene will look very different between these two photos, largely due to perspective.

If you are 90° to the sun, you can use a polarizing filter to darken the sky. This filter will deepen sky color, but will have little effect on the sky around the sun or directly away from the sun. Rotate the filter until you get the results you need.

The polarizing filter also works well to enhance and bring out clouds in the sky. Clouds are a very important part of a landscape's sky. Dramatic clouds, especially illuminated at sunrise or sunset, can be a big help in making your landscape come alive.

Different clouds offer varied moods for your landscape. A cloud-filled sky will need a very different balance in a composition compared to a sky with

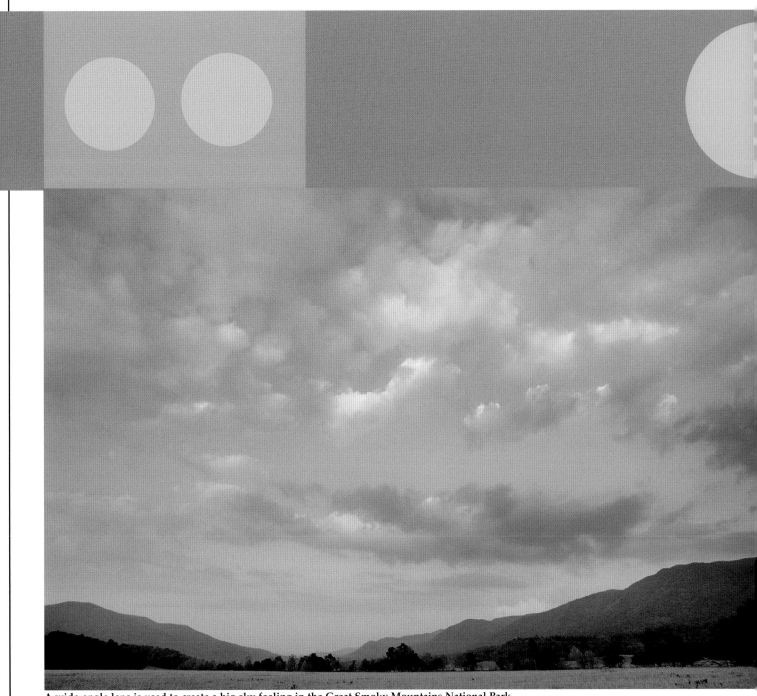

A wide-angle lens is used to create a big sky feeling in the Great Smoky Mountains National Park.

Note: Since the polarizer does not work equally across the sky, you will often find uneven skies when using it with a wide-angle lens. That can be easily corrected in the computer.

The sunset reflected on the ice on Jenson Lake, central Minnesota.

just a cloud or two. Look for clouds and ways to make them work with your landscape composition. You do need to be wary of extreme exposure differences from the ground to the clouds. This is where a grad ND filter can be a huge benefit.

Clouds also change quickly in different light. Backlit clouds may cause exposure headaches, but they are always dramatic. The eye will accept when some edges of the clouds are without detail because of exposure challenges (that makes them look bright), but be wary of overexposure. Clouds do need tonal detail to make them look right. Side-lit clouds can be an important part of a landscape that is also side-lit; textures and dimensions will really stand out. Front-lit clouds look great if the sun is near sunrise or sunset – a good reason to turn and look for photos away from the sun – but at other times, this light is rarely flattering to clouds.

The sky at sunrise and sunset can be very majestic, especially if you use a wider-angle lens to capture more of the nuances in color throughout the sky away from the sun itself. Contrast is quite high at that time, so look for interesting silhouettes in the landscape as detail will be more difficult to capture as the light lessens. Also, keep photographing past sunset. The sky often has some incredibly rich colors then.

Hint: High contrast clouds can be tamed with a special digital darkroom technique. Put your camera on a tripod and take two exposures (or more) to compensate for the extreme tonal range (e.g., one exposure for the ground, one for the bright clouds). In Photoshop (or another layer-based program), drag the best overall exposure on top of the other in a single image. Line up the two layers and then remove the bad parts of the top image to reveal the better exposures underneath. They can be removed with the Eraser Tool or a Layer Mask. Either way, use a large, soft-edged brush turned down in opacity so you can gradually blend the two photos.

The eerie landscape of Gros Morne National Park, Newfoundland.

depth of field

Depth of field is a core technique to master for landscape photography. Depth of field refers to the amount of sharpness that occurs in the photo from foreground to background. Most of the time landscapes look best with extensive sharpness, but it can be fun and creatively inspiring to photograph a landscape with limited depth of field. Either way, control it so that you don't just end up with random sharpness that doesn't work for your subject.

Depth of field is affected by four main things: f/stop, focal length, focal distance, and print size. We can't affect the last, print size, when shooting, but realize that the larger the print, the more you will notice what is or isn't sharp.

Fields of flowers create bands of color in the Texas Hill Country near Burnet.

f/stop

Every lens has f/stops (this is covered in more detail in Chapter 3). Small f/stops create greater depth of field and large f/stops lessen it. That sounds pretty simple, but I know that f/stops confuse a lot of people. Small f/stops use large numbers like f/16 or f/22. Those numbers will give you maximum depth of field with your lens. Large f/stops include f/2.8, f/4, or f/5.6, and minimize depth of field with your lens. Compact digital cameras usually do not have f/16 or smaller f/stops. This is because of the size of the cameras and their lenses. At f/11, for example, the opening in the lens is so small that anything smaller causes diffraction of the light and unsharpness.

Hint: Watch your shutter speed. Because small f/stops like f/16 do give maximum depth of field, there is a tendency among beginners to automatically choose them. This can result in a shutter speed that is too slow for sharp photos without a tripod, so you will often need a tripod. If you must handhold the shot, use an f/stop that allows a faster shutter speed for better sharpness (typically 1/125 or faster). Even when the camera is on a tripod, small f/stops can result in shutter speeds that are too slow for a windy day.

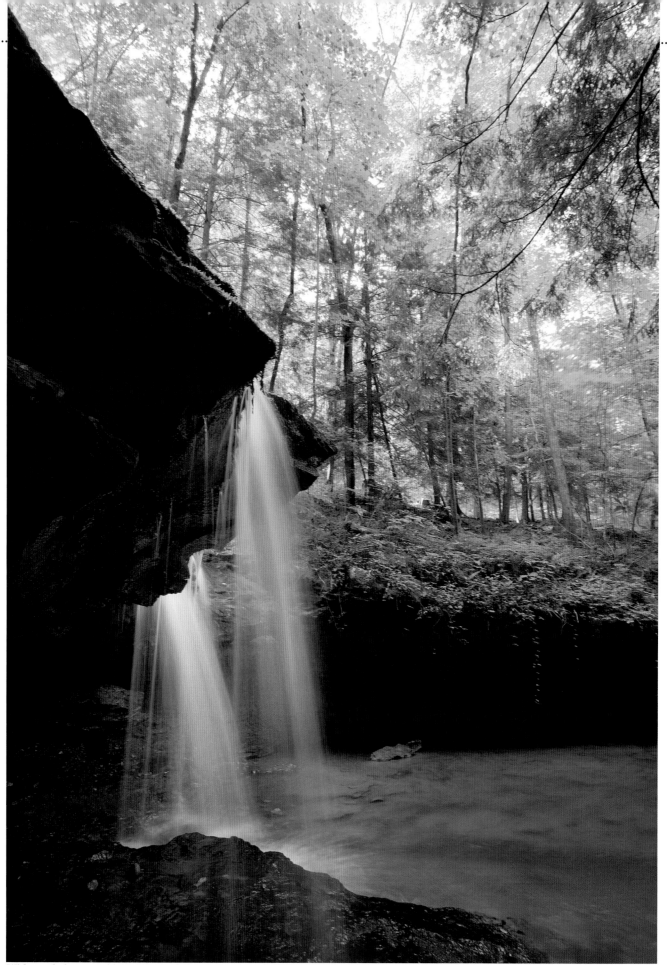

Wide-angle lens up close to a waterfall in Eastern Tennessee.

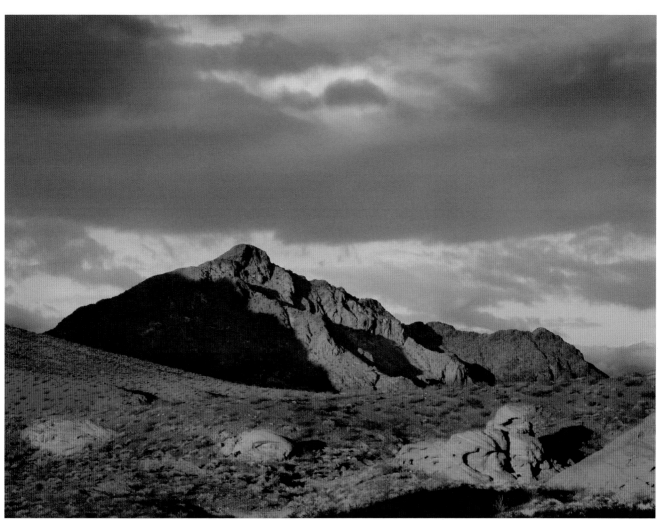

A telephoto shot of a landscape in the Muddy Mountains of Nevada near Las Vegas.

Focal length

Wide-angle focal lengths have more apparent depth of field than telephoto focal lengths, and this applies even to a wide-angle or telephoto zoom lens. In those cases, the shorter focal lengths have more depth of field than the longer ones. Since small-format digital cameras have smaller lenses with shorter focal lengths, depth of field for them can be extensive.

Distance to the Subject

The closer you focus, the shallower the depth of field. As you move away from the subject, or focus farther away, depth of field increases. Depth of field is also greater behind the subject than in front at landscape distances. You don't need to worry much about depth of field if your landscape is mainly of distant things. But when you want to include close foreground and distant background, depth of field can be challenging. You will need to focus carefully, use small f/stops, fast shutter speeds, and wide-angle focal lengths. Try putting your camera on a tripod, stop your lens down to a small f/stop, then focus on something in the foreground that isn't closest to you.

The Pod—a beanbag support with a tripod screw.

key gear – getting the landscape shot

Photographers have captured great landscape images with even the simplest gear. You can use whatever gear you have for landscape photography, whether it fits in a belt pack or a backpack, but you will find that you can consistently capture the best landscape images with at least some of the following gear.

Tripod – Don't leave home without it! Every pro has a sturdy tripod. Shooting with small f/stops for more depth of field, photographing at dawn and dusk, plus other conditions, will result in slower shutter speeds – usually too slow to handhold. A solid tripod does more than just help you avoid blurry images. A rock-steady camera will ensure you are getting the most from your lens, keeping image brilliance (which is related to tiny highlights) high.

Carbon-fiber tripods have come down dramatically in price from what they were when they first came on the market, though they are still not cheap. Yet, they truly do make tripod use easier. They are light enough to make carrying them a pleasure, and have an inherent stiffness that keeps your camera still during exposure. They last a very long time with proper care, so this is a very worthwhile investment. Aluminum-alloy tripods are an excellent value, but they are heavier.

The key to buying a tripod is to be sure it is tall enough for your purposes without extending the center column. A camera atop a high center column is not as sturdy as it is close to the stable three legs. In addition, try the leg locks. Do they work for you? Extend the tripod to its top height (not including the center column), lock it, and put your weight against it. With a good tripod, you will not feel at all insecure doing this.

You'll also need a tripod head. Many nature photographers use ball heads because one locking control frees the head for movement in any direction, making it easy to level. However, other photographers prefer the pan-tilt heads that have different controls for front-to-back and side-to-side movements, allowing each plane to be adjusted separately. Either is a good choice, depending on your personal preferences. With ball heads, avoid the smallest ones. They don't work well to stabilize a camera and won't hold a heavy camera/lens combo well at all. Magnesium heads are more expensive, but are light and balance a carbon-fiber tripod well.

Filters – (see page 86 for a complete discussion) Graduated ND filters in two and three stop strengths, plus a polarizing filter, are tools you will find in most pros bags when they are shooting landscapes.

Lenses – It is possible to photograph landscapes with just one lens. This will limit some of your options, but landscapes, unlike close-ups or wildlife, do not require special equipment. It is helpful to have at least a wide-angle and telephoto lens, or equivalent focal lengths on a zoom lens. You may find you prefer wide-angle views and favor those focal lengths. You will still want at least a moderate telephoto to keep your wide-angle view fresh. On the other hand, you may favor telephoto points of view. The same advice applies, but to those focal lengths.

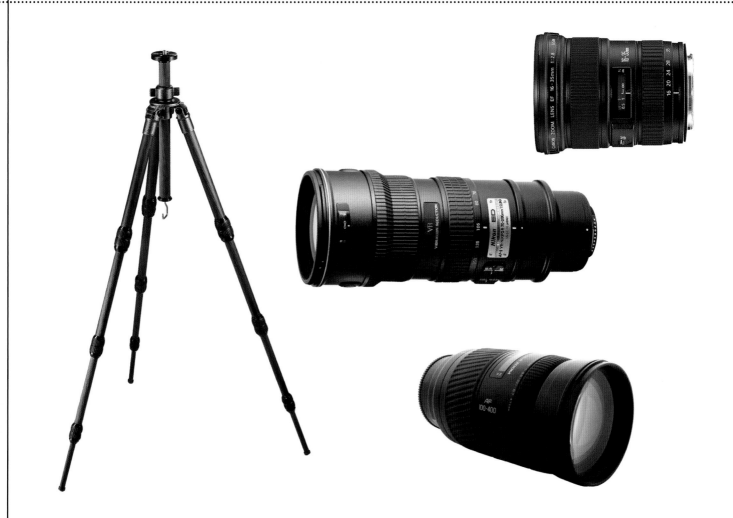

Wide-angle lenses give you the classic wide-view landscapes. They are critical to have if you are stuck in one location and can't back up to get the whole scene into your composition. Wide-angles offer great opportunities to work the foreground/background relationship. They let you get close to a foreground subject while still being able to see the background. This emphasizes depth in a landscape. Wide-angles give more depth of field in a scene, so they are important when you want a lot in focus from front to back. If the day is hazy, wide-angles also let you get in close to your scene so that you see less of the haze.

Telephotos offer the chance to focus in on details in the landscape, and can be especially important when you can't get physically close to a scene. They are great for isolating a special, dramatic part of the scene. Telephotos flatten out a landscape's depth, making objects look closer together, which can be a useful dramatic effect. They make foreground/

background relationships harder to define. They limit depth of field, which is a problem if you want most of the frame in focus. Telephotos will emphasize haze in the air, which can make for interesting tonal effects shot against the sun.

Zooms allow you to combine multiple focal lengths into a single package. This offers a lot of flexibility when you are photographing a landscape. You can quickly frame a composition, change perspective effects in an instant, and minimize the number of lenses you carry. While you still hear folks saying they aren't as sharp as single-focal lengths, that's really not true. However, zooms do tend to be slower (with smaller maximum f/stops) than single-focal-length lenses. Inexpensive and extreme range zooms (such as 28-200mm) often show barrel distortion at the wide-angle focal lengths, but it is not a problem in nature, where straight lines are rare.

1. Lock your autofocus (beginner) – Lock your autofocus on the most important part of your landscape to ensure that it is sharp. Point the camera at that part of the scene, press and hold the shutter lightly to lock focus, and then realign the composition to the desired framing. This is especially important if you have a strong foreground that needs to be in focus.

2. Use foreground sharpness (intermediate) – When working on a strong foreground/background composition, you may find that you cannot get enough depth of field to cover the distance. Focus so that the foreground is sharp and accept what you get with the background. A slightly soft background is better than a slightly soft foreground.

3. Use foreground unsharpness (advanced) – If you decide that the background really needs the best sharpness, then focus on it, use a larger f/stop, and more of a telephoto focal length. This will limit depth of field, creating an interesting contrast from out-of-focus foreground to sharp background. Slightly soft foregrounds usually don't look right, but a seriously out-of-focus foreground can look creative.

4. Look for foreground color (beginner) – If you look for a bright color in your foreground, you can quickly and easily create a strong foreground/background relationship.

5. Use a level (intermediate) – Even on a tripod, a camera can be misaligned to the horizon. Crooked horizons are frustrating, so avoid them by using a level on your camera. You can buy levels that fit into your hot shoe at many camera stores, or just find a small level at a hardware store that has a flat edge you can hold against the hot shoe.

6. Experiment with blurs (advanced) – If the day is windy and causing problems with sharpness, don't fight it, work with it. Try stopping your lens down, adding a polarizer (to cut the light), and start photographing as the grass, trees, or other parts of the landscape move. You'll need to play with exposure and timing – no two shots will look the same.

7. Use a frame (beginner) – If you look for something dark in the foreground that can go along the edges or top of the image, you can use this to create an interesting frame for your landscape.

8. Bracket your compositions (intermediate) – Try taking multiple compositions of any landscape you photograph, bracketing them by trying more and less sky, more and less foreground, and so forth. The landscape doesn't move, so this is a great chance to really experiment and learn good composition.

9. Find a better composition (advanced) – Once you have found what you think is the best composition for your landscape, ask yourself where the next composition is and if you can find a better one. This will make you work the landscape like a pro.

10. Try an extreme telephoto (advanced) – Most photographers photograph a landscape with wide-angle or moderate focal length lenses. If you have a long telephoto, including tele-extenders, put it on your camera and look across the landscape. You will find fascinating details with a dramatic perspective.

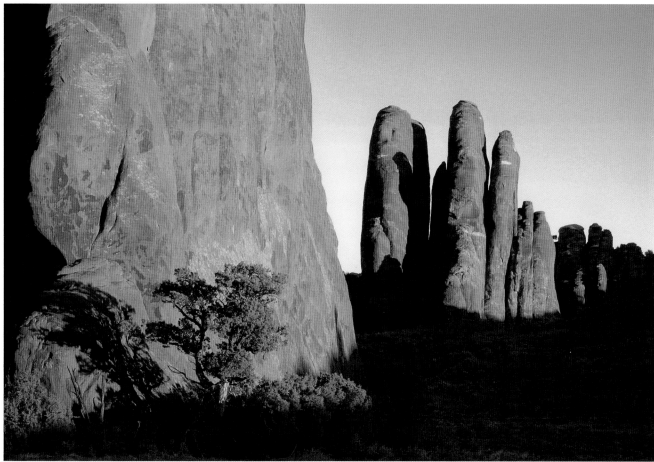

Rock formations in Arches National Park, Utah.

Connections – Bones of the World

Rock formations show off underlying geological structures, but to me what they truly represent are the bones of the world. I have seen beach rock formations heading into the ocean that look just like the spine of a sea serpent. I have marveled at boldly shaped rocky slopes in the desert that are positively skeletal. I have sat on gray granite outcroppings cutting through a forest that seemed more like ancient fossils than rock.

These rock patterns can be fascinating both aesthetically and intellectually. Rocks give you the underlying lay of the land and show off some of the forces that created the landscape you are photographing. Their formations often represent the key structures that form the scene. Isn't that, after all, what bones really do? They structure our bodies and give shape to the forms of all sorts of animals.

Most landscapes occur from a number of distinct forces, but the most common are erosion from wind and water. The rock resists these forces and keeps the shape of the landscape as it is able. Rock resistance forms everything from mountains, to cliffs, to waterfalls, and much more. It changes the direction of rivers and roads.

It is interesting how much photographers see rocks as imparting structure to a landscape. Look at a series of landscape photographs and you will always see rocks at some point. Often, those rocks are important structural parts of the photo's composition as well. Not all landscapes will have clearly defined rock formations – they can be buried by water or centuries of deposited soil. However, if you have a landscape with bold rocks in it, those rocks will be key to both how the land was formed and how you will photograph it.

© Jack Dykinga

new twists on classic landscapes, jack dykinga

Jack Dykinga is one of the top landscape photographers in the world. His work is always striking and goes beyond simple documentation of a scene. He has a wonderful eye and finds unique compositions that challenge and stimulate us. He was, after all, a Pulitzer prize winner when he worked as a photojournalist in Chicago 30 years ago.

Talk to Dykinga for any length of time and you quickly discover his deep connection to the land. He photographs from the heart. He uses a great deal of technical knowledge and skill gained from years of practice, but applies it to images not for its own sake, but in service of his love for the world.

Jack Dykinga: I think it is important to realize that you can shoot great pictures anywhere. Everybody will go to Organ Pipe Cactus National Monument to capture the spring desert bloom. I won't. I'll be out on some BLM land, not stuck in photographer traffic.

Solitude, to me, is more valuable than the perfect subject. It's almost like a Zen thing — I believe you need to find what is important to you and not run with the pack. You can't do that if you just photograph the subjects and locations where everyone else is.

I think this also gives you the chance to really find something unique. Even if I go with a preconceived notion of what I will photograph, being alone with the setting and fully experiencing it makes you more receptive to it. You become immersed in the location, vibrating with that place. It's really hard to put into words. Some people even think that this need for being alone is elitist, but I believe that solitude component is important to my photography.

When I first came to Arizona nearly 30 years ago, I was totally human centered in my photography. I had been a newspaper photojournalist and then a photo editor. We never even ran a photo without a person in it.

Here, it is different. As you spend time in the wilderness in Arizona, you must respond to the schedule of life of the desert. Geology, plant growth, all happens at a pace independent of man. Sometimes we can be incredibly arrogant as humans, thinking the world is centered around us.

© Jack Dykinga

© Jack Dykinga

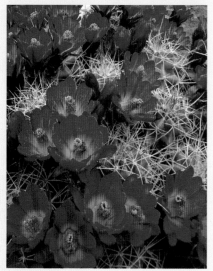

© Jack Dykinga

© Jack Dykinga

Society, and living in urban settings, like I do, can make us lose touch with the earth. For me, photographing in the wild parts of Arizona makes me less urban and more in tune with the environment. You become connected with the world when you can read clouds or footprints in a canyon.

Part of my search for unique images comes from my newspaper days. I could get security clearance to photograph right alongside a presidential candidate, for example, but that meant also being with a whole lot of other photographers who were going to be shooting the same basic things. I would often sacrifice that "prime position" to find a unique angle – a shot from the other side of a fence, from inside a crowd, and so on.

You have to be willing to take a chance, even that you might lose the shot, just so you can find images that are unique to you. Go out in bad weather. Do a skyscape from the bottom of a canyon. Shoot high or low because everyone else is shooting at eye-level. Get in the water and shoot toward land rather than just photographing from the shoreline.

Do things that you're not supposed to. For example, I shoot with a view camera and will often adjust the camera way past recommendations on how you are supposed to use a view camera.

© Jack Dykinga

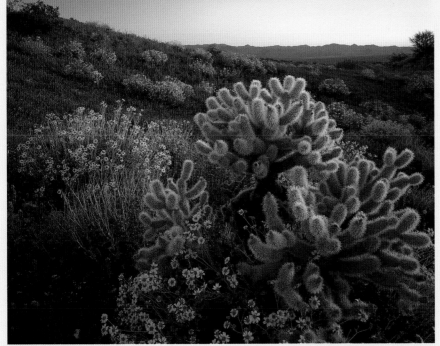

© Jack Dykinga

Arca-Swiss F-Field 4X5 view camera with an assortment of Schneider lenses ranging from wide-angle to telephoto. Usually, that will mean focal lengths from 75-400mm. You can partially convert these into 35mm equivalents of 21-180mm, but this is not exact because of the way you can change perspective with a view camera's movements. For special purposes, I will go to more extreme focal lengths of 38mm and 720mm.

I carry a Fuji Quickload film holder with 40 sheets of Fujichrome Velvia 50 film. I now use Gitzo 1325 and 1227 carbon fiber tripods because they reduce my weight with Arca Monoball and Kirk heads attached to them. It's a lot to carry, but that's what I need in my large format "toolbox."

I print digitally on Epson large-format printers, and I especially like the archival quality of the pigment-based inkjet prints for my gallery exhibitions. For me, this expedites the finishing process and gives me a whole new range of tools to work with.

But again, this is just a toolbox. To use it effectively, you have to keep looking through the camera to find new and exciting images that work for you. Think, "What if?" What if the camera were lower, higher, to the right, to the left? Don't just find a subject and be static.

Everyone knows the old saying, "The harder you work, the luckier you get." In nature photography, that is very, very true.

More about Jack Dykinga and his work can be found at his website, www.dykinga.com.

For me, the camera and its controls are simply the toolbox you carry to get your photos. Every lens, filter, adjustment, and even film size, are there for specific photographic reasons. You want to understand what your tools do. Large format can be a complex tool, but it is still a tool for you to use to get what you want. I actually like the way a view camera shows you an upside-down image on the ground glass. You see design and composition better because you aren't as distracted by the subject.

I typically carry about 50-60 pounds of gear into the field. I typically carry an

flowers

They carpet the floors of spring forests, force their way through late winter snows, decorate the tops of mountains and rainforest trees, weave a tapestry of color into prairies, and provide dramatic and stunning color in arid deserts. Flowers bloom nearly everywhere.

That alone makes them attractive subjects. But get close and they show extraordinary displays of color, form, and design; magical displays that range in size from millimeters to feet. They wake us up from winter, inspire people to steal them from protected swamp areas, and so very much more.

Photographing flowers brings us close to this marvelous life, and allows us to capture some of the energy and exuberance they hold.

why photograph flowers?

That's a little obvious, right? Everybody likes to photograph flowers because they are beautiful, because of their color, and because of their connection to our lives.

That, however, can be the very problem. Flowers should be easy to photograph. Yet just framing it and squeezing the shutter is no guarantee of a good photograph. Sometimes expecting the beauty of the flower to carry into the photograph is the problem.

A flower and a photograph of a flower are not the same thing. This is a very important thing to understand. If the "why" of photographing a flower is simply because it is pretty, then that frequently leads to failure, because the photo can never be as good as the true flower.

On the other hand, you can photograph flowers for many reasons, from simply seeing it clearly for identification purposes, to going for an abstract interpretation that expresses how you feel about the sensuous color of flowers. Both of these extreme examples demand a different approach to the photography, and each gives a new look at the same flower. So for success in photographing flowers, you need to know why you are photographing a flower and how you can portray that in the photo.

Green eyes in Northern Florida.

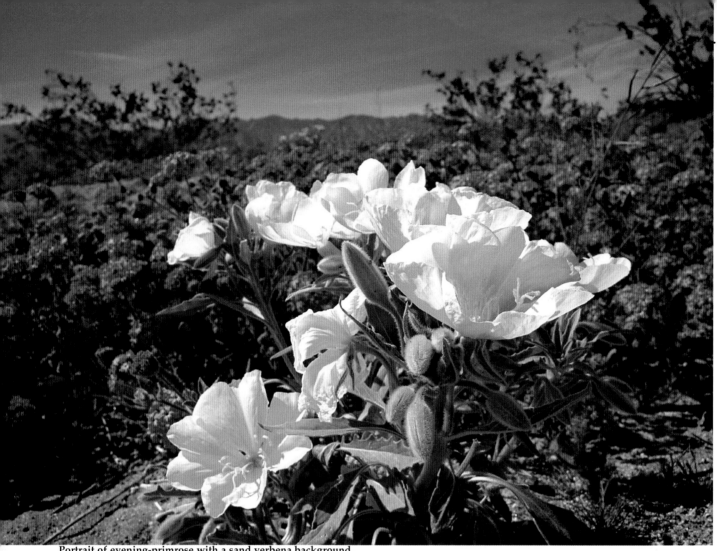

Portrait of evening-primrose with a sand verbena background.

having fun
photographing flowers

Flowers are so colorful and filled with so many connotations of joy, that photographing them can be a fun thing to do on its own. This influences the "why" of photographing them as well. Anyone's reasons for flower photography can be simple or complex, but for me, photographing flowers gives me deep pleasure. There have even been times in my life when the world seemed to be coming apart, so I took time to get out and photograph flowers. I relaxed and felt better, even if the world was still a challenge.

Add this to the reasons why you photograph flowers, and you will have many ideas of how to make that composition work for you and your subject.

straight-on flower portraits

Flowers look great, from the common sunflower to the exotic calceolaria. But just pointing a camera at a great looking flower won't get you a good photograph.

The best way to get a good image is to treat the flower as a portrait subject. Whether you like to photograph portraits of people or not, you know that it is not simply a snapshot of the subject. Many things go into making a nice portrait, such as light, expression, and clothes. Those same considerations can affect a flower portrait and give you ideas on what to do.

Detail of a bull thistle flower head.

Close-up portrait of a blood flower milkweed.

Hint: The wind is often a frustration when photographing flowers. Don't let it keep the fun from your photography, though. If you watch the blowing flower, you'll often find there is a moment that it pauses in its movement. Shoot at that point. For really windy conditions, you can block the wind. Have someone stand in the wind, hold a reflector, or try holding the flower stem with your hand to keep it steady. There is a product from Wimberly, Inc. that clamps to your tripod called the Plamp. It will hold most macro subjects for you, such as steadying a flower stem.

Camera height

A portrait changes dramatically depending on the camera height to the subject. One effective way of photographing a person is to put your camera right at their eye-level. The same thing is true about flowers. The most common angle of flower photography is from above looking down, which can make it dull. While that is the way we see flowers, it is not the most effective view of them. Getting down low to blossom level will often elevate your images.

Backgrounds

A background can make or break a portrait photo, and this is absolutely true for flower pictures. A background needs to set off the subject so the viewer of the photo can see the subject clearly, or it must have a clear relationship to the subject so that background details support the subject. One thing a background should not do is distract from the subject.

Look carefully at what is behind your flower subject, not just what is in focus. A bright, out-of-focus red blob from another flower, for example, can take the eye away from your white flower subject just as easily as an out-of-place, sharp blade of grass. Move your angle to the subject to minimize distractions.

Background attention is not just about distractions. Look for things that can enhance your subject. A dark shadow, a complementary color, or an area of consistent tone can set your subject off from the background. Shapes in the background can balance your subject in the composition. Other elements that add information about your subject are also important.

Clothes and Make-up

Portrait photographers will often have their subjects dress a certain way, and in the glamorous end of the photo portrait business, make-up is a part of the process. You don't need to carry a wardrobe or flower paints, but thinking about appearance can help you get a better flower photo. This means choosing the right flower for the close-up. Blossoms with snail-eaten petals and faded colors aren't particularly attractive up close, yet photographers who don't pay attention to such details are bound to find them in their images.

Look for the best flower to photograph: color, shape, form, and condition are all important. Unless you are after an environmental shot showing the ravages of life on flowers, there is little point in photographing a ratty subject. In addition, do a little cleaning around your subject; remove any garbage that might be there such as dead leaves, distracting stems, and so forth.

Hint: Experiment with new angles by finding a way to shoot from below the flower. This angle gives a bold, even statuesque, view of the flower against the sky. Looking for new angles to shoot the flower gives better possibilities to every angle.

California poppy from a low angle.

Butterfly weed in Minnesota prairie.

Light

Light on your flower subject can change it dramatically, taking it from average to superior as a photograph and changing the mood and feeling for it and its surroundings. There is no rule about light that will work for every photographer and every flower. Bright sun on a sunflower is very natural, yet may look awful on a trillium.

Consider if the flower looks best in direct sunlight or in a more diffused light. For light coming directly from the sun, try using backlight to make the flower glow, or sidelight to give it texture and dimension. A reflector can fill in the dark side of the flower when it is shot with backlight.

If the sunlight is too harsh, block it or use a portable diffuser. You may also have to wait until the sun goes behind a cloud, the light moves off the subject, or just photograph at a different time of day. The time right at and after sunset can give a wonderful, warm skylight on a flower.

Flash

Many people portraits are made using flash because of the way light from a flash can be controlled. Flash works for flower portraits as well, giving you total control of the light source. The easiest way to do this is using a flash with a dedicated extension cord connected to the camera. This gets the flash off and away from the camera lens. You can move the flash higher for a top light, to the side for a sidelight, and so forth. You just have to be careful where you aim your flash.

In addition, you can use flash to brighten dark areas of your subject to balance the existing light (check your camera manual as the specifics vary from camera to camera). Flash is made easy with the use of a digital camera because you can see exactly what the flash is doing to your flower subject on the LCD.

Expression

While expression and gesture seem perfect for the people portrait, it may seem an out-of-place concept for a flower subject. Flowers have "expression," but in a different way. How a blossom is positioned on the stem, or how it sits up or droops down will change your photo. You will often find slight variations in a group of flowers. Each blossom may look equally good, but close examination may show one with distinct, hard-edged markings, while another uses a softer palette of tones for the same markings. These flowers will photograph quite differently, so it is worth checking for.

Hint: Sometimes the contrasting background area is too small. A way to deal with this is to use a telephoto lens for perspective effect. If you back up to keep the flower the same size as it was with a wide-angle lens, the telephoto will magnify the background, allowing you to use what would otherwise be a small area of contrast to now fill the area behind the flower.

isolating flowers

Isolating a flower in an image can help you capture its unique beauty and show off its display of design and color without unnecessary distraction. With good isolation technique, a flower can show up strongly in a photograph, even if it is not a close-up.

There are three key ways of isolating your subject from the rest of the photograph, and they are all related to contrast. You want to find a way to contrast the flower against the background. This will immediately create visual dominance for the flower and allow you to clearly define your composition.

The first isolation technique is using tonal contrast. Tonal contrast simply refers to the brightness of the flower compared to what is around it. The flower can be lighter or darker than the background to stand out against it. Because of the way light works in nature, there are almost always changes in brightness across a scene. Plus, nature is rarely consistent in tone, so by moving around, you can almost always find a contrasting tone.

Tonal contrast will work with flowers in many conditions of light, even if you shoot in the black-and-white medium. Because flowers are small, you can more easily find contrast compared to larger subjects, such as a landscape. Often just slightly moving your position relative to the flowers will give you some contrast to work with. You need something in the background that is lighter or darker than your flower subject.

From left: a garden rose; lupine in Wyoming; pink mallow, California; wild onion, Texas.

The second isolation technique comes from the use of color. Anytime you can put a distinctly different color behind your subject, the subject will stand out. Flowers are generally very colorful, so this is an excellent technique for contrasting them. The challenge occurs when similar flowers are massed together; flowers behind your subject may be the same color as your subject, offering no contrast. You have to look for ways to get around this in your composition.

There are several ways of looking at color contrast that may help you find the right contrast for your flower. By moving your camera position slightly, you can often find multiple colors to use. The most obvious color contrast is one that uses completely different hues than the background. For example, a red flower will dramatically stand out against a solid band of green foliage behind it, or an orange flower will be bold against a blue sky.

Another color contrast is one of saturation. Saturation is the intensity of a color. This usually works best if your subject flower is more saturated than the background behind it. If the subject is more intense than the background, it will stand out.

The third isolation technique is sharpness. Any time you can make your subject sharp and the background unsharp, your subject will stand out. This can be a very effective technique when your flower subject is the same tone or color as whatever is

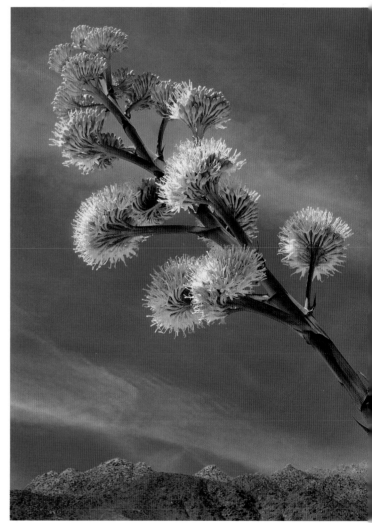

Nicely isolated desert agave in Anza Borrego State Park, California.

behind it. Many photos of flowers benefit from this technique, but two things cause problems for the beginning nature photographers:

1. Automatic program exposure with D-SLR cameras— In program exposure modes on a D-SLR, the camera may chose an f/stop that creates too much depth of field, so that there is no sharpness contrast. Yet, you won't see that in the viewfinder. That is because the D-SLR shows you the scene through the lens at its widest aperture (least depth of field), regardless of the actual aperture used. D-SLR cameras are set up this way so you can see the scene more clearly and so you and the camera can focus better. The camera stops the lens down to the proper aperture when the shutter is released.

2. The idea that everything must be in focus in a picture— This is a common misconception among beginning nature photographers. While certain scenes do look good with maximum depth of field (see page 111), that can be a problem if you are trying to highlight a single flower amongst similar detail around it.

To use sharpness as a contrast, the subject must be sharp while things behind it are unfocused. The quick and easy way to deal with this is to use the widest aperture or f/stop on your lens. Choose something like f/2.8, f/4, or f/5.6 (or whatever your lens offers as the widest f/stop). This will give you a very high shutter speed. In really bright light, you may need to use a neutral density filter or a smaller f/stop to cut the light. Be sure to focus carefully on your subject, because if the sharpness is off, the image will not look right.

Telephoto lenses or telephoto settings on a zoom lens can be a big help in isolating your flower using sharpness contrast. Higher numbered focal lengths on a lens reduce depth of field. Another thing you can do is move around to find an angle to your subject that has more distance between the subject and

background. The common 45° down angle on flowers makes the background fairly close to the subject unless the plant is very tall. If you get down to the level of the flower, the background is often much farther away, and therefore more out of focus.

Sometimes one of these isolation techniques works best on a particular subject, sometimes another. Try all three with different subjects. You'll get a feel for them and will be better able to choose which one works best for a given situation.

Hint: Many D-SLRs have a depth-of-field preview button. This stops the lens down to the taking aperture and will give you an idea of what is in focus. It takes some practice to use, as the viewfinder will get very dark. You have to force yourself to look for sharpness differences. Digital cameras can be very helpful in offering a preview and review of the image so you can see the depth of field. On non D-SLR cameras, you can see the shot live on the LCD, which will help preview the depth of field. On all digital cameras, you can check the LCD after making the shot and compare sharpness of subject and background.

Compare these pink mallow flowers shot with a wide-angle lens to the ones on page 131 that are shot with a telephoto; the depth of field is considerably different.

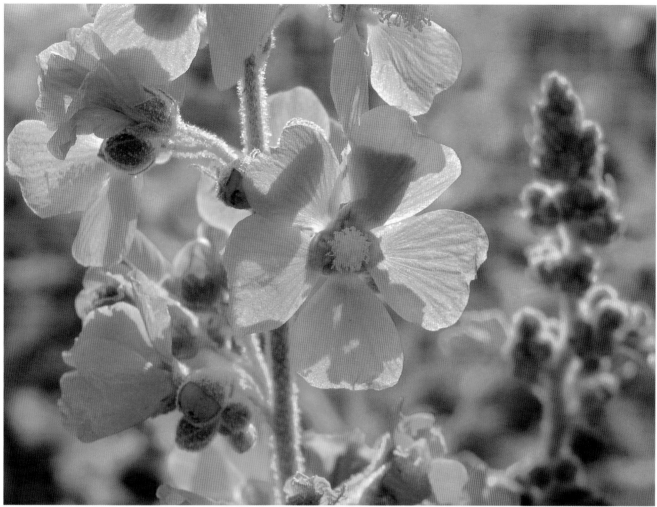

Backlit pink mallow flowers seem to glow in the light.

Essential Flower Technique – Using Backlight

While the use of light is a core technique for any type of photography, backlight is something you will definitely want to master for photographing flowers. Backlight, as discussed earlier, is the pros light. They use it all the time. You can too, and the results with flowers will make your images snap, crackle, and pop with color and vibrancy.

For flowers, and this refers to everything from close-ups to big groups, backlight does several important things to bring new life to the subject.

Backlight makes colors glow – Color is one of the wonderful parts of flower photography. With backlight, that color will look radiant.

Backlight separates picture elements – Because backlight is a light of highlights and shadows, it will create separation and definition to your flowers.

Backlight dramatizes the subject – Since backlight always has contrast from light and dark areas, it makes photos more dramatic. Not commonly used by the average photographer, backlight gives a look to the flower that is different and striking. If you get down really low, you can even get the sun behind the blossoms, adding a strong touch (you may also get flare in the shot, which can be considered part of the drama).

Backlight may add sparkle to the shot – With the sun behind the subject, the light will sparkle at times off petals, especially off any dew on your subject.

Backlight increases contrast – Contrast can be helpful in bringing more life to a photo on days that have less contrast. Just shoot toward the brightest light.

When you shoot toward the sun, the right exposure can be harder to achieve. Increased contrast can cause problems, and flare may become distracting. Here's how to deal with these challenges when shooting flowers:

Exposure – Expose for the highlights or bright parts of the flowers. With digital, you can see what you are getting, so check to see if the colors look right. Enlarge the image and learn to use the histogram explained on page 43. It can also help to bracket your exposure.

Increased contrast – Too much contrast will give you an ugly photo with visually dense black shadows and harsh highlights. Train yourself to see when the contrast is too harsh for the flowers, and do that by taking photos (you can learn very quickly with a digital camera's LCD review). You can fill in dark shadows with the use of a reflector or flash.

Flare – A lens shade will help keep the sun off the lens, which causes flare. You can try blocking it with your hand or a hat, but watch the edges so they don't get into your photo!

flowers and setting

Where a flower lives can be an important thing to include in a photograph. A close-up of a delphinium flower, for example, could be done in a garden or at its native site in the mountains. While both shots could be great, the close-up won't define the location. To the viewer, the pictures might have been taken at the same location.

There are two ways of showing setting. One way is to make a composition that includes the flower and its environment; the other is to take two photographs, one of the flower up close, the other of its surroundings.

Including the flower and its environment can be tricky. It is easy for the surroundings to overwhelm your subject. Use the isolation techniques described above to help set your flower apart from its surroundings. Playing around with depth of field can be very helpful, allowing you to make your flower sharp and the background not as sharp, yet still recognizable. The depth-of-field preview can be very helpful for that.

You might also try a composition that uses the whole frame to establish a relationship between subject and background, and does not simply plop the subject into the center. It can make for a clearer composition if you use the image area to visually relate the subject and environment; for example, placing the flower in the lower left corner and a background mountain on the right.

Taking two photographs is another good option. It is easy to see you got the shot with the close-up – it looks great on the LCD review, the light and color are wonderful, and so on. But without the surroundings, it will lack context. Often, it is impossible to make a good composition that both flatters the flower and shows the surroundings. In that case, make the best image possible of the flower, then make the best image you can of the environment. This is a great technique for slide shows and multiple prints of a location. It gives the viewer a sense of place for the flower.

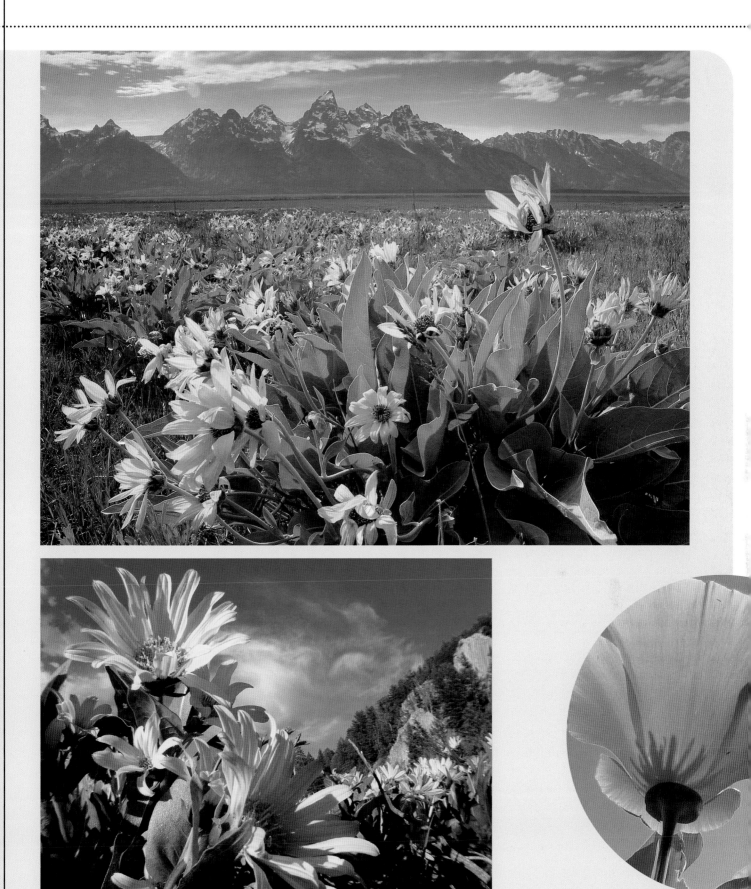

Above: These images are variations of mules ear flowers. The top photo shows a strong setting, while the bottom one only hints at it. Right: California poppies.

Special tripod accessories can help get better close-up photos.

key gear – getting the flower close-up

Close-ups are an important part of flower photography. Sooner or later, you will want to get in close to a flower so you can really show it off in your photograph. Many people think macro lenses are the only way to do close-ups. While an effective close-up tool, a macro lens can be limiting if that is your only way to get close-ups. There are five main ways of getting close-ups: close-focusing lenses, close-up accessory lenses, extension tubes, tele-extenders, and macro lenses.

Close-focusing lenses (and cameras) – Today, many lenses focus quite close without added attachments. This is especially true for most zooms on the market. This makes close-up work quite convenient. There are two limitations, however. First, these lenses are often not designed for optimum sharpness up close, so the close-focusing feature often only looks its best when the lens is used in the middle range of f/stops (such as f/8 or f/11). Second, they are often set up so that you can only use a certain part of the focal length of the lens (usually either the wide-angle or telephoto end of the zoom, and rarely all the focal lengths).

One nice thing about most small digital cameras is that they usually have a close-focusing feature built into them. Since you can see what the lens is getting by viewing the LCD, you don't have a problem with composition or focus. These little cameras can be a great way to experiment with shooting flowers since you can try different close-up shots and see each one on the LCD monitor as you go.

Highly corrected, achromatic close-up lenses can even be used on compact digital zoom cameras for high-quality close-up work. They come in various sizes and can be used on any camera lens with the right filter size.

Close-up accessory lenses – Sometimes called close-up filters, these lenses are attached to the front of your camera lens and enable it to focus closer on your subject. They make close-up photography very easy. As long as they fit a lens, they can make any lens focus closer and without complications. They can even make a zoom focus close at any focal length.

They come in two types: inexpensive single-element lenses often sold in groups of three, and more expensive multi-element, highly corrected lenses. The inexpensive close-up lenses are a quick and inexpensive way of getting in close to flowers. However, their image quality is not very good and will make photos look soft (which can also be an interesting effect).

The multi-element, highly corrected lenses are often called achromatic close-up lenses. They are available from a number of manufacturers, including Canon, Century Optics, Hoya Filters, and Nikon. These lenses also attach to the front of your camera lens, but offer very high quality images. This is somewhat dependent on the quality of the underlying lens, but results can match any other close-up gear.

Extension tubes – I wouldn't be without a set of extension tubes. These are simply empty tubes that fit between your lens and D-SLR camera body (also connecting the two electronically as needed) and make your lens focus closer. As you shift a lens farther from the focal plane (where the sensor is), it will focus closer. No optics are involved, so the cost is low. Image quality is excellent, but is still dependent on the quality of the original lens. Some lenses simply do better than others for close-up work, regardless of their quality at normal distances.

You can buy them separately or in a set of three. The great advantage of these is that they will make any and every lens you have focus closer (you can't use them with extreme wide-angles, however). They are rugged, easy to use, and very portable. A bellows works similarly in that it adds space between the lens and camera, but bellows are more specialized gear, bulkier, less rugged, and not very portable.

Extension tubes come in different sizes, from small to large. Smaller sizes have less of an effect on the focus distance of a lens. They do not work equally on different focal lengths. When used with a wide-angle lens, a small tube can put you right on top of a subject, while the same tube may have hardly any effect on a telephoto lens. As a lens moves from the camera, less light reaches the sensor. This requires an increase in exposure and will be corrected with the camera meter, but will reduce your shutter speed if you keep the same f/stop.

Tele-extenders – Sometimes people confuse tele-extenders with extension tubes. Tele-extenders are optical elements that fit between camera and lens on a D-SLR . They magnify the image seen through the lens and bring the subject closer, though they do not allow the lens to focus any closer. They can be used for close-ups because of that magnification, though image quality is less than using extension tubes or high-quality achromatic close-up lenses.

A swiveling or tilting LCD can make close-up work easier.

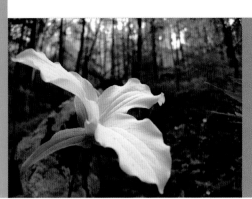

A large-flowered trillium.

Macro lenses – Macro lenses are lenses specifical-
ly designed for optimum quality at close-focusing
distances. They are not the same as so-called
macro-focusing zoom lenses, which are just close-
focusing zooms that may or may not be as sharp
close-up.

Macro lenses let you focus from infinity to
extremely close without any accessories. How close
depends on the lens, but most will go to 1:1 or 1:2
(1:1 means the subject is exactly the same size in
real life as it is on the sensor; 1:2 means the subject
is half its real size on the sensor). Macro lenses offer
the highest quality in close-up work and feature the
great convenience of continuous focus from near to
far, but can be expensive. Like extension tubes, they
lose light at the focal plane as they focus closer.

Skullcap

Digital cameras with fold-out LCDs – This is a
special sort of close-up gear that can offer some
amazing results. Many advanced compact digital
cameras have an LCD that swivels out and rotates
(and they all offer close-focusing capabilities built-
in). For close-up work, this means you can get the
camera into all sorts of angles to your flowers, and
still see what the lens is seeing. You simply pivot
the LCD until you can see your image. You can put
the camera down to ground level, look up at a
flower against the sun, and still see the composi-
tion. You have to train yourself to see the LCD in
bright light (it can be hard to see), though the latest
models work well. You may have to shade the
screen from direct sun.

These cameras' built-in close-up capabilities will
help get you started, but the settings are usually
limited to certain focal lengths of the lens. I have
found a great combination to be one of these cam-
eras with a high-quality, achromatic close-up lens.
They usually have adapters for adding filters and
accessory lenses that can be used for the close-up lens.

A pink azalea

Blue phlox

Wild geranium

1. Get down for new angles (beginner) – One of the most common ways beginners shoot flowers is to aim down 45° to the subject. This makes the photos all look the same. Get low for new angles to your flowers. Shoot them from right at the ground all the way to slightly above them and every spot in between. This may even mean lying down on the ground and looking up at the blossoms against the sun.

2. Bring a reflector (intermediate) – You don't need anything big or fancy to act as a reflector for flower photography. It can be a small white fold-up unit purchased from your camera store or a silver sunshade for a car windshield. A reflector can add light to the shadowed parts of your subject, put light into dark shadows where your subject sits out of the light, shade a flower when the light is too harsh, or laid out on the ground to hold your gear out of mud and sand.

3. Diffuse your flash (advanced) – Small diffusers on an accessory flash don't do a lot to the quality of the flash for distant subjects. However, even a small diffuser up close will affect the light on your subject. It can be effective in making your flash-exposed flower look more attractive.

4. Create your own shade (beginner) – Gaining contrast between your subject and background can be an important technique for flower photography. If there are no natural shadows there, look for ways to create your own shadows. Hold a jacket or have somebody stand in the sun to block light on the subject or behind it, creating contrast of sun to shade.

5. Wide-angle subject/environment (intermediate) – A wide-angle lens can help in connecting your subject to its surroundings. It allows you to get very close to your flower subject and still see its environment. This creates a strong perspective effect, making the flower big and the background small. Get in very close to your subject. You will find the effect is quite dramatic.

6. Wide-angle close ups (advanced) – For a really wild perspective, try using a wide-angle lens for flower close-ups. Many small digital cameras allow you to do this with their close-up settings. You can also add a close-up lens or extension tube to a wide-angle lens on a D-SLR to photograph up close with that lens. This can give very interesting perspective effects.

7. Get down to flower eye-level (beginner) – Everyone has seen flowers shot from above because that's the way people typically photograph them ("look at this pretty flower," bend down, take a picture). Yet a flower's personality often comes clear when you shoot with your camera lens right at the same level as the flower itself. Think of the flower as a person and imagine shooting so that you are looking right into that person's eyes.

8. Hold a flower in front of the lens (intermediate) – If you shoot wide-open with your aperture and go for very limited depth of field, you can get great unfocused color effects by holding a flower literally right in front of the lens. Move it around until you like the splash of color, then go for it.

9. Flowers against the sunset (advanced) – Shooting a flower against a sunset yields a very creative and unusual photograph. You need to get low, obviously, on a flower that has access to the setting sun (you can do this with a sunrise, but the logistics are harder and colors usually less dramatic). Silhouette the flowers against the sun or use a warm filtered flash to balance the sunset. Either way, you will have a special shot few other photographers will attempt.

10. Go for glowing color (intermediate) – If you like color in flowers to really glow, you need two things: backlight and strong shadow. Find colorful flowers with strong, low backlight, and move until you find a dark shadow directly behind them. Compose for the flowers surrounded by darkness and the colors will jump. Be careful of exposure, though. Too little and the flowers are too dark; too much and the color washes out.

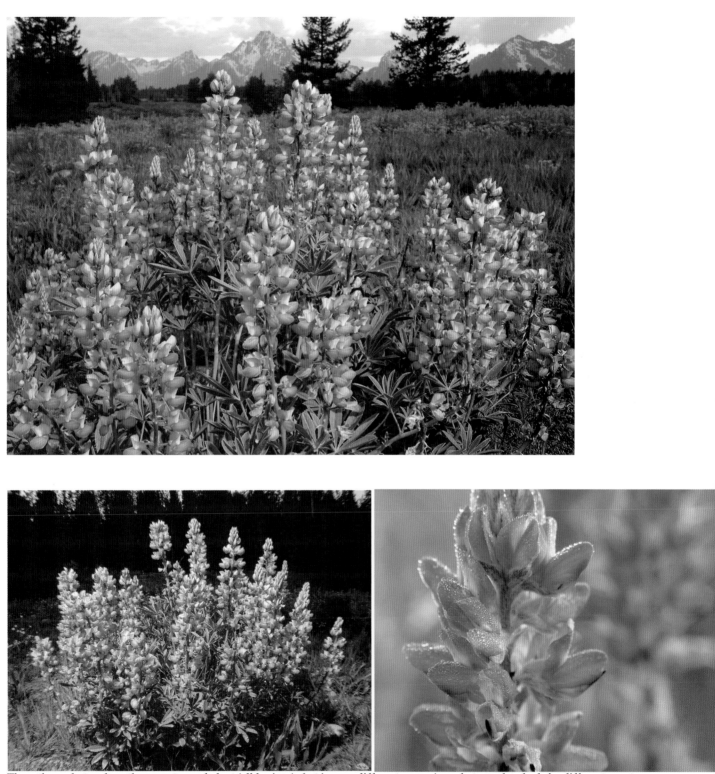

These three photos show the same type of plant (all lupines) shot in very different ways. As a photographer, look for different way to capture your floral subjects.

Connections – Plants and Their World

Plants, and of course their flowers, are not randomly arranged throughout nature. Once you start really looking for flowers to photograph, you will notice that certain plants grow in one area and not another. Some flowers are so highly restricted in their range that you have to know exactly where to look, even to the point of getting very specific directions from someone in the know.

While there are a number of factors that affect flower distribution, two major reasons for a plant to be in one spot and not another are microclimate and soil type. Microclimate refers to a small area that has very distinct temperature, light, moisture, and wind conditions (among others) that vary from the overall climate of a location. Soil type is related to things like rock content, acidity differences, water-holding capacity, and so on. Soil and microclimate changes can mean the difference between finding flowers and not finding anything.

Microclimate differences are the easiest to discern. For example, a small stream flowing due east through rolling hills in southeastern Minnesota is subject to the overall climate of hot, humid summers, short springs and falls, and a long, harsh winter. But look at the hills north and south of the stream, and you will find major differences in the plants growing there. The south-facing hillside warms up faster, melting snow in winter, bringing out early wildflowers in the spring. But this same hillside can dry out in the summer, even to the effect of keeping some plants out, such as ferns and birch trees.

On the other side of the river, where the slope faces north, you may find foot-thick, old birch trees, whole stands of maidenhair ferns, and much more. You may learn of a moisture-loving orchid relative in the area, but have no luck finding it until you explore the protected, northeast-facing slope that rarely dries out.

Spring flowers are greatly influenced by microclimate. The earliest blooms of a species will show up in the sunniest, south-facing spots in a location, while you can often find late bloomers of the same species long after most have gone by looking for cooler spots on north slopes or low areas that get cold air drainage. You don't have to be an ecologist to understand how microclimate affects the growth of flowers. Once you find a plant in a location, look for other locations that have similar temperature, light, and moisture conditions in order to find more. Some plants are extremely sensitive to microclimate variations, and you will only find them in very specific spots.

© Rick Sammon

flying flowers, rick sammon

Rick Sammon is a photographer and author always on the go, and always, it seems, with a new book project in process. He travels the world in search of interesting subjects that he can share with his readers, his classes and workshops. He loves the colors and shapes of everything from underwater sea life in the Red Sea to camel riders in the Kashmir to butterflies at home.

Sammon started his butterfly project a few years ago after falling in love with butterflies at a butterfly zoo of sorts, Butterfly World, in Florida. His story is one about a photographer's passion for a natural subject:

Rick Sammon: Who can gaze upon a butterfly, light as a feather and decorated with rainbow colors, and not smile in wonderment, joy and awe at one of nature's most magical creations? There is a quote from British novelist Elizabeth Goudge that I like: "Butterflies ... not quite birds, as they are not quite flowers, mysterious and fascinating as are all indeterminate creatures."

You have to wonder how can a crawling sack of green goo with stubby legs and poor eyesight, the caterpillar, transform itself during a nap into a creature with delicate, scaled wings and excellent eyesight – a creature that can fly quickly and effortlessly through the air, navigate great distances (some, like the monarch, thousands of miles), deter predators with camouflage and coloring techniques, find a mate, weather a storm and even freezing temperatures, reproduce . . . all within a brief lifetime of weeks or months?

The answer to that question is a mystery, one that has intrigued humankind for centuries – evidence of the butterfly's importance can be found in ancient Aztec, Chinese, Egyptian, European, Hopi, Mayan and other cultures.

My interest in photographing butterflies and moths, which became an obsession for a year, began during a 2003 trip to Butterfly World in Coconut Creek, Florida – which is home to up to 4,000 butterflies at a time.

While photographing Butterfly World's flying flowers, as they are often called, I met Ron Boender, a butterfly expert and owner of the facility, and Alan Chin Lee, the lepidopterist at Butterfly World. Alan, who eventually became my science advisor on this book, saw me trying, and I do mean trying, to photograph the elusive creatures with my digital SLR. An expert photographer himself, Alan quickly offered to help me get some good shots. He soon pointed out two clipper butterflies mating – a beautifully lit scene in which the butterflies seemed to become one in color and pattern for a moment in life.

It was that sight, and the sight of seeing the image of those animals on my camera's LCD monitor, that immediately convinced me to do a book on live "flying flowers," which became a reality in 2004 with the publication of Flying Flowers – the beauty of the butterfly.

Why did I want to produce a book on live butterflies? Because, as a photographer, I wanted to capture sights like that with my digital camera – of live butterflies, and not simply of dead butterflies, as we see in many butterfly guide books.

Over the next year, I made five trips to Butterfly World, where I gained more and more experience photographing live butterflies. Each time I came home to Croton-on-Hudson, New York, with more and more photographs of different species each time.

My wife, Susan, also got hooked on butterflies. She planted butterfly bushes in our backyard, which attracted monarchs, tiger swallowtails, viceroys, gulf fritillary, orange-barred sulphurs, mourning cloaks and even one of my favorite flying flowers, the hummingbird moth, which, when you see it for the first time, actually looks like a tiny hummingbird.

My backyard quickly became my butterfly photo studio, as did our kitchen, where I set up mini-photo studios for caterpillars in which to feed, weave their chrysalis (butterfly) or cocoon (moth), hatch and then fly off into our garden.

In January 2004, I ventured off with Alan and two of butterfly experts, Dr. Tom Emmel and Dr. Gary Ross, to Michoacan, Mexico to photograph a colony of millions of Monarchs during their annual migration. After a five-hour car ride from Mexico City, a one-hour drive on winding roads to the area, another hour on horseback and then about another hour's walk, we arrived at the colony. It's hard to describe the feeling of witnessing such a massive gathering of these magnificent insects. That's why I like photography – it makes it easy for me to share my experiences, and the wonders of nature, with others.

My butterfly project would not have been possible if it had not been for my digital SLR system and image-editing software programs. After taking a picture, I could immediately see on my camera's LCD monitor what went right and what went wrong, so I could make exposure and lighting adjustments accordingly. That was of the utmost importance, due to subject movement, changing lighting conditions and the reflectivity of some of the subjects.

© Rick Sammon

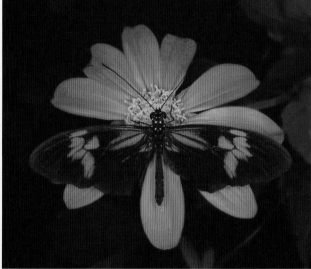

© Rick Sammon

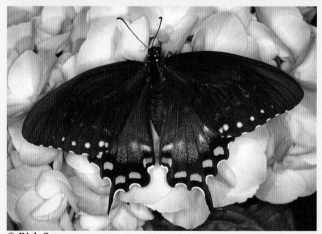

© Rick Sammon

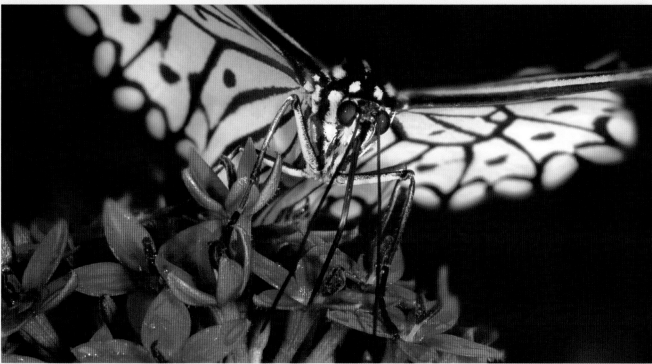

© Rick Sammon

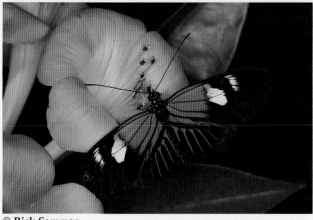

© Rick Sammon

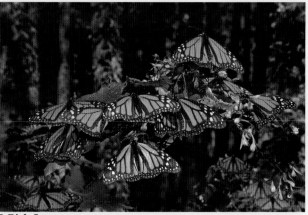

© Rick Sammon

© Rick Sammon

Shooting fleeting subjects in the field was a challenge, especially when it came to choosing the background. In Adobe Photoshop, I darkened and soften the background in some pictures to make the subject more prominent in the scene – a technique similar to ones traditional darkroom artists have used for years. To enhance the sharpness of low-light images, I used nik Sharpener Pro! from nik multimedia.

Visit Rick Sammon's website at www.ricksammon.com.

8 wildlife

meeting a wild animal in its natural environment can be a thrilling experience. Capturing that animal in a photograph can be exhilarating and exciting. While the big animals like moose and bear get a lot of the pictorial attention, there are many other wild animals that make superb subjects, from herons to muskrats to toads.

Being a dedicated wildlife photographer is hard. It can be one of the most challenging types of nature photography. That being said, it is very possible for anyone to have some satisfying success at photographing wildlife. We don't have to match the best photographers in order to enjoy and appreciate attainable wildlife photography.

the need for magnification

Wild animals do not generally let you walk up to them and pick your focal length like you would with a flower. They keep their distance, sometimes a short distance, sometimes long, but a distance, none the less. The result is that wildlife shows up too small in a photograph.

You need to magnify the animal so it is sized well in your viewfinder. This means telephoto lenses are a necessity. The so-called "normal" focal length for 35mm is a 50mm lens (this relates to how we see the world). Six times that focal length is 300mm – what a six-power binocular offers. Eight and ten times that is 400mm and 500mm, respectively.

These are really quite reasonable focal lengths for wildlife work, and offer magnification for the photograph that works for animals. These focal lengths match 35mm cameras exactly, but most digital cameras have smaller sensors. You need to look for a 35mm equivalent to see how they compare (D-SLRs typically have a 1.5—2.0x equivalency factor; with compact digital cameras, just look for an equivalent focal length).

Here are some rough guidelines to help you in deciding what focal length you will need for a particular type of wildlife photography.

200mm – This is the minimum focal length for practical wildlife photography. It will work with larger animals in areas where they are used to people (though it can be dangerous to use with animals like bears and bison because it encourages you to get too close) and can be used in a photo blind in some situations.

American toad, Minnesota.

300-400mm – This is a good all-around focal length for wildlife. This size lens is large enough to magnify a wary animal onto your sensor, and you can purchase models that won't require a loan against your house or a truck to transport them (big telephoto lenses can be expensive and heavy). A number of compact digital cameras include these focal length equivalents in a very affordable little camera.

500-800mm – These are focal lengths that the pros use for some of the wildest animals. These are mostly large and pricey lenses, but if this type of photography is important to you, you have to consider them. These focal lengths are also important for certain types of bird photography.

White-tail doe, Minnesota.

finding wildlife

To photograph animals, you have to find them first. This is not always an easy task. There are always places, however, where animals have become accustomed to people and give you the chance to photograph them more easily. Wildlife refuges, parks, beaches, feeding areas, and other natural places of congregation are all great things to look for. Some of the great locations like this are wildlife and photographer magnets, such as Yellowstone National Park (Wyoming), Ding Darling National Wildlife Refuge (Florida), Bosque del Apache National Wildlife Refuge (New Mexico), and others.

You don't have to make long trips, though. There are almost always wildlife places near everyone in the U.S. that have truly wild animals. The U.S. National Wildlife Refuge System is an amazing group of areas managed specifically for wildlife, and they are everywhere across the country. Most cities have parks with wildlife that is accustomed to people. Check a map for parks and refuges. Contact park rangers for ideas. They are out in the parks all the time and know what animals can be found where. They also give great advice about when wildlife endemic to the park is active, what routes animals travel, when they feed, and places to go for good shots.

Hint: Zoos are a good place to try out new gear, compose shots, and observe wildlife behavior. They are never a substitute for wild conditions because of the limitations of captivity on an animal, but zoos can help you learn a lot about animals and have some fun trying out wildlife photography techniques.

easy wildlife

There are some animals and wildlife situations that can be helpful for the beginner who wants to get good wildlife shots.

Acclimated Birds

Many wild birds co-exist with people at certain locations and become acclimated to that contact. City parks, such as Central Park in New York City, hold an amazing number of animals that don't seem to care about the people around them (though they really do pay attention; get too close or move too fast and you'll find that out). Many cities have the common mallard ducks and Canadian geese in city lakes, but these birds often attract other birds to come to the water with them, so look beyond the obvious subjects. Lake and ocean beaches often attract shorebirds familiar with people.

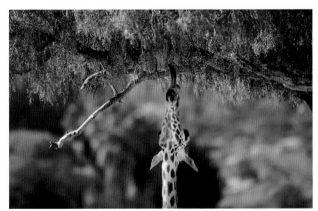

A giraffe at the San Diego Wild Animal Park.

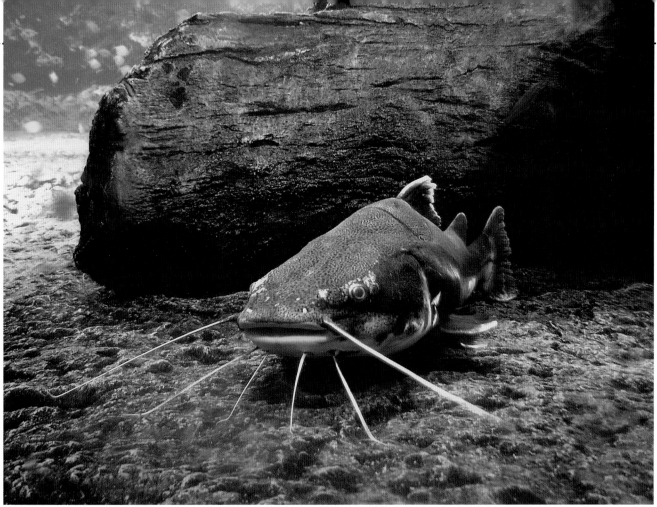

A catfish in a public aquarium.

Bird Feeders

Set up a bird feeder outside of your home to meet and photograph the resident birds and small mammals of your area. You can place feeders near windows so you can photograph from inside. (It helps to string soft, lightweight objects over the window; they blow in the wind and help keep birds from crashing into the glass.) Try placing some strategic branches near the feeders. The birds will use them as perches, making them perfect spots for a photograph.

Nature Centers

Most large urban areas have nature centers of some sort. These locations offer trails, boardwalks, feeding stations, blinds, and more that will help you see and photograph many types of animals in your area. If the center has a water spot, you will even find congregations of migrating waterfowl in the spring and fall. Because these places protect animals and have a lot of people going through them, the animals tend to be very comfortable with photographers.

National Parks

In many of the popular national parks, such as Yellowstone and Great Smoky Mountains National Park, a whole range of wildlife is accustom to the crowds. These animals know they are safe, and they will feed, graze, go through mating calls, and other behavior not far from main roads. It is important to realize that all these animals are wild and to treat them with respect. There are many stories of photographers harassing bears or bison and getting badly hurt. Check with the rangers on where animals can be found and their suggestions for safe photography.

Food

If you know where animals eat, plan to be at a location before they are. Set up your camera and tripod there, and wait for them to arrive. You can find out about wildlife food locations from observation and from the people working in parks and refuges. A little research on any animal in your area can uncover foods they like and where they eat.

Water

Water is a key part of all wildlife. In areas where water is scarce, a water hole is an animal magnet. Animals will stop by the water source throughout the day, especially toward the early morning and evening. Even in areas with abundant water, the water itself is an attraction. Animals want water access away from dense vegetation where predators can hide, and they want water of a depth that is usable; a small bird is not going to bathe along a steep bank (the bathing is awkward and they are vulnerable to attack from a fish).

Another thing about water is wildlife in the water is less wary of the wildlife on shore. Animals on the water can see those from afar not hidden by obstacles.

Edges

Animals love edges. While some will strike boldly across an open field, as a whole, animals will work the edges. Scientists have found that most wildlife is found along edges of habitats: the edge between a meadow and a forest, the edge of prairie and rocky cliffs, the edge of water and land, and so forth. They use the edges for movement, safety, and feeding. Look along the ground and in the air; both terrestrial and airborne animals work the edges.

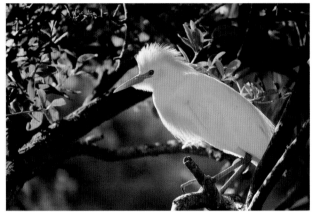

Cattle egret, Florida.

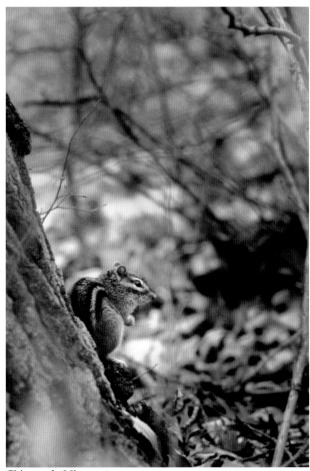

Chipmunk, Minnesota.

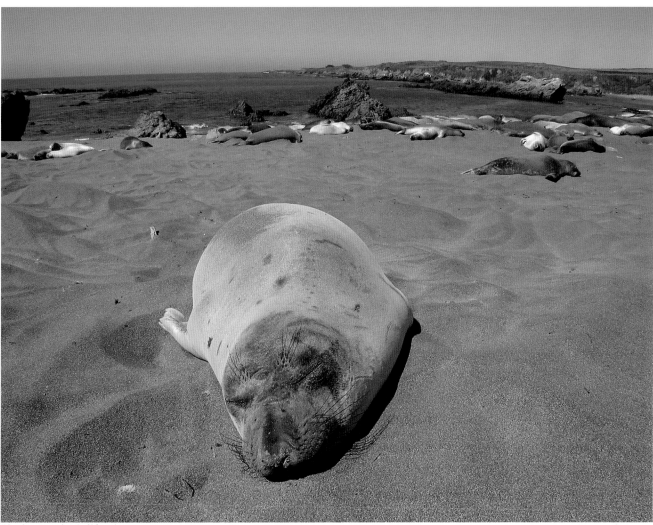

Elephant seals, California.

Regular Paths

Animals are creatures of habit. They take the same paths again and again to and from feeding or sleeping areas, and use them at consistent times. These can be visible paths along the ground, such as deer trails, or simply regular routes along the edge of a field, in the water, or in the air. If you scout an area for wildlife and spot animals of interest, watch to see if they are following a distinct route. This can be a place to come back to at the same time on another day.

Perches

Many birds use the same perches again and again. Use binoculars to scan an area for places where birds can sit above the vegetation: stumps, old trees, tall shrubs, fence posts, and signs. Watch for birds in these locations. You can hike near the site, set up at a comfortable distance, sit down, and wait. Depending on the bird and local conditions, sooner or later, the bird will come back.

From left: egret and young, Florida; cricket frog, Minnesota.

wildlife behavior 101

Masters of wildlife photography have studied their subjects. They know how their subjects behave. What do they eat? Where do they go for food? How do seasons affect them? When are they active? What things influence mating and having young? All of this can be extremely helpful in knowing where an animal will be and what it will do, which will influence how the animal can be photographed.

Obviously, we can't get into extensive detail on the habits of any animal in this book, but there are some things you should know right away that can help you make better photographs of wildlife.

Flight Distance

Animals have an invisible circle of attention around them. If you are outside of that circle, they are relaxed and go about their normal business. If you get near that circle, their behavior changes. They become more alert and stop doing whatever they were doing. Once you cross that circle, the animals take off, flying, running, or otherwise moving rapidly away, hence "flight distance." An animal does not know if you are a predator or not, so this flight distance is a safety mechanism.

The flight distance is not fixed. A white-tailed deer not used to people might bolt when you are hundreds of yards away. An acclimated deer might tolerate an approach of less than 100 feet. In addition, a relaxed animal being approached by a cautious photographer will let that person get much closer than someone less careful.

Key Senses

Animals use their senses differently to stay alert for danger. If you have an idea of what is most important for an animal, you can adjust how you approach them. All animals are sensitive to movement. Even animals with poor eyesight will notice obvious or fast movements. Birds use their eyes as the primary way of checking out their environment. They have superb eyesight, often far better than ours, and are very visually aware of what is going on in their world.

Mammals, on the other hand, mostly have poor eyesight compared to us, but have superb hearing and smell. They pay attention to the slightest sound differences around them. Their ears can tell you when they get nervous and start really paying attention. Many birds have a good sense of hearing, but rarely match that of a mammal.

Mammals also have an excellent sense of smell. In some animals, this sense is far past our understanding. You can tell a smell has caught an animal's attention when it lifts its head and nose to smell the air.

Green heron, Minnesota.

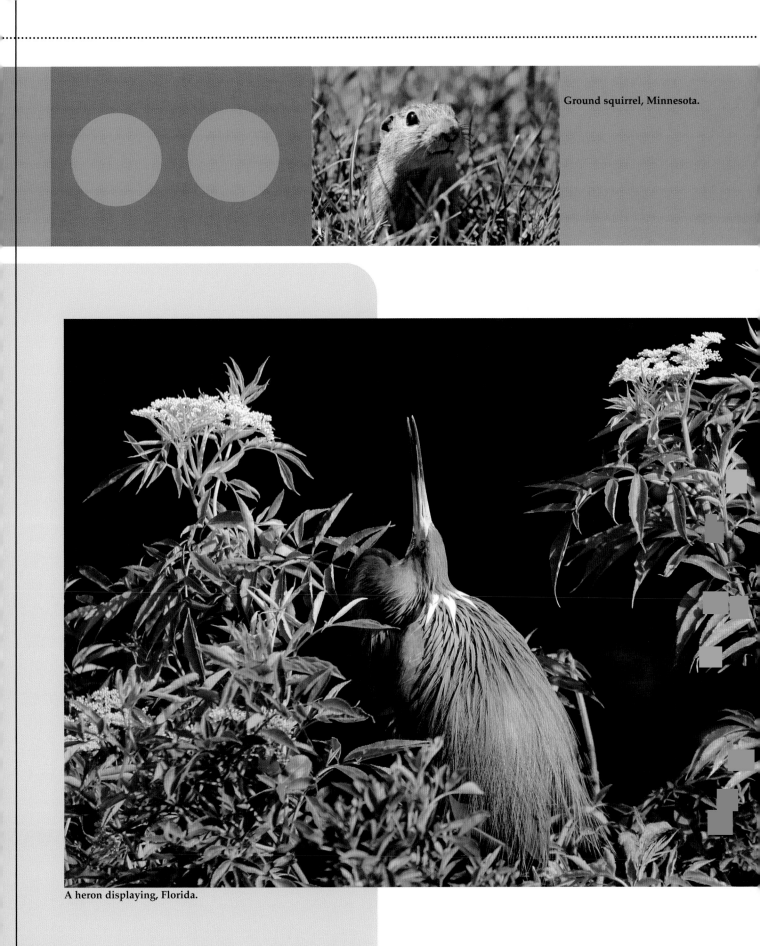

Ground squirrel, Minnesota.

A heron displaying, Florida.

Tree frog, Florida.

Hint: Bring along a monopod. This makes it much easier to pause while stalking, so you can keep the camera high without wearing your arms out since the monopod supports your gear. You can also use it as a support staff when there is rough footing.

key stalking techniques

Stalking is a key technique for getting close to animals. It simply means stealthily moving closer to your subject, without scaring it, until you are in range for the photo. Stalking is challenging and not for the impatient, but good practitioners can get very close to wildlife.

There are a number of things you can do to become a better stalker, but one thing is sure: stalking will teach you to accept failure. Animals can be very unpredictable, and may decide you are too close well before you are ready to take the picture. Start taking pictures early and throughout the stalk so you get something for your efforts.

Be Prepared

When you head toward an animal, be sure your camera is out, the right lens on, the proper focal length chosen for a zoom, the exposure set, and so forth. When you are in position to take a picture of your subject, you can then do it instantly. Keep your camera and lens close to your face. Then you only have to move your camera a short distance to your eye. Some of the advanced digital zoom cameras with tilting LCDs and long zoom focal lengths can be very helpful as you can keep them below your eyes, see as you move, and still see what the camera is seeing at all times.

Tri-colored heron, Florida.

Beach crab, Bonaire.

How to Move

Move slowly without any sudden movements. Your movement needs to be like that of a nonpredatory animal, like a deer or a cow. Watch a cow feeding. It moves a little, stops, eats, and moves again. It usually doesn't move in a straight line.

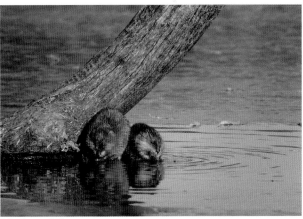
Muskrats, Minnesota.

A little blue heron, Florida.

Young cottontail rabbit, Minnesota.

To a wild animal, the only thing that moves in a straight line towards it is a predator. Wander slowly, making progress toward your subject, but not in a straight line. Stop and pretend to deal with some business around your feet. It can be surprising how much closer this approach will get you to an animal.

As you move in, don't stare at your subject or keep your big lens pointed directly at it. Again, a predator looking for food is the only thing that usually stares at an animal, and this is something you don't want the subject to think about. Avert your eyes, looking directly at your subject irregularly, especially with birds. They have extremely good eyesight and know if you are staring at them or not.

Island lizard, Bonaire.

Caspian tern, Florida.

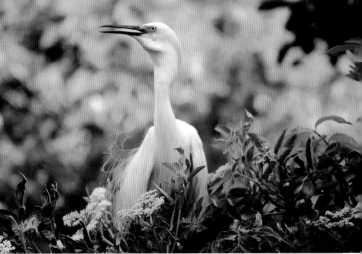
Snowy egret, Florida.

Watch the attention of the animal as you move. If it looks away or puts its head down to move, you can often move quickly into a closer position.

Move in anticipation of any animals' movement. If you see a group of ducks feeding along the shore, move quickly inland from them and take up a position along the shore ahead of their movement and wait for them. Or maybe you see a deer grazing along the edge of a field while you are driving a country road. Drive farther up to where the field edge crosses the road and start your stalk from there.

Watch Your Silhouette

The human silhouette is easily recognized by most wildlife. Anything you can do to blend into the surroundings can help. Avoid clothes that contrast with the environment. Camouflage clothing can be a good investment for the serious wildlife photographer, but it isn't a necessity. Khaki clothing, or something similar, can help you blend into many environments.

No matter what you are wearing, it will do you no good if you show your shape against the sky. Plan your approach to your subject so that you do not cross a rise that will put you in silhouette against the sky. It can help to keep a tree or other large object behind you as you move, just to break up your shape. If you do have to go against the sky, keep low and minimize the human silhouette.

Red eft, Tennessee.

Be Aware of Smells

If you want to get closer to a mammal, you need to pay attention to the wind direction and plan your movements so you close in on a mammal downwind from it. Birds usually pay little attention to smells.

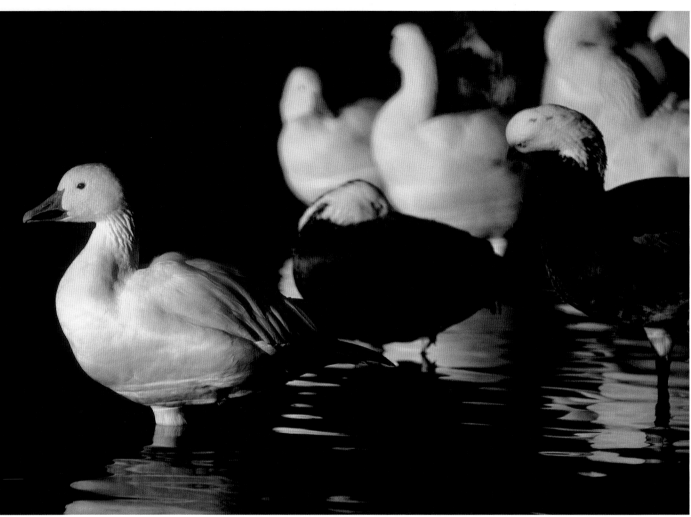

Snow and blue geese, Minnesota.

Keep Quiet

All animals are sensitive to sound. Watch the route to your subject and try to plan it to keep noise to a minimum. Walking through green grass, for example, will get you closer than trying to get through downed branches. If the ground has too much noisy stuff on it, move slowly and watch how you plant your feet. The extra slowness can't hurt the stalking.

Stillness

As you are actively stalking, you are not keeping still. But often you will find that if you get a certain distance to your subject, then notice that they are aware of you and beginning to act nervous, you can just stop, sit down, and wait. Often the animals will get used to you and relax again.

Boat Stalking

Water animals watch things on shore or below the water, but they don't tend to be bothered as much by slow moving boats, kayaks, and canoes. In general, water animals' flight distance is smaller if you approach them by water. To stalk by water, pay attention to wind and animal movements, and use that to move into photographing position. Move slowly, even using the wind to bring you to the right spot.

using blinds

Blinds are a key part of most professional wildlife photographers' work. They are simply something that hides the photographer and gear from view of wildlife. You don't have to be a pro to use blind techniques, and they can be an excellent tool for helping anyone get better wildlife photographs. You can buy a blind for a lot less money than a new lens, and speaking from experience, sitting in a blind while an animal moves close to you is an amazing experience, even if you don't get a great shot.

You can use many things for a blind, from on-location materials to specially made camouflaged tent-blinds. Before looking at options, know the basics of using a blind, because this will affect your choice. Blinds cannot be randomly placed. You need to know where animals congregate and place the blind there. This means doing some scouting of an area. Blinds can be situated alongside game trails, specific flight paths, and near food and watering holes.

Blinds should be placed so prevailing winds don't blow your scent over animals that could be spooked by smells. They should fit into the landscape as much as possible, allowing animals to get used to them faster.

Use existing materials for blinds. Often, you can use things that animals are already used to; wood piles, a group of bushes, farm implements, or buildings near feeding areas.

Use your car. In many wildlife refuges, a car is seen as non-threatening and wildlife pays little attention to it. It can help to use a window mount for your camera to be ready to shoot. Be sure to turn off your engine, and do not stop and step out of the car.

Use camouflage. A simple and portable blind is camouflage fabric you can drape over yourself and your camera. You still need to set up near natural objects to block your silhouette. There are special blind coverings that are specially made for photographers and hunters that fit like oversized clothing and roll up for portability.

Tent-like structures. You can buy a number of tent-like structures that are either made to be blinds or act as one. Blinds usually have zippered or tied windows for gear as well as observation ports. They are often made of camouflage material so that animals get used to them faster. These structures can be quite wind resistant, so be sure you stake them down. Also, they can be people magnets, so find places where you will not be disturbed.

Permanent structures. If you have access to a location that is frequented by animals you like to photograph, you could make a permanent blind out of wood. This can be especially helpful in areas where the weather is bad, as the structure can be totally wind and rainproof. There are permanent blinds in many wildlife refuges and nature center areas that are worth checking out.

Wildlife familiar with people and man-made structures will get used to blinds quickly. You may find some animals will shy off of temporary blinds, such as camouflage cover over you, if your shape is too different than what they expect at that location. Pros will often build or put up a blind days before they actually plan to use it so that animals get accustomed to it.

ethics

Wild animals must be treated with respect. Sometimes over-excited photographers will inadvertently harass wildlife, which stresses the animals unnecessarily and makes photographing them harder for everyone. Pay attention to the animals' behavior. Watch when they get nervous or jumpy. If they keep

From left: mated Canadian geese on muskrat house; photographer in a portable blind.

running from you, back off and leave them alone.

Taking a picture of an animal is not particularly stressful to it as long as you don't press the animal past its comfort zone. You do need to be careful of animals with young and nests. Do not disturb the surroundings of a nest in order to photograph it. Photographers have been known to cut down offending branches and even nearby trees for a better shot, but this opens up the nest to predators.

Under no circumstances should either you or the wildlife subject be put into danger. Pay attention to the animal's body language to ensure its safety and your own.

key gear – getting the wildlife shot

Gaining magnification from a telephoto is a necessity for wildlife photography. There are a number of ways to deal with the necessary gear.

Telephoto size – The physical size of a telephoto lens can strongly affect you and your photography. Compare two 300mm lenses. One is big and heavy, the other light and much smaller. One costs three times the other. The size and price of telephotos comes from the maximum f/stop used. The big and heavy 300mm will be a f/2.8 lens, the lighter model will be f/4. On a long lens, increasing the maximum aperture requires a big increase in glass size. This makes the manufacturing more difficult, too, so the lens goes up dramatically in price.

High speed lenses, like the 300mm f/2.8, used to be more important than they are today for pros. Slow color films meant that you needed every last bit of light in order to get every little bit of faster shutter speed you could. Today's D-SLRs have excellent quality at ISO settings above 100 (a setting of 200 would allow a 300mm f/4 lens to match an f/2.8 lens in shutter speed if the latter used 100). This is a real benefit for photographers because it means really big, fast lenses are no longer a necessity.

Telephoto zooms – Telephoto zooms are an excellent option for the wildlife photographer. They offer a range of focal lengths in a compact package that is easily transported. Image quality is excellent. A zoom can match a single-focal length lens in quality and usability. Many zooms now feature high-quality low-dispersion glass (a technology that really improves the image quality images taken with telephoto focal lengths). Zooms can have one problem: small maximum f/stops. It's not unusual for the wider part of the zoom to have an okay, though not remarkable, maximum f/stop that then shrinks to an f/stop that can make low light work harder as the focal length increases.

D-SLRs and telephotos – Most D-SLRs have a sensor that is smaller than 35mm film. This means that telephoto focal lengths for 35mm size sensors (called full-frame sensors) will be framed differently on the small-format cameras. The smaller sensors see a smaller part of the focal length's coverage, effectively magnifying the subject in the composition and viewfinder. This is a real benefit for wildlife photography since you can use smaller lenses to get the same magnification effects of the larger lenses used by photographers with 35mm sensor size.

Small digital cameras with big zooms – One interesting trend in the small digital zoom camera is the incorporation of very long zoom ranges – offering 35mm equivalent focal lengths to 300mm, 400mm, and more – in a compact camera and lens. These lenses are specially designed for the camera, optimizing the optical path, plus they frequently have high-quality special lens elements like low-dispersion glass and aspheric elements and may even have image stabilization technology to minimize problems from camera shake. You can get a very high quality wildlife camera and lens at a quite reasonable price in an extremely portable size.

Technology – Computer-aided design allows companies to develop smaller, better lenses, add in computer-aided manufacturing, and lower the price. Low-dispersion glass elements (SD, ED, SLD glass) are a tremendous help in creating sharper, more color accurate lenses, and were once the province of high-priced lenses. That's no longer true. Aspheric lenses, a necessity for wide-to-telephoto zooms, were way too costly to make years ago. Now they are made for even low priced cameras. Internal focusing and quiet, high-speed AF motors make even large lenses autofocus faster. Lens stabilization technologies allow you to handhold telephotos at slower shutter speeds. A very big benefit for wildlife photographers is that they allow you to use lighter tripods that might be unsteady without it. Diffraction optics let manufacturers make shorter, lighter lenses of the same focal lengths.

Tele-extenders – Tele-extenders, as discussed on page 135, are an optical device that fits between camera and lens to increase the focal length and magnification of the original lens. They mostly come in 1.4x and 2.0x strengths. You do lose light, one f/stop for the 1.4x and two for the 2.0x. In addition, they tend to work best with single focal length lenses. On some zooms, quality can be very poor. Still, the price, quality, and convenience of a tele-extender can be well worth the investment if you buy quality tele-extenders made specifically for your lenses.

Extension tubes – These can also be very helpful in the larger sizes when used with telephoto lenses. See page 135 for more information.

Digiscoping – Digiscoping has become a very popular way for birdwatchers to photograph birds, and does have application for the wildlife photographer. Digiscoping is simply the use of a spotting scope with a small digital camera. Spotting scopes from companies like Leica, Nikon, and Swarovski can have adapters attached that hold a small digital camera and can offer excellent image quality with very high magnification.

Tripod heads – Tripods were discussed in detail on page 36. Everything said there about the tripod itself applies to wildlife. However, wildlife photographed with long telephoto lenses can be difficult with a ball head or pan-and-tilt head. Serious wildlife photographers like heads that are specifically designed for moving large lenses around smoothly. Gimbled heads (such as the Wimberly head) are very popular, as are medium-sized fluid tripod heads made for video camcorders.

1. Set your autofocus early (beginner) – Your camera needs time to find the animal, lock focus, and track it. Hold the shutter release button down to start autofocusing as the animal approaches, follow the animal as it moves, and squeeze the shutter when you like the shot.

2. Use binoculars (intermediate) – A compact pair of binoculars can be a tremendous asset for photographing wildlife. It is much easier to use them than the telephoto lens on your camera for watching an animal at a distance.

3. Note wind direction with birds (advanced) – Many birds will take off into the wind because it is easier and faster for them to get airborne. This can help you position yourself in anticipation of their movement.

4. Practice panning (beginner)– Flying shots of animals can be a lot of fun to try, but following a moving animal with a camera and lens, panning, can be extremely challenging. Practice by photographing things that you can control, like a running dog.

5. Sight over a powerful telephoto to find the animal (intermediate) – If you have a long telephoto focal length, you may have trouble finding your subject with it. Take your eye away from the viewfinder, sight over the camera and lens, and point the camera so the lens appears to be aimed right at the animal. Often, you'll find you've got the animal dead-on in the viewfinder.

6. Learn to use a wildlife call (advanced) – Many wildlife predators are attracted by certain sounds of a dying animal, which wildlife calls mimic. If you are well camouflaged (or in a blind) and downwind of likely approaches, you may find foxes, coyotes, and bobcats will come to a call. Duck calls can also be used to help waterfowl become comfortable with your blind.

7. Use a lens hood (beginner) – If you are stalking an animal, or even just hiking with camera at the ready, keep a lens hood on the lens. You never know which direction relative to the sun you will shoot with an unpredictable animal, so the hood will minimize lens flare. The hood will also keep branches, rocks, brush, and long grass from hitting your lens as you bring it quickly to your eye.

8. Get to know game wardens, rangers, and park naturalists (all) – These folks are outside all the time and know their wildlife. They love the outdoors and know good places and times to look for animals. They can save you a lot of time and trouble finding animals, give you advice on how to best photograph specific species, and let you know if there are regulations that could affect your shooting.

9. Shoot for the gesture (advanced) – Look for moments where the animal is doing more than just standing there. Watch for gesture – a tilt of the head, a lean to the posture, a change in the look of the eyes or ears, a special moment as the animal walks, runs, or flies. Gesture is just like watching and photographing people – the best images are those that show a person more animated and caught in an interesting gesture.

10. Get up early (all) – Wildlife is active at dawn. The day is cooler, night animals are returning home, day animals leaving, and crepuscular wildlife is at its most active. In areas where there are a lot of people, dawn is a time of few people to disturb the animals. Lakes are devoid of boats and national parks have few of the regular tourists. A great deal of wildlife movement occurs then. Dusk is another peak wildlife time, though in people-popular areas, this will be a time when people are still out and about and are, likely to spook your subjects.

Connections — Territories

This chapter actually includes quite a bit about the nature of wildlife since photographing them requires this knowledge. You can drive through the Grand Canyon and step out at any overlook and get a landscape photo of some sort. And if you see an accessible flower, you will have no problems photographing it. Wildlife is a different story. If you want to photograph white-tailed deer, you need to know where they live, how they live, what they eat, and so forth, to be successful.

One aspect of wildlife that I always find fascinating, and that also affects photography, is territory. Animals have very specific territories, or ranges, that they live in, based on a number of factors. These include microclimate conditions, habitat, the influence of man, the distribution of favorite plants, the availability of nesting or birthing areas, and even habits (certain groups of animals will habitually use specific trails and sleep locations, for example).

While all animals have territories that they range through (places they visit through their daily lives), some are extremely territorial and set up very specific boundaries for their living space, defending that space quite dramatically. During breeding and nesting season, birds can be especially territorial. I have had terns and red-winged blackbirds dive-bomb me as I walked along a marsh. You wouldn't think a little bird like a red-winged blackbird could do much, but I still remember such a bird that knocked the hat off of a ranger I knew, then dove again, hitting him on the head and drawing blood! The need to defend territory can be very strong indeed.

This helps anyone who wants to observe animals, however, because even small critters like dragonflies will set up and patrol a territory. Once you find animals in a location, there is a good possibility that you will find them there again (as long as it is not migration time).

White pelicans, Minnesota.

© Heather Angel

© Heather Angel

curious mind for wildlife, heather angel

Heather Angel is a globe-trotting nature photographer based in England and world-renowned for her wildlife and macro work. She is probably the best known female wildlife photographer, a profession dominated by men, but Angel has proven that strong images with a naturalist's eye will beat down sexist barriers.

Angel's long interest in nature led her first to become a biologist (including getting a master's degree in marine biology). She got into photography by taking pictures of marine life she was studying and this led to her life-long career in nature photography.

Heather Angel: A biology degree is by no means a pre-requisite to being a wildlife photographer. However, with hindsight I would say my biological background has been a huge asset to me in so many ways. My biology education has proven invaluable in knowing where to find subjects, how to identify them and for weaving background information into the text of my books and articles.

But nowadays, in-depth studies on the biology and behavior of animals are no longer taught. When I employ biology graduates today, few know much about the way of life and natural history of animals – even in their own country. Yet, on the other side of the coin, the high quality

wildlife/nature television documentaries are far superior to anything which appeared when I was a child.

I have a curious mind that is fascinated by how animals live, how they fit into the food pyramid. For that reason, I will tackle a huge range of subjects – anything from a water flea to a whale. For many of my trips in the past, I adopted a generic, rather than a specific, approach to my photography because this gave me a better chance of recouping my expenses by being able to write a variety of articles on different topics about a remote location.

In recent years, however, I have invested a lot of time working on a charismatic animal – the giant panda. Five trips to China, specifically to take photographs of pandas, has resulted in two books on pandas and countless articles. By using everything from wide-angle to macro to telephoto lenses, I can vary the pace in an article or a book even when focusing on a single subject.

Face-to-face shots of mammals appeal for posters and covers, which bring in the bucks, but I would be bored stiff adopting this approach all the time. It is the surprising and unexpected shots which draw the eye – such as a panda sliding down a snowy slope with all four legs in the air. Looking for all the world like an upturned table, this is far and away my best selling panda shot.

I like sharing my experiences in nature photography through articles, books and workshops. I enjoy teaching and giving something back to photography which has played such a large part of my life for so many years. Sometimes, students' questions can even spark ideas for articles and books. I even weave some biology into my workshops, notably at my annual plant photography workshop at Kew Gardens in London and also as part of the photography module I teach to biology students at Nottingham University.

© Heather Angel

© Heather Angel

© Heather Angel

Some folks need their confidence boosting on a one-to-one basis, which is not possible at a lecture with a huge audience. This is why I like doing small-scale workshops, too. Also, women can relate better to another woman who has made it, even with a family. This I discovered when I co-tutored a Women's Conference at Yellowstone some years ago.

In all my classes and workshops, I stress an approach that encourages learning about your subject and respecting it. Every aspiring wildlife photographers needs to keep these things in mind:

a) Always put the subject first, NO photo is worth risking the welfare of any animal. Getting up close with a wide-angle may make for drama but it may also stress an animal.

b) When nothing seems to be happening remember patience, patience, patience, pays off in the long run. The more hours you invest out in the field, the better

© Heather Angel

© Heather Angel

your eyes will become attuned to animal behavior, so you will be able to predict their actions.

c) Now that travel to far-flung parts of the world is easy, the world is awash with penguin, lion and elephant images. You need to develop your own style and seek animals that have not received so much attention.

I do believe that any wildlife photographer who cares about conservation – and no-one should call themselves a pro wildlife photographer if they adopt a cavalier attitude about it – should be prepared to help by donating some images to a cause they feel is worth supporting. I certainly do this.

Finally, I have to say that digital has revolutionized the way I work. When I am taking high-speed action that is impossible to compose, I keep shooting until I get what I want and delete the other shots. If a client wants something quickly which is in season, I can shoot it and get it up

on my website within a matter of hours – or if it is in our garden – in minutes.

The downside of digital is it is very easy for some photographers to "enhance" their nature pictures to create biological untruths. I have no qualms with composite images of animals appearing in absurd situations being used for advertising, but I do object to false naturalistic images being used for editorial purposes. We have all seen images of wall-to-wall zebras without a single blade of grass. Yet, however dense the herd, in reality this does not happen.

Not content with a mother and one baby? No problem, let's add another baby. When such a picture is circu-

lated of a mother panda with "twin" cubs alongside the same mother with her single cub, not unnaturally designers or editors pick the twins, because two youngsters look cuter than one. Once published, the photo perpetuates the myth that panda mothers always raise two cubs (they may give birth to two, but very rarely raise both). A genuine wildlife photographer who knows and understands nature would never contemplate such falsehoods, but cowboys wanting a fast buck simply don't care.

You can see more of Heather Angel's work at www.heatherangel.co.uk and www.naturalvisions.co.uk.

© Heather Angel

9 close-up

If you really want to explore the magic of nature photography, you have to consider close-ups. Close-ups let you explore a world of life that is not regularly seen by the average person. Most folks go blithely past explosions of life in their yards, alongside the road, or even in a garden. Photographers who find that life in a picture can show off images that will surprise and delight their viewer just because the subject matter is largely unseen. But this is not the best part of close-ups.

Kodak did research on how photographers took pictures, and found that among the millions of photographs going through photo labs, very few were of subjects photographed closer than two feet from the camera. If nothing else, taking close-ups will give you a set of photographs that will stand out from the crowd, bringing in oohs and aahs without having to travel to far-off places. But that is still not the best part of close-ups.

Close-up photography is easier than ever. Even the least expensive of digital cameras have a close-up setting, macro lenses are affordable, and almost every zoom lens has close-focusing settings. But even this is not the best part of close-ups.

The best part of close-up photography is that, for the lover of nature and photography, close-up photography is always possible, any place, any time, and any season. There are always bits of nature that can be photographed – a weed patch offers amazing colors and forms, a rock outcropping in close focus shows off abstract patterns that could hang in the Museum of Modern Art, a frosty window in the depth of winter brings close-up delight to cabin-fevered northerners, a nocturnal orbweaver spider offers opportunities to test your flash technique while observing a true wonder of nature, and so it goes.

This is very exciting, because it means nature photography is always possible. You do not need weeks off to photograph the bears of Katmai (that's exciting, yes, but not practical for most of us), and you don't have to worry that you can't get to the Grand Canyon or other distant location (go there, yes, but you don't have to wait until that trip to get great nature photos). Opportunities are yours, just for learning to photograph the close-up. For more information on close-up photography, I recommend another book in this series from Lark Books— The Magic of Digital Close-Up Photography by Joseph Meehan.

Left to right: grass seed head; immature lubber grasshoppers; Florida; lichens, Utah.

new worlds to explore

Flowers, wildlife, and landscapes are the big subjects that everyone wants to photograph, but close-ups bring you into contact with new subjects and worlds of nature. This can be exciting in and of itself. Sure, the adrenaline will start flowing if you are near a bull elephant, but most people aren't going to have that opportunity. On the other hand, I can guarantee some excitement if you focus your close-up gear on busy bumblebees working a bed of flowers. If you are allergic to bee stings, you don't want to chance that, but bumblebees will rarely bother a curious photographer. Still, being that close to them will get the adrenaline flowing.

Close-ups are like that, showing you details of worlds that are microcosms of the bigger places we all know. Close in on a carpet of the common hair-cap moss and you'll see forests and jungles of dense vegetation. Move in on a spider web and you may witness a life-and-death struggle akin to a lion kill on the Serengeti Plain. Magnify a rock surface and you may discover jewels worthy of a king.

These truly are new worlds because you gain access to spaces you cannot physically go. You will see places and events there that the average person cannot experience, except through your photography. You can even explore images of nature that few photographers have. Millions of people have

photographs of the Grand Canyon. A far fewer number have photographed a grasshopper-killing wasp, or the amazing abstracts of crustose lichens. You may not care for these subjects, but there is such an abundance of possibilities with close-up subjects that if you put the close-up gear on your camera and start exploring, I guarantee you will find intriguing compositions and subjects.

the rules change

Once you start photographing close-up, you will quickly discover things are not quite the same as they are for normal distance subjects. This is not about finding new worlds and subjects. I am talking about the way photography technically works up close. For some photographers, this is disturbing, throwing their thought processes out of balance. But for others, this is exciting. It makes photography reinvigorating. Open yourself up to the changes that occur with this photography, and you will discover that all of your photography is affected, and for the better.

Focus

The first thing that changes is focus. Focus is critical up close, and the closer you get, the truer this is. If you photograph a mountain, your actual focus point is basically "far away" and little else matters. If you capture a waterfall at a moderate distance, you need to be sure the camera is focused on the waterfall, but beyond that, it usually doesn't matter. Focus on a grasshopper up close and personal, and if you miss focus by a fraction of an inch, the photo will change from perfect to a throw-away. If you focus on the stamens of a flower and miss the tips, the photograph will look like a mistake.

We're talking small fractions of an inch. When you are at true macro distances where a tiny subject is filling the viewfinder, even a slight puff of air can knock the subject out of focus in the time it takes between focusing and pressing the shutter.

Now, there are some things you can do to help:

1. Take your camera off autofocus (AF) – Autofocus is a tremendous technological achievement and serves photographers very well, indeed, but not in close-up photography. Autofocus will often find the wrong thing to focus on when you are up close. It may have trouble focusing at all on your subject, preferring instead to make things behind your subject sharp (any photographer who has used AF with close-ups will know this by experience). Autofocus will also frequently keep searching for the right thing to lock onto. Manual focus lets you lock the focus on a specific thing.

2. Move your camera to focus – Once you've manually focused to the distance desired, move your camera to and from the subject to get the optimum focus point. You do have to be careful, obviously, because it can cause enough camera movement to make your photo blurry. Still, it is worth the effort because it is so much easier to get the right point in focus this way.

3. Choose your focal point carefully – As you move the camera, watch what goes in and out of focus. Each shift in sharpness will usually change the photo dramatically. It often helps to take multiple exposures, even trying different focal points just to ensure you get something focused right. A digital camera can really help you to be sure you got sharpness where you need it (magnify the image in the LCD).

Hint: A macro-focusing rail can help you move your camera into focus when using a tripod. These tripod accessories attach to the tripod head and usually feature a geared rail for the camera that moves with a knob control. Some focusing rails have a second rail at right angles to the first that let you also position the camera left to right.

Blood flower milkweed detail.

Depth of Field

Similar to focus changes, depth of field also affects what is sharp and unsharp in the close-up. Depth of field is, as discussed earlier, the amount of sharpness in depth from front to back in a photo. However, up close, the amount of sharpness in depth is measured as shallow, shallower, and even more shallow. Depth of field is a distinct challenge.

In addition, most lenses have what is called a diffraction effect that affects sharpness up close. Small lens openings will diffract light, making sharp areas less sharp. This is why most lenses are at their peak sharpness in the middle range of f/stops. Small lens openings don't hurt most photos at a distance. If they did, lens manufacturers would get rid of them (which is exactly why you don't see very small f/stop settings like f/16 or f/22 on small digital cameras).

Up close is a different story. As you get to macro distances, an f/16 or f/22 setting can drop image quality significantly on most lenses except for macro lenses (which may still show the effect). Using very small f/stops for more depth of field may not be an option. Basically, you often have to live with a certain amount of unsharpness in close-ups.

Here's how to deal with that:

1. Be sure of your focus – This goes back to the last section on focus. Since depth of field is very narrow, you must be sure you have it where you want it.

2. Work the contrast – It can be photographically interesting to contrast your in-focus subject with a distinctly out-of-focus background.

3. Be sure that what should be sharp, is sharp – That means using higher shutter speeds, higher ISO settings, or electronic flash. Soft images due to slow shutter speeds that can't stop camera or subject movement are disappointing. It is better to have something very sharp in a limited area than everything soft all over.

4. Watch the subject plane – If you can, point your camera at the subject so that the critical subject plane (that should be sharp) parallels your camera back. This keeps the prime area of focus on your subject.

Baton rouge lichens, Florida.

Dew on raspberry leaf, Maine.

Crablike spiny orbweaver, Florida.

Puffballs, California.

Cactus flower.

Light

Light does not really change up close, but how you deal with it definitely does. If you read the flower chapter, you have some ideas on modifying light to get better flower photos. With all close-ups, modifying the light is a key technique, so you can also use those ideas here. But let's look more specifically at light on the close-up.

Close-ups deal with very small areas, but if you think about that, this means you can easily change the light on those areas. The only way to change the light on a mountain is to shoot at a different time; the only way to change the light on an animal is to be patient and hope it moves. But with close-ups, you can quickly shoot sun or shade, for example, just by the position of your body. That can actually be frustrating when the best angle to your subject means you cast an ugly shadow into the picture.

The good news is that you don't have to accept the light on your subject if that light causes you problems. The first thing you can do is move your position to change the angle of the light on your subject, changing it quickly from front to side to back light. Also, shift your position to gain a new contrast in the background from the light.

If those don't do enough, it is time to modify the light. Block the sun completely by having someone cast shade on your subject or by putting up anything in the sun's path to your composition. Shade can be a much nicer light on many subjects. You can also put a diffuser into that light path. Anything, from a white shower curtain that is cut to fit your bag to small diffusers made specifically for this purpose, will work. Diffused light is highly effective for many types of close-ups.

Trying adding your own light. In a forest, this is as simple as using a reflector to redirect sunlight onto your subject. In any situation, adding light may mean using a portable flash. Flash is a very important addition to any close-up photographer's gear. It is a very controllable light. It can move any-

Hint: Telephoto lenses can be helpful in dealing with low-angled light that puts your own shadow on your subject. By backing up with such a lens, you can keep the same composition and have space that lets you move enough to get your shadow out of the picture.

where with the right cords and accessories, making it front, side, or backlight in an instant. It is easily diffused or reflected to change the quality of the light.

Flash gives another great advantage to the close-up photographer. It makes sharp photos. There are several reasons for this: first, flash has an extremely short duration in the thousandths or ten thousandths of a second, stopping any camera movement; and second, flash up close is almost always powerful enough to let you use any f/stop you want.

Flash is consistent. Once you set up a close-up flash system, you can count on it delivering the same results again and again. This can be a great advantage for certain subjects, especially insects that are constantly moving. On the other hand, that consistency can be a problem when photos taken with a flash system look monotonously the same, photo after photo. This can be avoided with systems that allow you to change the position of the flash or flash heads.

Flash does have disadvantages. The light is not natural, which means the existing light conditions, good or bad, will be lost. Flash also falls off quickly so that a close-up subject can be perfect in exposure, but the background dead black. Finally, flash systems can be heavy, bulky, and awkward to handle in the field, especially if they unbalance the camera.

close-up subjects

Flower Details: Sensuous Color

Let's look at specific close-up subjects and how you might work with them. We went into some detail on flowers as a specific and popular subject on their own in Chapter 7. But it can be fun to go beyond photographing flowers as whole flowers. By getting really close, you can focus in on incredible details, structures, and patterns that most people miss.

In addition, we all know flowers can have amazing color. On a pure scientific level, these colors have evolved to attract insects. But for us, the colors are far more than bug magnets. Look close into a bright flower and you can almost feel the color. It becomes a sensuous experience.

You can capture this experience in an image, but you can't do it by approaching flower photography literally. The way to do it is to use your camera's close-up capabilities and get right into the flowers. Use a wide lens opening, like f/2.8 or f/4, and start shooting literally right through the flowers with this limited depth of field. A telephoto focal length can increase the effect.

This technique turns the flowers closest to your lens turn into beautiful swaths of out-of-focus color. Find something interesting to focus on, but let everything else go soft. You have to experiment by moving around and having your lens look through different groups of flowers. You will start seeing all sorts of color forms and shapes contrasted with the sharp part of your photo.

These photos are a lot of fun to do. They become pictures of color, not the flower. You can be as realistic or abstract as you want – it largely depends on what you have in focus. You can find a complete flower for the focus point and surround it with color, or you can forget that amount of realism and just go for maximum color effect.

Bugs: Drama, Action, and Hollywood Effects

Many people are uncomfortable with insects, and even the most serious, all-nature-loving photographer has to have some sympathy for that. A few insects bite, several transmit diseases, and the idea of one crawling on your skin can give almost anyone the shivers.

Yet, insects are hugely important to the natural world and human life. There are more species of insects than all other animals combined. They are key parts of every ecosystem on our planet. Without insects, most flowers would no longer exist because they would not be pollinated in order to produce seeds. A huge number of birds would cease to exist without their food source. Without insects, we would have no honey or fruit. Very few insects actually cause us problems.

Across the top: crab spider eating bee in mules ear flower, Wyoming; damselfly, Utah; tiger swallowtail butterfly, North Carolina; land snail, California; katydid, Florida.

Catalina snapdragon, California.

No matter how you feel about insects and their relatives, they offer some of the most dramatic, action-filled nature photography that can be found anywhere, plus you get to see creatures up close and personal with amazing shapes, colors, and designs that even Hollywood's aliens cannot match. Insect photography offers a sense of adventure and contact with truly wild creatures.

Photographers find insects amazing subjects. Butterflies bring us beautiful colors and shapes, dragonflies are like flying jewels, ladybird beetles (ladybugs) are a joy to discover, cicadas stun us with their life cycles, caterpillars offer wonderful, slow-moving subjects, and the list goes on.

Insect relatives are great subjects, too. Spider webs are architectural and engineering feats, and many spiders have color patterns and shapes that absolutely amaze people when they take time to observe.

Fall leaves, New York.

Dragonfly, New York.

Starfish and barnacles, California.

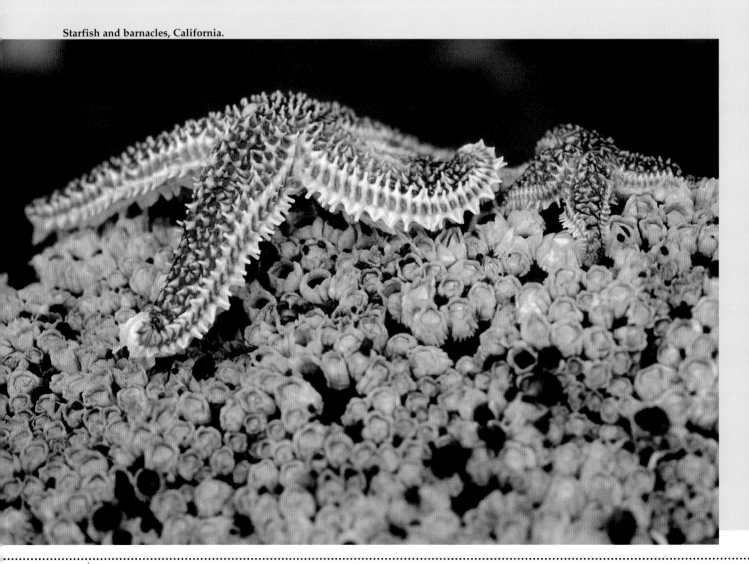

Photographing Insects and Their Relatives

Much of what we discussed about photographing wildlife applies, believe it or not, to insects. Plus there are some things that apply mainly to the little critters.

Here are some things to consider when photographing insects.

1. The need for magnification– Bugs don't always let you get close, so having a telephoto with extension tubes or a macro telephoto lens can be a great help.

2. Location, location, location– Not just a mantra for real estate, this thought will help you find insects. While they do "live everywhere," they tend to be more highly concentrated in certain locations. Like all animals, insects need food and shelter. Any place that has different kinds of plants will have many kinds of insects. Flowers are a great place to look for insects. There will be insects feeding on the leaves, pollen, nectar, and other insects.

3. Silhouette– A person silhouetted against the sky spooks insects as well as wildlife. While only a few insects have really outstanding eyesight, almost all have an excellent ability to discern a moving shape against the sky. Watch your back to see what you are contrasting with.

4. Movement– There is no animal of any kind that associates rapid movement with safety. Move quickly and you are like a predator – the bugs will leave. Many insects are very sensitive to movement, so move slowly and deliberately.

5. Vibration– Insects and their kin are, as a whole, very attune to vibrations. They sense heavy footfalls on bouncy soil (this can be transmitted through plants) and will often bolt the instant they feel a bump. You have to be careful how you move into position, making sure not to bump things.

6. Flight distance– Insects that have good vision have a definite flight distance. They act the same as wildlife, getting nervous as you approach, then flying, hiding, or dropping to the ground and looking for shelter. You can affect this distance by how you move in toward the bug.

7. Time of day– Since insects are basically the same temperature as the air (with some exceptions), they are most active in warmer weather. Really active bugs on a warm summer day can be very frustrating to photograph. Early morning is a great time to photograph insects and their kin. Lower temperatures and dew on them and their surroundings will slow them down.

Moss and Lichens

Moss and lichens are two entirely different sorts of organisms, even though they get mixed up (reindeer moss is actually a lichen). Both have growth forms that fit them tight against rocks as well as loose-growing ground structures that can rise several inches high. They grow from the ground to the tops of trees and from deserts to mountaintops.

Moss is a primitive plant, always some shade of green, and favors moister conditions. Lichens are a combination organism made up of a fungus and algae, and are technically no longer considered part of the plant kingdom. (Biologists gave up the two-tier kingdom idea of just plants and animals long ago.) Lichens can live in deserts and include a great variety of colors, though they are mostly gray, gray-green, orange, and red.

So why photograph them? Get to their level with a close-focusing lens, and you'll quickly see why. Mosses and lichens grab hold of your compositional senses and keep you looking for photograph after photograph. Mosses are incredibly textured carpets offering great opportunities for photographs that emphasize design. Other mosses will remind you of jungle forests when you get close, though the perspective is quite a bit different because of limited depth of field.

Lichens, on the other hand, give you amazing abstract patterns when you find the crustose varieties growing on rocks and trees (these grow like a hard crust with no height). Sidelight is ideal for shooting lichens. Foliose types (leaf-like) stay close to their substrate, offering a whole different set of radiating patterns if you look closely.

Probably the most spectacular lichens for the photographer are the fruticose type. These have long stems that lift the "plant" body well above the ground or rocks where they live. They have excellent shapes and forms that are well worth examining in close-up. Reindeer moss is a fruticose lichen, and has wonderful mounds of blue-gray growth. Another is the British soldier lichen, with its red fruiting bodies lifted high on gray stalks.

Water is very important for these organisms, even for the lichens in the desert. Water brings both mosses and lichens to life, enriching the moss greens, livening up the lichen colors of orange, red, and others. For some, constant water and humidity is critical, which is why mosses grow so well in temperate rain forests or near waterfalls, though some lichens need humid conditions, too (especially the hair-like versions that hang from trees along the west coast).

Moss and lichens don't move much from the wind, making them perfect for using a tripod. It is ideal for your tripod to have a removable center column, as you can position your camera right down to the ground. This makes shooting at smaller f/stops and very slow shutter speeds no problem.

Blood flower milkweed.

Red maple and blueberry leaves, Maine.

Rocks, Shells, and Other Hard Nature Objects

Rocks, shells, bark, fossils, and more are often at their very best when examined up close, making them ideal subjects for close-up photography. These subjects make great photographs when you concentrate on textures and patterns.

Texture is mainly affected by light. Sidelight will always make texture pop. Strong textures will take away from color patterns, so you don't always want sidelight. It works well when appropriate, but can be distracting if you want to see the colors.

Patterns are a compositional concern. Photographing the patterns on these subjects is easy. But patterns alone can be boring. It is helpful to include something that contrasts with the pattern and gives your eye something to relate to. What that contrast is will depend entirely on your subject and its surroundings. There is a very famous photograph by Eliot Porter of a pattern of clamshells near the ocean in Maine where wild rose petals have fallen – it offers a great color and textural contrast.

Here are some ideas to get you started. If you look around, you will always find ways to break up a pattern and get a better composition.

• Find a section of the pattern that deviates from the rest, such as a rock detail that includes a place where the rock form shifted.

• Look for a color that contrasts, such as a fall leaf on the bark of a tree.

• Use size contrast, such as a large shell amongst many small ones.

• Find movement in the composition that contrasts with the pattern, such as a vein in a rock that has an angle against the texture of the rest of the rock.

Detail of quartz veins in coastal rocks, Southern California.

Jellyfish on the California coast.

Shells on the East Florida coast near West Palm Beach.

key gear – getting close

In chapter 7, we discussed ideas for close-up photography, including a complete rundown on the gear you can use. Refer back to page 134 for specifics on close-up gear, especially as everything said there applies to this chapter.

Flash: When you add flash to your close-up gear, you extend your possibilities dramatically. Flash was once intimidating, but with automatic through-the-lens (TTL) systems, flash is a valuable part of every nature photographer's close-up kit. You can use any built-in flash to start.

For more power and control, you need a separate, external flash unit plus a dedicated flash cord. The cord is a simple accessory – just a connection between camera and flash that allows both to communicate to each other for proper exposure and more. With this cord, you can hold the flash at different positions relative to your subject. You can move it left, right, top, and bottom, giving your close-up a different look each time.

Another advantage of a corded flash is that you can do something called "feathering" if the flash is too strong. Sometimes a big flash is too strong, so instead of pointing it directly at the subject, point it a little off from the subject so only the edge of the light hits it. You can also point the flash completely away from the subject to brighten a background and not affect the subject.

> **Hint:** Aiming your flash at your subject can be a challenge. You can solve this by using a special flash bracket to hold your flash in position (most camera stores have them), by having a companion hold it for you, or by simply handholding it. Put your index finger on top of the flash. Point your finger at the subject and the flash is pointed there, too.

When buying an accessory flash for close-ups, you do not need the biggest, most powerful flash because it will generally be very close to the subject. You can often get away with a compact, easily carried unit that is also less expensive. On the other hand, it is true that the biggest, most powerful flash for a given camera is often the one with the most features. If you need a certain feature, such as a swivel head for indoor use, be sure the flash you are considering offers it. A powerful flash can offer you additional capabilities for filling in dark shadows in other types of nature photography, if that is important to you.

Wireless capabilities for flash are extremely useful. These allow you to set off a flash that is not connected to your camera (though you will need a camera-connected flash as a controller, even if it is built-in). With a wireless remote flash, you can put the unit anywhere in relation to your subject without worrying if a cord is in the way. You can also usually use more than one flash, giving you the chance to have a backlight and a fill light or a main light and a background light on your subject.

Ring flash and twin flash units fit right around your lens to get the light right in by the subject. While ring flashes are popular with dentists and fashion photographers (strange, but true), they are a little too flat in their light, for my taste, in close-ups since the light comes from around the lens as a very direct, frontal light. Twin flashes use two small, repositionable units on a ring attachment around

the lens. They can be moved for best light and their intensity varied to allow better light on the subject.

Telephotos for Close-Ups: A telephoto lens magnifies your subject at a distance, letting you get close-ups without you having to get close to the subject. This can be important if the subject is flighty, if it bites or stings, or if you keep shading your subject because your lens and camera are so close to it. If you find you experience these challenges a lot, you might look into a telephoto macro lens. Otherwise, a set of extension tubes is probably the best accessory to have with you as they will let any telephoto or zoom lens focus closer. An achromatic close-up lens sized for your telephoto or zoom can also get quality close-ups.

Wide-Angles for Close-Ups: Most photographers don't think of wide-angles for close-up work. Years ago, there were wide-angle macro lenses, but they haven't been on the market for a long time. Wide-angle lenses change your perspective and depth of field as described earlier. You can get amazing shots of close-up subjects with a wide-angle focal length. Use a short extension tube with a wide-angle lens or zoom to help it focus closer (even moderate-sized extension tubes rarely work). There are a few wide-angle lenses that focus close normally. A very easy way to make wide-angle close-ups is to use a compact digital camera. These cameras often have close-focusing settings that only work with the wide-angle part of their zooms, plus many allow the use of achromatic close-up lenses that give high-quality results at any focal length.

1. Try a beanbag (all)— Beanbags are a great way to support a camera when you need to get it low, such as photographing moss on the ground. You can get small ones that easily fit in your camera bag. Push the camera into the beanbag's softness for support and minimal movement.

2. Close-up seeing (all)— Many years ago I had a workshop with the great photographer, Ernst Haas. He gave us a tremendous exercise to better see the photo possibilities around us. Go to a spot of nature – a garden, an empty lot, or a park – and arbitrarily pick a small area (20 x 20 feet is good). Spend an hour there finding close-ups. Most people get bored after about ten minutes, but then are forced to look and find that in reality, one hour just gets them started.

3. Use a polarizer for rocks (beginner)— Rock colors and patterns can be easily diminished by sky reflections that dull the rock – you won't actually see sky reflected except for the color. A polarizing filter will allow you to remove those reflections. Put it on and rotate it until the colors of the rock look their best.

4. Use a round-the-lens reflector (intermediate)— Take a piece of white cardboard and cut a hole exactly the size of your lens. Put this over your lens when you shoot backlit close-ups. The white cardboard will act as a reflector, kicking light into the shadows. You can also buy these types of reflectors.

5. Use your hand as a clamp (beginner)— Since close-ups mean you are getting so close to your subject that the area seen by the camera is small, it is easy to use your hand to grab a wind-blown flower to steady it or pull it into focus and not see your hand in the photo. You can also purchase specially made flower clamps that attach to your tripod.

6. Use a waist-level finder (intermediate)— You can purchase a waist-level finder for most D-SLRs that will allow you to get your camera lower to the ground without having to smash your face into the soil. Another option is to use a high-quality, compact digital zoom camera with a swivel LCD. It allows you to use the camera at all angles and still see what the lens sees.

7. Temper your built-in flash (beginner)— To use a built-in camera flash for close-ups, you need to temper it. Few cameras are set up to give a good exposure for flash when used at very close-focusing distances, and the flash itself may be aimed poorly for such use. Put any kind of diffusing material over the flash to cut its light and make the light better for close-ups. You can use a piece of white cloth, translucent plastic, or even natural materials (I once used a cluster of white flowers).

8. Use continuous shooting for better focus (intermediate)— If your subject moves, you may find it difficult to get the precise focus you need. Put your camera on continuous shooting and hold the shutter down for a burst of shots as you work to find focus. You will almost always find that at least one of these shots will be perfectly focused.

9. Balance your flash (advanced)— If your flash completely overpowers the existing light, the photo may be dramatic, but the shadows may be too dark and the background black. Choose a camera setting that will balance your flash to the existing light so that some of the light from the sky, for example, will fill in the shadows. Unfortunately, camera manufacturers have not chosen a consistent way of doing this, so you will have to check your manual for more information.

10. Corral your insect subject (all)— Use the sensitivity of insects to your advantage when an insect moves away from you to the other side of a stem. Reach out and move a hand over there, or have a companion move to that side, and the insect will usually move over to where you are.

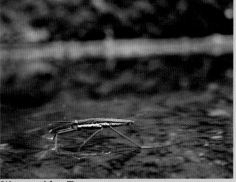
Water strider, Tennessee.

Connections – Little Stuff

The big stuff in nature is really what catches our attention first. A spider's web is a pretty impressive architectural feat, but put it in Yosemite, and it won't be what makes everyone stop and take notice. A bumblebee always looks like it defies the laws of gravity when it flies, yet a hawk riding up air currents as it migrates along Lake Superior will actually gather a crowd. A carpenter bee is a fascinating and important part of life in the Great Smokies, but it will be ignored when a black bear is spotted down the trail.

Yet on every level, it is the small stuff that really makes nature function. According to Piotr Naskrecki, author/photographer of the marvelous book, *The Smaller Majority*, 99% of all animal life visible to the naked eye is made up of creatures smaller, on average, than a human finger. It has been estimated that there may be 20 – 30 million distinct species of arthropods (creatures without backbones including insects, spiders, and centipedes) in the world, and 10 quintillion insects (this is 10 with 18 zeros behind it) are alive at any given time. This is an amazing amount of life that is always around us, ready to be recognized and appreciated for its contribution to the world.

One reason they do so well is because they are small. In a single tree, you can find dozens of species (perhaps hundreds in the tropics) because they fill in the very small microclimates, from the dark, damp soil around the tree roots, to the protected cavities in the bark, to the wind-blown and exposed leaves at the top of a tree.

How do these little creatures contribute? Our world is made up of very intricate systems of deeply inter-related and interconnected elements that start with energy from the sun. These systems are so tightly structured that even the most advanced computers cannot mimic them. We can see all the little pieces, from mosquitoes to bats, but we only see glimpses of how they all fit together. If a little critter is a keystone of a local habitat, we might not recognize that until it is gone and the habitat deteriorates.

The little things in our world tend to be overlooked by people who want to exploit nature, yet they are exceptionally important in the overall scheme of things. I don't believe that life on our planet is random. It is connected in complex ways that are not fully comprehended by man.

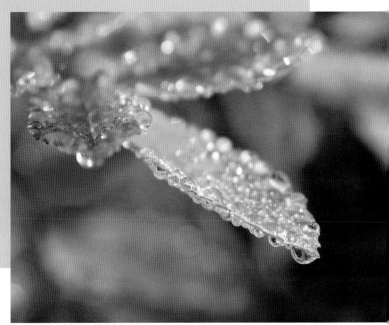
Dew on wild rose leaf, Maine.

10 special techniques

Photography is part art and part science and technology. Since the beginnings of photography, pressing the technology to make the art better has been a constant part of the craft. Today is no different, as digital photography offers new approaches to old techniques, resulting in new possibilities for all photography, not just nature photography.

This chapter covers three special photographic techniques that are a great benefit for the nature photographer and can further his or her quest to capture the magic of nature in a photograph. These are not "new" techniques, nor are they esoteric techniques that only few can deal with. In fact, two of them have been with photography since the beginning.

What puts black-and-white, panoramic, and infrared photography into the special technique chapter is that none are the common technologies that everyone uses to photograph nature. Black and white, once the only way to photograph, was dominant in photography until the 1970s. It nearly disappeared in the 1980s and 1990s when everyone was shooting color. It has staged a renaissance with renewed interest from many photographers, and is now seen as a specialty.

Panoramic photography has been around, believe it or not, almost since the beginning of photography. Many people think multi-shot panoramics are new because of digital techniques, yet early photographers from the 1850s had already made such images in their darkrooms. It has never been easy to do until digital. Panoramics are a great way of photographing nature, but for most people, they do represent a special technique.

Infrared photography has long held a special fascination with nature photographers "in the know," but was always difficult, espically when shooting film. A curious side effect of digital photography has been true infrared photography. It is curious because digital camera sensors were inherently sensitive to infrared, but digital camera engineers and designers tried to remove this sensitivity. When photographers discovered infrared worked beautifully with digital, they started "destroying" cameras to make the infrared work!

Panoramic in Arches National Park, Utah.

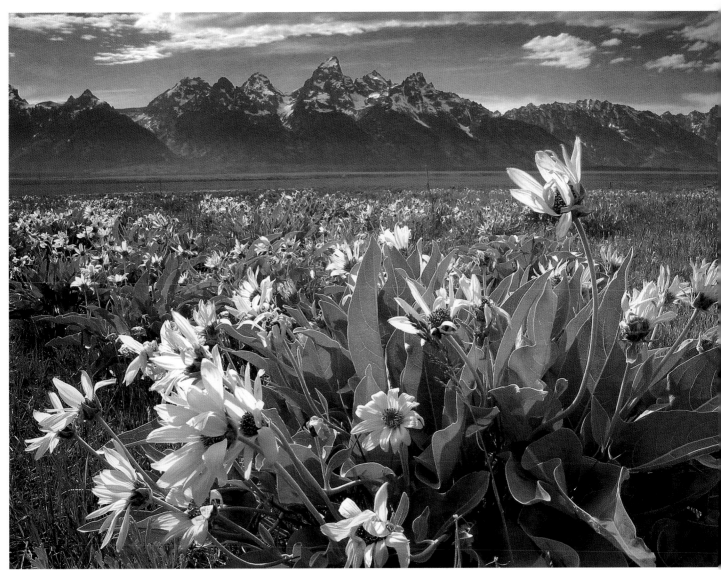

Black-and-white photo of mules ear flowers in Grand Teton National Park, Wyoming (compare to the image in color on page 133).

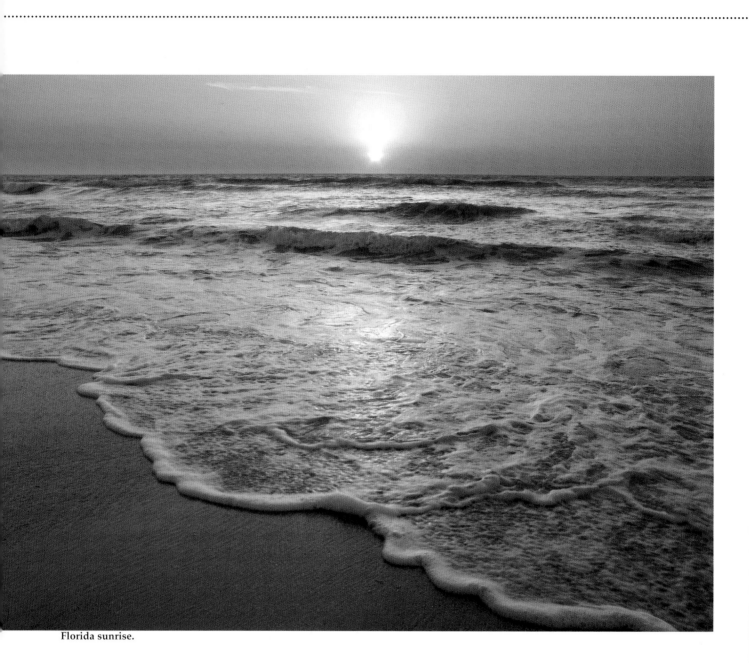

Florida sunrise.

black and white

In the early history of photography, photographers
wanted color but had to settle for black and white.
However, it seemed that nature demanded color.
Nature was filled with sunsets, flowers, blue sky,
and spring greens. Still, photographic technology
only allowed black and white. Photographers found
ways to get the most from it, working the tonalities
of their subjects until scenes looked great in just
black and white.

Foggy mountain scene in California.

When color became available and inexpensive, black and white became an endangered technology, though there were still photographers passionate about its possibilities. Black and white now has new popularity and it is often seen as a very "artistic" way of photographing.

You can do some wonderful things with natural subjects when you shoot in black and white. But black and white is not simply a photograph without colors. You cannot take pictures the same way you do with color as when you are shooting black and white. It demands a different way of seeing. This can make you see subjects in ways that you might not have thought about when shooting color, and can translate into better color photography, too.

Black and white is an abstract way of seeing the world, even if the photo itself is totally real. When color is gone, our reaction to the subject changes. We see it more graphically, which is also different from how we see the world.

Rangers buttons flowers in Eastern Sierras, California.

It's in the Tonalities

Tonalities, the differences in brightness in a subject, are the key to black-and-white photography. You must train yourself to see them and ignore the color. Color is distracting when you are first learning to shoot black and white. Colors mislead you so that the subject looks better than it does in just grays, or the color makes your subject stand out from its surroundings, but in black and white, the subject just looks bland.

A big mistake comes when you simply change your digital camera to black and white and photograph as you always do. The black-and-white images may be interesting for their novelty, but you will not get the most out of the medium.

Here are some things to look for to help you see tonalities for black-and-white nature photography.

• Look for brightness contrasts – Look for ways to make your subject and its surroundings contrast with each other. Find a flower in sunlight, for example, and contrast it against shade.

• Watch for same-tone brightness – If your subject or part of your subject is the same brightness as its background, it will blend in. This is why heavy gray days can be a real problem when photographing nature in black and white because so much of a scene will be the same gray.

• Look for subject tonal contrasts – Find a dark tree in a field of light gray grass to give your composition strength. Look for bright leaves that might contrast with darker leaves around them.

• Red and green can be a problem – In black and white, red and green often take on the same shade of gray. They look so very different in front of you because red and green represent a strong color contrast, but they blend together in black and white.

• Look for light that spotlights your subject – Anytime the light makes a subject strongly contrast with its background, this will make the same thing happen in both black and white and color.

• Use the black-and-white setting – Many digital cameras, even inexpensive ones, have a black-and-white setting. Use the camera to experiment, photographing all sorts of things in black and white, then immediately compare the results on the LCD monitor to what you see in front of you. This shows exactly how a scene will translate into black and white.

Black-and-White Skies

Skies can be a real problem in black and white. The blue often records as light gray, making the sky weak and hiding clouds. This can be frustrating for the photographer who likes what the scene looks like below the sky in black and white, but not the sky itself. There are several solutions.

• Avoid the sky – Sometimes you just have to keep the sky out of the photograph. At the most, you can keep a little sliver of sky up at the top of the frame to define the edge of a landscape.

• Use the sky for silhouettes – A dramatic use of black and white is to photograph a subject completely against a sky, exposing to keep the subject dark and the sky bright. This works well with such subjects as wildlife or trees.

• Use a polarizer – A polarizing filter will darken skies, but mainly when you are shooting at 90° to the sun. The effect falls off to zero as you point your camera toward or away from the sun.

• Use a graduated filter – A graduated filter can bring some tone into the sky, though you may find it sometimes makes the sky look dingy.

• Use a black-and-white filter – Colored filters used for black and white are a great way to intensify a sky. Black-and-white landscape photographers rarely photograph their scenes without such filters.

Filters Specifically for Black and White

Because colors don't always translate properly into black and white, special filters are available that change the tonalities of colors, even to the extent of making red look as different from green in black and white as it does in color. These filters are strong, solid colors that affect how the sensor sees tonalities.

The key to understanding these filters is that like colors stay bright and opposite colors get dark. In practical use, you choose a color filter based on what you want lighter or darker in the scene. If you want a lighter subject in relationship to everything else, choose a filter color that is the same as the subject. If you want a darker background, then choose a filter that is a very different color than the background. You will understand this quickly once you start using the filters. Here are three common black-and-white filters and how they work to affect colors.

Yellow – Long a mainstay of the black-and-white photographer, this relatively light filter has a moderate, but distinctive effect on the scene. Yellow flowers will stay bright, while the blue sky will get a bit darker. For most nature scenes, a yellow filter will strengthen the black-and-white contrasts in a very natural way.

Green – Anyone who photographs lots of trees and other foliage needs this filter. It makes green leaves lighter in tone compared to the rest of the scene. It will usually darken a blue sky slightly because of the yellow component in green. Red flowers will get dark, as will red fall foliage. This is an immediate way of making red and green different in tones. But the main use of the green filter is for any subject with lots of green foliage. It will give that part of the scene a rich tonality.

Red – Red is the filter of drama. It makes skies deep and rich in tone, strongly contrasting them with clouds. It will give most scenes more contrast if the sun is out and the sky is mostly clear. It keeps warm light from the sun lighter and darkens the shadows that are lit with blue light from the sky. It makes red flowers and foliage light in tone, and turns green foliage dark.

Rock formations and junipers in Arches National Park, Utah.

Red oak leaf, New York (compare to color image on page 177).

Converting Color Digitally

There are advantages to shooting black-and-white images in black and white right from the start. First, you can see on the LCD what the subject looks like in black and white and determine if you need to do something different in the photograph. Second, shooting black and white from the start means less processing. You can immediately have prints made.

But there are some advantages to shooting color for black and white, then converting it into black and white in the computer. Consider these benefits.

• You will have both a color and black-and-white image. If you decide you want a color image later and you have only shot it in black and white, you are out of luck.

Snowy panoramic in Wasatch Mountains, Utah.

• You can change your filtration of the color scene digitally for optimum black-and-white tonalities. In the computer, you can instantly go through the effects of a yellow, green, red, or any color filter at all. You are not stuck with what happened when you shot the image.

• You can easily use multiple digital filters on a single image. It is not as easy to use more than one black-and-white filter when shooting in the field.

There are several ways to convert your color photos into excellent black-and-white images in the computer. Most image processing programs offer this capability, from Photoshop to Paint Shop Pro. They all work, but not in the same way.

Grayscale or Desaturate – An easy command that instantly removes the color from your photo. Sometimes it works okay, but for most nature scenes, I think you will find it is a weak way of conversion.

Split channels – The RGB channels of your photo are actually three very different black-and-white representations of your picture. Sometimes you can simply choose one channel and get rid of the rest to emphasize its grayscale interpretation of the scene. Some programs let you split channels so that they show up as different grayscale images.

Channel Mixer – Adobe Photoshop's Channel Mixer is a great way to make an image look its best in black and white, but it takes some practice to get used to it. Check the monochrome box, then move the sliders around on the channels to change how the colors in your photo are translated into grayscale tones. You can think of the sliders like filters – red will lighten reds and darken blues, green will lighten greens and darken reds, blue will lighten blues and darken reds. As sliders are changed relative to each other, tonalities will change. If the number for each color adds up to 100, the photo will stay the same overall brightness. Higher numbers make the image lighter; lower numbers, darker.

Plug-ins – So-called Photoshop plug-ins are available to simplify color conversion to black and white and give you excellent flexibility. Color Efex from nik Multimedia includes three excellent black-and-white conversion tools, for example, that really offer you a lot of control and flexibility over your conversion of color to black and white.

Multiple "filter" conversion – Often you will have a scene that needs two different filter effects to get the best conversion to black and white. The sky might look best with a red filter, but the forest below looks much better with a green filter. You can do both in the computer. You can do it in two ways: selections or layers. With selections, you select part of the photograph and convert it to black and white using the Channel Mixer or a plug-in. Then select the other part and change it in a different way. If your selections weren't perfect, just do a Grayscale or Desaturate command to the whole image to remove the color where your selections didn't catch it. This will only affect the color parts

For layers, use the same process, but isolate each change to a layer. For example, adjust the sky's tonalities on one layer and block the effects on the rest of the layer with a layer mask. On another layer, you adjust the ground tonalities and block its effects from other parts of the photo. You can actually do this with as many areas as you want. This can be a very effective way of converting a bright flower surrounded by green foliage. You can make the foliage look great on a layer, then remove that effect over the flowers with a layer mask. Then you work to make the flowers look their best and isolate that effect to the flowers.

1. Watch the light – No matter what your subject is, no matter how dramatic it seems in person, it is totally the light that will make it work in black and white. Look for the angle or time of day that the light does good things to your subject's tonalities.

2. Look for black-and-white contrast – Colors are not your friend when shooting in black and white. You have to look for contrast that is separate from color, contrast based on black-and-white tones.

3. Expose for the shadows and midtones – Black-and-white images generally look their best when you can see good detail in the midtones and something other than a black hole in the dark shadows. Underexposure as a rule is detrimental to good black-and-white photos.

4. Look for the dramatic – You don't have to have dramatic contrasts and shapes in every black-and-white photo you take, but black and white responds so well to such drama that you should be regularly looking for it.

5. Try photographing the shadows – Shadows can be great subjects in and of themselves with black and white. Look for scenes that have strong shadow shapes that can be plainly seen against something simple that enhances, not competes, with the shadows.

Oak leaf in rocks, New York (compare to color image on page 66).

Rio Grande River and sky in New Mexico.

Desert scene, Anza Borrego State Park, California.

Panoramic scene of goldfield and California poppy flowers, dramatic sky, California.

the really
big scene – the panoramic

Note: We'll see that panoramics can be shot in both horizontal and vertical formats. I'm using the term "wide scene" to simplify the discussion, not to limit the scope of panoramic images.

The wide, panoramic image has fascinated photographers and viewers since photography began. The earliest photographers shot multiple images across a scene and either blended them together in the darkroom or printed the shots separately, overlapped them, and pasted the images together in a sort of panoramic collage. Later, big panoramic cameras were developed that took very wide photos onto a long roll of film.

Today, you can shoot panoramic photos in two ways: photograph a wide scene complete in itself using a camera specially made for panoramic photography, or take multiple standard photographs across a wide scene and combine them in the computer.

You can also crop a standard photograph into a panoramic format. This works especially well with medium and large format cameras because they have the extra film size that can take the cropping without losing too much quality. There are advantages and disadvantages to both single and multi-shot panoramics:

**One shot with panoramic
camera or cropping – advantages:**

- One shot completes the photograph
- No additional work is needed after processing
- Action can be easily photographed
- Panoramic composition can be seen in the viewfinder

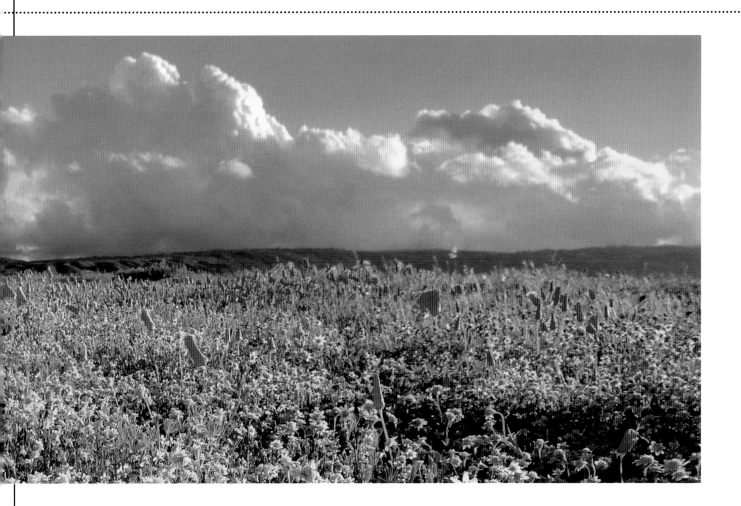

One shot with panoramic camera or cropping – disadvantages:

• Cameras are expensive

• Panoramic cameras are almost exclusively film cameras

• Cameras cannot be used for other purposes

• Cropping means less quality because you are removing pixels or film area

Multiple shot, digital technique – advantages:

• Any camera can be used (including film if you scan the results)

• Digital cameras work very well

• Technique has become easy to do; even many point-and-shoot cameras include panoramic aids

• Cameras can be used for all types of photography

• Many focal lengths can be used

Multiple shot, digital technique – disadvantages:

• It can be hard to see wide-area composition as you are building it in steps

• You have to be careful about shooting on a tripod and lining up shots

• Shooting at oblique angles (up or down) to a horizontal scene can be difficult because the images will not go together easily

•Action is difficult to capture because the scene must be photographed in multiple shots

•You have to put the images together in the computer (though there have been a very few cameras designed with this capability built into the camera itself)

Composing the Panoramic

Panoramic images require a different approach to the scene than a standard photograph. This is a whole new way of seeing. Simply putting a scene composed for a standard image into a wide composition never works. Such a photo looks just like a regular scene surrounded by too much space.

The first thing you have to do is see the scene in front of you as a strong horizontal or vertical composition. Most panoramics are horizontals; they easier to find and usually more attractive to viewers. But verticals can be very compelling, too. Think tall trees or waterfalls, for example.

Now you need to examine the scene for its potential. This is easiest with a panoramic camera because you can look through the viewfinder and see the image. You have to imagine a multi-shot panoramic put together. Can you eliminate the nonessential elements above and below the horizontal area of interest and not have the scene suffer? Or the same to the right or left for a vertical composition? This is very important to consider, as many scenes have important elements that can't be cut off.

Next, check the scene from left to right for a horizontal, or bottom to top for a vertical. You need a composition with something interesting and important at the left, then additional elements all along the scene until you reach the right side of the composition, where there still needs to be something visually important. Apply the same reasoning to a vertical. Many panoramic images fail because there is simply not enough interest throughout the composition. This doesn't mean there has to be drama throughout – good color, interesting graphic elements, or anything that keeps the eye engaged and moving across the scene is good.

If you are shooting with a dedicated panoramic camera, you simply take the photograph and have the film processed. This is it. You don't need anything more to complete the image. Shooting the multi-shot panoramic requires more effort.

Hint: You can make a panoramic composition aid from a piece of cardboard. Cut out a panoramic shape from the center of the cardboard. Now hold the cardboard in front of you, using the opening as a window. Move the aid in and out from you to cut the angle, and back-and-forth to see the best parts of the scene.

Shooting the Multi-Shot Panoramic

The panoramic purist is extremely careful in how he or she sets up the camera for a multi-shot image. There is no question that such an effort does make for images that go together better in the computer. Don't let that keep you from the magic of panoramic shooting (because it is magic). You can get good results even from casual image capturing.

Here are the basic steps for getting good panoramics from multi-image capture with a digital camera.

1. Use a tripod. While it is possible to shoot panoramics without one, a tripod helps in keeping the separate images aligned and it will help you see your composition better.

2. Level your tripod and camera. If you shoot at an angle to your scene, the images you shoot will be hard to combine in the computer. Use a level if you can.

3. Plan out your composition. Decide where the panoramic shot will go – from where on the left to where on the right.

4. Set your camera on manual. Set both exposure and white balance to specific settings. Don't use autoexposure or auto white balance. You need the individual shots to match, but autoexposure and white balance will tend to put variations into the shots. Don't use a polarizing filter, either, because it polarizes a wide scene unevenly.

5. Shoot starting from the left, then overlap your individual shots from left to right. Use at least 30% of the image for overlap. Shooting from the left just mimics the way we see and makes it easier to track your compositions.

6. If you need to bracket, bracket whole sequences, not individual shots.

Putting It Together: Once you have the images for the panoramic, you need to put them together in the computer. This is called stitching. There are two ways of doing this: software designed to automate the stitching process, or standard image processing software, such as Photoshop, to do the process manually.

Multi-shot panoramic shot with normal camera. Top three photos were combined to show off wide view of marsh at bottom. Southern California.

Wide-view close-up of Texas paintbrush flowers in Texas Hill Country.

At one time, automated stitching software was a real compromise. That is no longer true. While the traditionalists like to manually stitch images together, you can get equal results in most automated programs. The algorithms used are amazing, and in some situations, actually do a better job than the piece-by-piece work in something like Photoshop. Manual stitching, however, can be a necessity when the individual shots have not been carefully matched for exposure and overlap.

Automated stitching programs come in two types: dedicated programs designed only to stitch panoramic images, and automated parts of an image processing program. One of the best dedicated programs is ArcSoft Panorama Maker. This inexpensive program offers a set of excellent tools that automate the process as well as make the blending of individual shots work well. Adobe Photoshop and Photoshop Elements include a very good automated function in their Photomerge feature.

In an automated program, you simply bring in your photos, put them in the right order if the program can't sort them properly (usually it will), and tell the software to go to work. You usually have some ability to tweak the panoramic where individual photos haven't merged as well as others. When done, you can bring the image into Photoshop or other image processing programs and use such things as the cloning or healing tools to fix problems.

For manual blending, bring the images into a program that offers layers, and for the most efficient work, layer masks. To fully explain this is beyond the scope of this book, but there are many books available that explain the process. Here is a quick overview to help you understand how it works.

1. Open all of the images in your panoramic sequence.

2. Take the far left shot and increase the Canvas size (not the image size) to equal to the size of your final panoramic image (e.g., if each shot is 10 inches wide and you have four shots, make the canvas 40 inches wide).

3. Drag all of the other images in the sequence onto this expanded image (use the move tool and drag the image onto the expanded canvas). It works best to drag them in the order shot. In most programs, this puts each image on its own layer (which is what you want).

4. Line up all the images, overlapping them as appropriate until they match as best as possible. Turn down the opacity of a layer you are moving for overlap so you can see through it and match the underlying image. You may have to rotate the image slightly if it is perfectly aligned with the other shots.

5. Fix any non-matching images for tonality and color.

6. Start blending the overlaps. Use a layer mask to help you paint in and out each layer through the blending area. This can take some time and practice.

7. Fix any image matching problems by working each layer, one at a time.

8. Fix difficult overlaps with the clone tool.

1. Look for strong horizontal lines – A strong horizon line or other horizontal line that cuts across your panoramic from left to right can integrate it visually; this is an easy way to get a good panoramic composition. If you are shooting a vertical, look for a strong vertical line.

2. Be wary of polarizing filters – The polarizer is a great filter for landscape photography, but usually not for panoramics. This is because the sky is cannot be polarized in such a way that the color and tonality stays consistent across a panoramic scene.

3. Try composing from the outside in – This goes against the way most people start their compositions. However, it can really help ensure that your panoramic composition has interesting elements starting at the outside edges.

4. Use space in your panoramic images – Space is not the same as empty places in a composition. Space can be an important creative element for a photograph if you look for it. A good example of this would be if you created a composition with a striking tree at the left side, then a big expanse of blue sky (the space) through the middle and right side of the photo.

5. Be careful of your autofocus – When shooting a multi-shot panoramic, you may find that your camera autofocuses in the wrong places on some of the shots, ruining the effect. Either turn off the autofocus or be very aware of where the camera is focusing for each shot.

infrared digital photography

Years ago, many photo enthusiasts experimented with infrared black-and-white photography and discovered they loved the results but hated the process. Shooting with infrared film was a pain. You had to load it in the camera in a darkened room, check your camera for infrared leaks (which even perfectly good cameras often had), use a pitch black filter that you could not see through, guess on exposure, unload the camera in a darkened room, and have it specially processed.

The results were very interesting once you got them back, though. Vegetation turned white, skies were black, shadows were very dark in tone, haze disappeared from the scene, and new things were revealed. But it wasn't worth the effort for most photographers. A few even tried color infrared, but the results were too weird for most, making the effort even less inviting.

Digital changed all this. Photographers at first had no idea that the image sensors in digital camera were sensitive to infrared light. Camera engineers knew, but considered it a defect and tried to eliminate this (which did affect the quality of normal photography). Before that happened, though, some innovative photographers tried infrared shooting and discovered that a digital camera gave true infrared photographs with none of the problems of film. In addition, you could instantly see results so exposure and composi-

Infrared photo of central California hillside with live oaks on hill, willow in foreground.

tion could be corrected on the spot.

This opened up new avenues for nature photographers. It became easy to duplicate the exotic, rarely used infrared film results. Instantly, photographers gained whole new looks for common subjects. Trees became white because they strongly reflected infrared light from the sun. Skies became dark because little infrared came from them. Hazy scenes suddenly had rich contrasts because infrared light was little affected by the haze.

Shooting Infrared

While all digital camera sensors are sensitive to infrared, you can't use all digital cameras for infrared shooting. This is because camera engineers put infrared filters on the sensor to block infrared light to improve certain image quality parameters for standard photos.

You can check to see if your camera will record infrared very simply. Point a remote control at the camera, push a button on the remote, and see if a light appears on the remote control when you look at the LCD if your camera is a compact digital camera or in an image that you take if you are using a D-SLR. Many compact digital cameras (including point-and-shoots) will show this even though most D-SLRs will not.

There is an active market on e-Bay for old Minolta Dimage 5 cameras because these long-outdated digital cameras have good infrared response in a compact camera with complete photographic controls (newer versions of the Dimage advanced compacts do not record infrared). There are a few people who will modify old Canon D-SLRs and some Nikon cameras by removing the infrared filter to allow these cameras to capture infrared light (www.irdigital.net). To shoot infrared once you have a camera that sees it, follow these guidlines.

1. Buy an infrared filter for your camera and use it. These are nearly black filters that remove most light except the infrared. A red filter designed for black

5 Quick Tips for Getting the Most from Infrared

1. Watch the direction of the sun – The strongest infrared effects come when the subject is reflecting this light directly back at you from the sun. This is why most infrared photos are shot with front light.

2. Look for bright green trees – These strongly reflect infrared light and record as a dramatic white color. They can really make an infrared photo snap with life.

3. Avoid infrared shooting on heavily overcast days – You won't get much infrared light bouncing around on cloudy days and the photo will generally look just like a dull black-and-white photo.

4. Try it on hazy days – Infrared effects are not as strong on hazy days, either, but infrared shooting can give you an advantage because it cuts through the haze. It can make the scene look much less hazy than what you saw in the visible spectrum.

5. Look for blue skies with clouds – You get very strong contrasts between clouds and sky with infrared. This is a very dramatic look and can be worth including in many scenic infrared shots.

6. Process your digital infrared images in your computer – Because digital cameras are not optimized for infrared capture (even though they do it), images will often lack the tonalities that they need. Use your image processing software to be sure the blacks are black, the whites white, and contrast looks good.

and white will also work, though not as well.

2. Change the camera to black and white (if you can). The camera will record a color image with an infrared filter, but it won't really look like much in color. If you have to shoot color, the picture can be converted to black and white in the computer.

3. Use a solid tripod. Infrared filters cut the light hugely, requiring longer exposure times.

4. Experiment with exposure. Many cameras tend to underexpose infrared.

5. Work on the image normally in the computer as if you were getting the most out of a black-and-white shot.

From the top: a variety of infrared photos- a vineyard in Napa Valley, California; cottonwood near Moab, Uah; willows in Central California.

Connections – Visible and Invisible

We don't see infrared or black and white. Though many things are invisible to us, they are very real to nature. Human vision is very good, but our perception of the world misses many things that are important parts of many animals. Since we do not have the eyes of a cat or a bee, we cannot know exactly what they see, but scientists have studied the vision of animals and have a good idea of what they react to.

Few animals outside of primates seem to be able to see color to the degree that we can, though they probably do not see the world as if it were a black-and-white photo. Most likely, they see very different things than we do, largely responding to the immediate needs of their world. Many birds have extremely good eyesight. You would expect that a hawk circling high above a meadow could probably see a mouse wending its way through the grass just because that hawk will dive and catch such a mouse. Some scientists believe a hawk has a vision with eight times the acuity of human vision over small areas.

If you spend anytime outside after dark, you know immediately that many animals can "see" in the dark much better than we can or they would not be active. Some animals, such as cats, have eyes with different sensors in them compared to people, giving them the ability to see in light levels that leave us blind. Bats use high-pitched sounds to act like radar to give them a very strong "vision" of the world around them even though that is not seeing in a traditional sense.

Insects can sense a whole range of things that we can't. Bees and butterflies actually see a different spectrum than we do, being able to see ultraviolet light, and therefore, new patterns on flowers that are invisible to humans. Insect sense organs detect such things as smells that we could never smell, and temperature gradients that we don't even notice. This information has a dimensional quality to it, almost like seeing, yet it is no vision that we recognize. A mosquito, for example, can sense minute quantities of CO_2 as well as weak temperature gradients in order to find a warm mammal for blood.

That may be a part of the appeal of black-and-white and infrared photography. It shows us new visions of the world no longer limited by our senses.

composite panoramas: going to great lengths, george Lepp

I love making panoramic images for the great visual they present to the viewer. They are big, bold ways of seeing the world and give me a photograph that helps me keep the viewers interest for a longer time on the scene.

At the very beginning, a potential panoramic scene has to be viewed differently than a single capture landscape. If we aren't careful, all we'll accomplish is a long boring image that has the only benefit of being longer than usual. "Bigger is better" just doesn't cut it.

Composition is very important. To make a good panorama you need a starting point, interesting material in the middle, and an ending. If you have all of these and a technically good image on top of it, you have something special that transcends the single image landscape.

With that composition, I can get your attention at the beginning and then let you wander visually (or even physically with a large print) through the image until you finally come to the far end. Think of a large, long print in a hallway, and as you walk down that hallway, the image grabs your attention, and you linger and slowly follow the information trail to the far end. I've had your attention a lot longer than if a single smaller image was on the wall that caught your eye for only a moment and never even slowed you down.

I made my first panorama about 37 years ago. It wasn't very pretty; actually, crude is a term that comes to mind. I took a series of hand held snapshots overlooking Honolulu, Hawaii, a series that stretched from Punch Bowl Cemetery towards Honolulu. I slightly overlapped each image to capture a panorama on black-and-white film.

The 4 x 6-inch prints were later physically overlapped and glued down to a board to make an unobstructed view from the mountains behind the city, all the way around towards Pearl Harbor. It might have been rough...but it was effective, and it did work to give a dramatic view of the area not possible in any other way.

© George Lepp

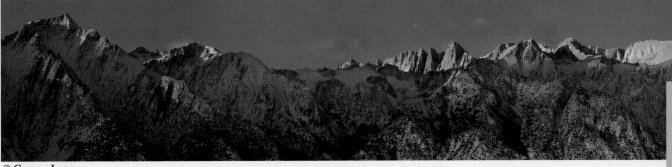

© George Lepp

I went back a few months ago with the goal of redoing that original image, but this time with the modern composite panoramic technique of making multiple shots across a scene then blending them together in the computer to make the final image. The place I originally shot from isn't available anymore, the buildings are higher and more plentiful, and my techniques have greatly improved. Yet, while the image is different, the concept is the same.

The view I saw 37 years ago spoke to me in a long horizontal scan. That's how we see most vistas. The sky doesn't hold much interest unless wonderful clouds are present, and the earth at our feet isn't often as interesting as the scene that caught our attention in the distance, so

why include them? Why not shoot with as much detail enabling quality as possible?

Here's where digital comes to the forefront. Even the negatives I shot 37 years ago could be scanned into the computer. I could match their tonal values and composite them into a greatly improved image. It might take a bit of work, as those original shots were not lined up to match for work in the computer, but still, I could get a panoramic image that that would look a lot like I had shot it today with a digital camera.

Of course, those recent shots were taken with a tripod that was leveled, using high-resolution digital capture that will far out-detail film, and the images will match at the onset, there-

fore the assembly is far easier. The technology is better, but again, the concept is the same.

lepp's technique

Capturing a quality composite panorama starts with proper technique in the field. I think that a tripod is imperative. A tripod that can be quickly leveled is very useful. There are several leveling bases available from Manfrotto and Gitzo. They usually replace the center column, have a cup for articulation and a spirit level to let you know when the tripod is level to the world. This beats the old method of lengthening and shortening the legs until you have attained a level state.

© George Lepp

Next you need to level the camera. A ball head or multi-axis tripod head will accomplish this if you have a bubble level on the camera's hot shoe. First level the camera to the horizon. If the horizon will be noticeable in the image you may also have to level the camera front to back. If you don't, the horizon will be curved when you finish the assembly.

Take your series from left to right (that's the way most software works) and overlap the images by 50% if you are using a wide angle lens and by 20% if you are shooting with a normal to telephoto optic. Make sure the exposure stays the same for all the exposures, and with digital, keep the white balance the same as well. If you don't, the images will not match and you will have extra work in Photoshop.

Another element to consider if you are taking panoramas with a wide angle lens is a factor called the "nodal point" of a lens. The lens must rotate around this "nodal point" for all the images in the series to composite together properly. The nodal point is the point at which the image flips from upright to upside-down near the middle of the lens, or to be more scientific, it is where the light paths cross before being focused onto the film or imaging sensor. Finding this point is relatively simple for single focal length lenses and a moving target for zoom lenses because it changes with the focal length.

A focusing rail or slider like the ones offered from companies like Kirk and Really Right Stuff will allow the lens and camera to be slid back and forth over the rotating position of the tripod head. Find two vertical features, one quite close to the front of the camera and one considerably farther away. When the camera/lens is positioned correctly over the nodal point, the two near and far features will not change in their relation to each other as you rotate the camera/lens from side to side in the image area that includes them. If this explanation leaves you confused, go to the Internet and search under "nodal point" as there are numerous websites that illustrate the concept.

Next comes the assembly back at the computer. For most images, the secret concept is "Layer Masks." However, if you took a panorama with a wide-angle lens, you most likely will need "stitching" software to bend all the distorted images into compliance to make one panorama. Inexpensive software that I've had great luck with is Panorama Maker 3.5 from Arcsoft.com. No matter which method is employed in the compositing of the panorama, the end result will be best if the field techniques are followed closely.

what to
do with the result

You have this extra long image file, what will you do with it? My favorite method of display is a print that has been properly mounted and presented. A number of inkjet printers are capable of printing panoramas. The smaller format Epson printers allow a 44-inch long print. The Epson larger format printers permit up to 90 inches and with special printing RIPs, you can print as long as you have paper and ink. I wouldn't purchase a printer that didn't have the panorama capability, so check before you buy.

I like to mount my prints on Gator board (usually 3/16 or 1/2-inch thick). You can frame with glass, though this is an expensive proposition for really large prints. You can also have a laminate placed over the print to eliminate the need for glass. The laminate surface I prefer is a luster finish that doesn't reflect much and still allows the print detail to show through.

All my 90-inch panoramas are laminated and a small-edged black or white frame is added. One other method to present the panorama is to wrap the edges of the print over the edges of the mounting board and add a small mounting frame on the back of the print. This doesn't work with laminated images due to the added thickness. I spray the surface of the panorama prints that aren't laminated with Krylon Kamar varnish or Premier Art Print Shield to protect them from fingerprints and moisture.

All that's needed now is a large wall, long hallway, or tall ceiling to welcome your long creation. The viewers will understand that you went to great lengths to accomplish these extraordinary images.

George Lepp's website is www.lepp-photo.com (be sure to use three p's).

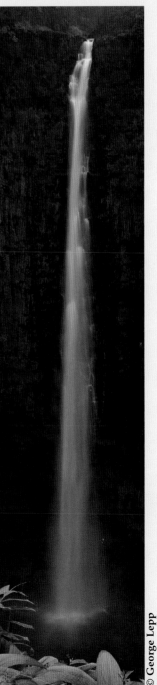

© George Lepp

message

a message from our sponsor

No, this isn't an advertisement. But in a sense, this is a message from our sponsor, the natural world. Nature photographers could not photograph anything if it weren't for nature. Okay, so that's pretty obvious ... or is it?

A few years ago at a meeting of the North American Nature Photography Association (NANPA - www.nanpa.org), one of the sessions included discussion about photographers and protecting the environment. Many photographers were adamant about environmental concerns and how to be involved with them. But one photographer took strong issue with this approach. This person said all they wanted to do was go out in nature and photograph its beauty. This photographer had no interest in environmental protection business as it really didn't affect them.

As you may guess, the group was pretty hard on this individual. This is not an isolated instance. Every time articles are run in *Outdoor Photographer* about environmental issues, we get letters saying we should stick to photographing nature and stay out of the nature business.

It is true that environmental protection has become political, yet most Americans value the nature of our country and consider it very important that we protect and preserve it. Photographers have a role to play by communicating the magic they find in nature through their photographs – magic that deserves to be preserved.

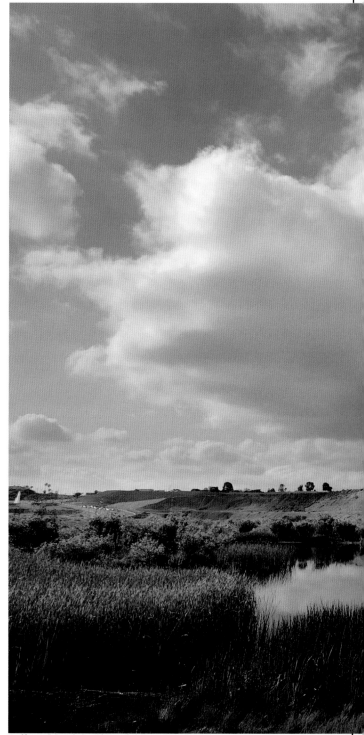

Ballona Marsh in Playa del Rey, Los Angeles, California.

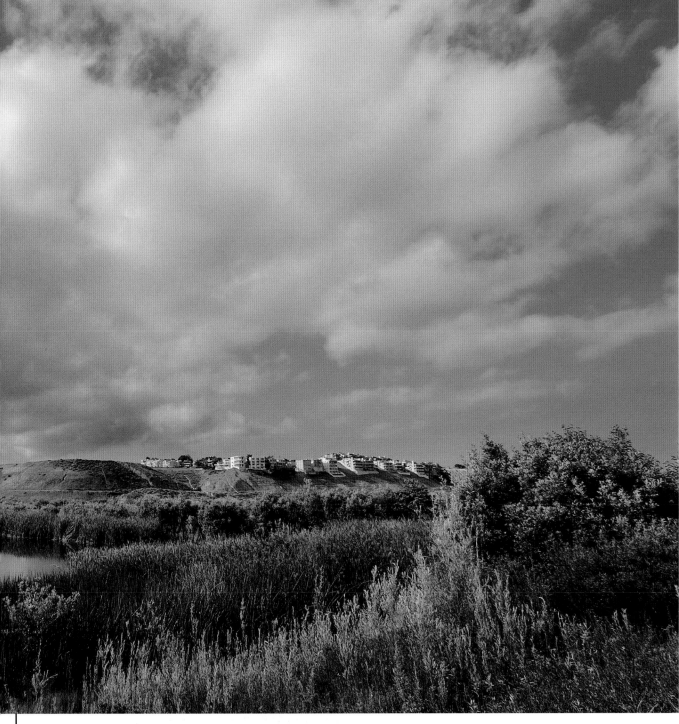

I want to be able to celebrate our beautiful world through photography for as long as I live. I also want my children, and someday, my grandchildren to have the same chances I do to explore and enjoy the wonders of the natural world. Wetlands, for example, are still being destroyed at alarming rates. It is noble to want to save the rainforest (and it also deserves attention), but closer to home, the marshes, ponds, and sloughs affect our direct experience with wild America, including the ability to photograph and enjoy wildlife. Policies of our government today cause problems for refuges and parks that will take years to repair, while also costing our children a lot of money.

A sad trend, to me, is the steady reduction in federal funding for parks and refuges in recent years, stressing the systems and forcing managers to look for new ways to get money to keep the parks in good shape. This is why new fees are proposed.

But shouldn't parks be open and accessible to everyone? Shouldn't we, as photographers, have the right to photograph in our property, the parks and refuges that we own as citizens of this country? I think we should have that right, but we also have a responsibility to maintain those places for future generations and for our own photographic needs.

A traditional value of our country since the work of Gifford Pinchot, Theodore Roosevelt, and John Muir in the early 1900s has been the importance of public lands and the federal government's support of them. Our grandparents and their parents made an investment in parks and refuges through the government in their times. That is an investment that I believe we need to build on, not use up.

What happens to all the young people of our country as they become adults and have to deal with something less than what we have today? Will they be able to experience nature with the richness that we have been privileged to witness and photograph? Will their children be limited in their ability to go outdoors because they suffer from asthma (a chronic problem with strong links to air quality)? Will they have the park experiences we have today or will parks be damaged beyond repair because we didn't care enough about our kids to take care of their parks, too? Will our children resent us for giving them a financial burden to clean up their world because we didn't do it?

I know there are no easy answers in the very politicized and partisan world we live in today. But as one who has photographed and enjoyed the natural world since I was a kid, I want to leave behind the opportunity for such experiences with my children. It may be all well and good to reduce the "death tax" so that a family pays less for inheriting money and property from a loved one, but what about the world they inherit? What kind of legacy will we offer? A place of broken parks, drained marshes, poisons in our rivers, and the very air we breathe?

It is easy to get caught up in the partisan battles of our elected officials. I don't want to do that. I believe that we can work together, no matter what our political leanings, and make a commitment for keeping our world healthy, strong, and beautiful.

When you see an issue that affects you, let your representatives, senators, and even the president know. Your voice is important. When people speak up, that input does make a difference, especially since so few people do. You can even share your photos with these people to help them see the magic of nature that is important to you. Also, check out sites such as the Natural Resources Defense Council (www.nrdc.org) to find out about important issues that will affect our use and photography of the outdoors. We can and must take responsibility for clear air, water, and wild places, or they simply will not exist in the future.

Connections – Life in Touch with the Environment

Plants are very sensitive to their environment because they are so closely adapted to it. Desert plants don't live in rain forests and rain forest plants don't live in deserts. The deserts of the Southwest are quite sensitive to environmental conditions. One heavy, rainy winter covers the ground with plants like sand verbena and evening primrose. The very next year there can be nothing.

While frustrating to photographers, this cycle is an important one for the plants. They need water to grow and reproduce. Though they do this quickly, they still need enough water to ensure they can complete the flower-to-seed process before they run out. With enough rain, they "know" they can sprout, grow, blossom, and set seed in time.

The forest is a wetter environment than the desert, to be sure, but both are highly dependent on limitations on their resources – sunlight for the forest, water for the desert. A forest filled with spring blooms is a joyful sight indeed to anyone wanting a long winter season to end. But the flowers have a very tight schedule to fit their cycle of growth, bloom, and seed. Like all plants, they need light to photosynthesize, create food, and develop. As soon as the forest canopy fills out with leaves, that light drops dramatically. Once leaves are fully expand, they can block 90 – 95% of the light that once reached the ground.

Most of our world is governed by cycles strongly connected to conditions in the environment. Obviously, we are, too, to a degree. Animals grow thicker fur when it gets cold; we buy warmer jackets. Since we cannot make food the way plants do, we also are affected by changes in the weather as it affects our food crops.

If we make changes, for example such as climate changes that warm the earth in unnatural ways and altering important cycles, we are disrupting patterns that have taken eons to develop. It is worth paying attention to cycles and what is happening to them. The cycle of life and death is the ultimate cycle, and can result in the life and death of certain species that can no longer adapt to changing conditions. Because this planet is our only livable ecosystem, this affects us all.

Canaveral National Seashore, Florida.

index

lighting
 backlight 66-67, 68, 70, 72, 73, 74, 83, 88, 127, 131-132, 138,
 171, 178
 built-in flash 71, 88, 178, 180
 diffused flash 138, 171
 electronic flash 57, 169
 fill flash 81
 front light 68, 70, 196
 sidelight 68, 70, 127, 176, 177
 top light 69, 127

M
macro lens (see lens, macro)
magnification 28, 33, 39, 128, 135, 144, 145, 158, 159, 167, 168,
 175, 179
Manual Exposure Mode (M) 49
megapixels 24, 27, 28, 30, 58
memory card 30, 53, 54
metering 60, 84, 85
 spot 60
monopod 152
monitor
 LCD (see LCD monitor)

N
noise 27, 28, 30, 42, 44, 50, 58, 60
normal lens (see lens, normal)

O
overexposure 42, 60, 110

P
Photoshop (see Adobe Photoshop)
pixels 28, 30, 74, 90, 191
program modes 47

R
RAW 42, 51-54, 60
resolution 21, 199

S
sensor 27, 28, 30, 32, 33, 41, 43, 44, 46, 53, 54, 58, 60, 70, 86,
 135, 136, 144, 145, 158, 182, 186, 195, 196, 197, 200
Shutter Priority Mode (Tv or S) 47, 49
shutter speed 27, 34, 35, 36, 37, 41, 46-47, 48, 49, 50, 86, 111,
 113, 114, 130, 135, 158, 159, 169, 176
sidelight (see lighting, sidelight)
spot metering (see metering, spot)
stitching 193, 194, 200

T
telephoto lens (see lens, telephoto)
TIFF 51
top light (see lighting, top light)
tripod 35, 36-38, 46, 50, 56, 70, 72, 99, 103, 110, 111, 113, 114,
 116, 121, 125, 134, 148, 159, 168, 176, 180, 192, 193, 196,
 199, 200
TTL 178

V
viewfinder 14, 16, 27, 34, 77, 86, 91, 99, 100, 103, 130, 144, 158,
 160, 168, 190, 192

W
white balance 27, 54-57, 69, 72, 91, 193, 200
wide-angle lens (see lens, wide-angle)

Z
zoom lens (see lens, zoom)